Sir Mortimer Wheeler
was born in Scotland and educated in Yorkshire
and London. He was Director of the National Museum of
Wales, Keeper of the London Museum, and Director of the
University of London Institute of Archaeology, which he
was largely instrumental in founding. Later he was Director
General of Archaeology in India and Archaeological Adviser
to the Government of Pakistan. He was also President of the
Society of Antiquaries and Secretary of the British Academy.
Among his numerous published works are *Roman Africa in
Colour, Early India and Pakistan, Civilizations of the Indus
Valley and Beyond, Archaeology from the Earth*, and the
autobiographical *My Archaeological Mission to India and
Pakistan*. He was the General Editor of New Aspects of
Antiquity, the series of archaeological monographs. Sir
Mortimer Wheeler served in the Royal Artillery in both
World Wars, and attained the rank of Brigadier. He
died in 1976.

WORLD OF ART

This famous series
provides the widest available
range of illustrated books on art in all its aspects.
If you would like to receive a complete list
of titles in print please write to:
THAMES AND HUDSON
30 Bloomsbury Street, London WC1B 3QP
In the United States please write to:
THAMES AND HUDSON INC.
500 Fifth Avenue, New York, New York 10110

ROMAN ART
AND
ARCHITECTURE

Sir Mortimer Wheeler

215 illustrations, 60 in colour

THAMES AND HUDSON

© 1964 Thames and Hudson

Published in the USA in 1985 by Thames and Hudson Inc.,
500 Fifth Avenue, New York, New York 10110

Library of Congress Catalog Card Number 84–51306

Printed and bound in Singapore by GnP

Contents

Preface

The Roman arts have, on the whole, had a bad deal from friend and foe alike. On the one hand, fallacious comparisons with Hellenic or Hellenistic artistry have distorted their proper values; on the other, tendentious scholarship has abstracted them from their context, has insulated them from the broad sweep of intellectual evolution, and has lost itself down side-turnings.

The Romans themselves are not free from blame in this muddled thinking. Unlike the Renaissance societies, which were aristocratic and intelligently selective, Roman society was through-and-through *bourgeois* and was not at all clear, culturally, where it was going. As is the way of *bourgeois* societies, it was inclined to look over its shoulder. Of course it knew what it liked; and by the grace of fortune its taste was moulded in a world that was full of good things. But this happy circumstance whilst it ensured a high average level in the furnishings of the wealthy – supplied as they were with looted originals from the Greek world, or more widely with competent but usually pedestrian adaptations – did little directly to encourage, and tended rather to hinder, evolutionary progress in art. It led, incidentally, to the crowding of our modern museums with dull derivative stuff in the name of Rome, and so to creating a false image of the Roman achievement.

But the important thing is that all this antiquarianism also falsified that image in the contemporary Roman mind. It created a sort of double thinking throughout what may be called the classical Roman period: say, from the second century BC to the third century AD. On one side there was this almost infinite reserve of second-hand material, constituting a sort of Alma-Tadema complex to which polite acclaim was ever ready to award the Order of Merit. On the other side there were here and there genuine attempts, some successful and some experimental, to inform art with the varying needs and

capacities of half a millennium of evolutionary change. Of course all ages of art can show something of this dichotomy. It represents the perpetual tendency to conflict or 'drag' between the creative artist and his public. But in Roman times the schism was vastly magnified by the perfection and authority of the preceding Greek attainment within the proper range of its own ambitions, and by the fecundity of the Greek artist, particularly of the Greek sculptor, under traditionally lavish patronage.

Thus it is that the critic of Roman art is kept constantly and sometimes uneasily aware of at least two divergent values in his material: an academicism of a kind, quantity and quality which have never been surpassed in the history of art, and an urge to new expression which sometimes used that academicism (in a fashion that has been well called 'Greek art in the service of the Imperial idea'[1]) and sometimes tried quite drastically to supplant it. Faced with this kaleidoscope the poor critic is liable to be dazzled and puzzled.

So indeed was that sensitive observer the late Bernard Berenson – like many others before him – in the presence of the familiar Arch which confronted Constantine the Great on his return to Rome in 315.[2] Its odd collection of reliefs, many of them adapted from buildings of the late first and second centuries, others newly carved in a raw but vigorous documentary style of an alien and even original kind, others again a compromise between the two, combines strangely to produce a balanced and integrated monument which satisfies the modern eye and must be supposed to have satisfied the contemporary eye. Here in literal fashion the dichotomy is restated and in a measure healed. In this, the last great monument of Imperial Rome, less than a dozen years before Constantine traced the outline of his new eastern capital, a wind of change was blowing from the east and, for good and ill, was gathering and dispersing the dust of the Hellenizing past. In a sense, the Arch of Constantine is a summary and a symbol of the composite Roman experience on the brink of the Byzantine world.

Who were the Roman artists? Who carved that astonishing portrait-gallery upon the Ara Pacis which celebrated the homecoming of Augustus in 13 BC? Who wound that great spiral relief

about the Column which commemorated Trajan's wars? (The craftsman who cut his name 'Orestes' in Latin script upon the Column is no help.) Who was the architect of Hadrian's Pantheon? We do not know. It is a remarkable fact that creative Roman art and architecture, with vague or trivial exceptions, are anonymous. Even Apollodorus of Damascus, whose name lurks behind the architectural prowess of Trajan, remains a tantalizing ghost. Greek art and architecture, and even the Greek hackwork produced for the Roman market, are splashed with names. At first sight, in an age when the individual was of high account – when portraiture, for example, reached its zenith – this anonymity may seem a paradox. The truth probably is that the cult of the individual had here over-reached itself; that the Roman patron was now the man who counted; that even a Column and a Pantheon were so closely integrated with the personality of a Trajan and a Hadrian that the artist and architect mattered not at all. They were employees. The difference between Athens and Rome in this matter is of interest to the student of historical moods and manners: the democratic free-for-all which had characterized the embellishment of the Athenian acropolis was now focused upon the supreme personality-cult of the Emperor. We have the Parthenon of Pheidias, Iktinos and Kallikrates, but on the other hand we have the Altar of *Augustan* Peace, the Baths of *Caracalla* or *Diocletian*, and the Arches of *Titus* or *Constantine*. There is a historical logic in the change of standpoint.

In the following pages I have not hesitated to include architecture and town-planning. Indeed I have given them priority. Roman art presumes Roman architecture and at every turn spills over into it. In this close involvement, Roman art in its broadest sense was enlarging and at the same time almost utterly transforming the Greek tradition; preparing prophetically for that astonishing after-life in which it was to dominate the post-Renaissance world down to the noonday of modern times. In any appreciation of the complex process we are not allowed to forget that, unlike Hellenic art, Roman art was essentially and undisguisedly secular. The Parthenon had been a superb temple shyly concealing a skied procession of impersonal actors; the Altar of Augustan Peace, four centuries later, was

a vivid family group before it was an altar. This primary awareness of humanity is always present to Roman architecture, even (or particularly) in the most exuberant manifestations of its five orders and its brave vaulting. It is fair to say that no facet of the Roman experience, the Roman achievement, can be studied without reference to the architectural frame, with its sturdy 'reason' which was yet not too strong for fantasy.

London, 1964 MORTIMER WHEELER

The Roman Contribution

At the cost of logic it is perhaps not a bad thing to anticipate at once some of the major conclusions to which our summary catalogue may lead us in the following pages. If we add up these selected achievements of the Roman world, what is the order of their magnitude? How far are they coherent and creative? Their main external source lies within the Hellenistic world; the stream flowing first through Etruscan and Colonial Greek channels and later, from the second century BC, directly from metropolitan Greece itself. That is, however, only a part of the story. Alexander the Great had already given political expression to that widening of the Greek mind which was in fact becoming generally manifest in the latter part of the fourth century. Aristotle is the father-figure of this age of change, and Alexander was a pupil of Aristotle. Alexander's own greatness, as is the proper habit of successful men of action, was due in first instance to good timing; his epiphany occurred at precisely the right moment. In a world subconsciously prepared for him, his theatrical success marked, for all to see, the beginning of a new international concept, which led directly on to the Roman Empire and, on the way, fed into the Hellenistic tradition all manner of variant or alien ideas and attitudes. In so far as these new ideas fitted into the orderly evolution of human comprehension, they gradually and logically re-shaped that tradition and, amongst much else, eventually gave us 'Roman' art and architecture.

In measuring this metamorphosis, let us first glance for an instant at essential aspects of the Hellenic achievement, as yet untroubled by Hellenistic mutation. It is fair to affirm that on the Acropolis of Athens in the latter half of the fifth century BC the Greeks said practically all that they had to say about architecture: in the Doric Parthenon, in the Ionic Erechtheum and temple of Athena Nike, in the Doric and Ionic Propylaea, all between 447 and 405 BC. And the

first point about all this masterly construction is that it is essentially extrovert. The Parthenon is probably the most intelligent extrovert building that the world has seen. True, it imprisoned in its crepuscular interior the massive gold-and-ivory bulk of Athena, just as it imprisoned the more secular tribute of the faithful; it was a religious safe-deposit. But to the world it showed a plain and sturdy exterior set squarely and possessively on its rock and owing its sturdiness to infinite judgment and finesse. And, secondly, it showed too in its external sculptures an impersonal pageant of heroic but utterly extrovert mimes, impeccably wrought, chiselled (at their best) as marble may never be chiselled again, but with nothing whatever in their heads. Neither the building nor its decoration had any inner life; it was a perfect exterior, a perfect piece of man-made geology, and *because* it was, within its proper limitation, perfect, it marks an end. The finality of the Parthenon, architecturally and sculpturally, is its defining quality.

Only at Bassae, far off in the Peloponnese, is there a contemporary building, made perhaps by the chief architect of the Parthenon himself, with a hint of things to come. Here, within, was the first Corinthian capital; here too the sculptured frieze was carried round the *inside* of the shrine, not the outside (*Ill. 1*). For the first time here was a major classical temple with an *interior* as well as an exterior. But the revolutionary innovation was not pursued. Bassae long remained in Greece a desolate and untimely pioneer of the rich order and the rich interior that between them were to dominate the architecture of the Roman Empire: an architecture that was to look more and more inward, to become more and more – in a crude usage of the term – introvert.

For the Roman problem was above all to create and adorn *interiors*, larger and more magnificent interiors to match imperial pride and the growing self-consciousness and importance of the individual. New techniques – particularly, from the second century B C onwards, the increasing exploitation of 'concrete' and brickwork – stimulated and were stimulated by this endeavour. By the end of the first century A D the whole complex process was approaching its early prime. But its oldest surviving triumph is Hadrian's Pantheon

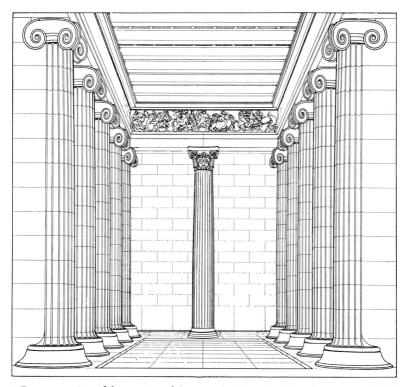

1 Reconstruction of the interior of the Temple of Apollo Epicurius at Bassae, built *c.* 450–425 BC

(*Ills. 81, 82, 83*). 'The Pantheon is perhaps the first major monument to be composed entirely as an interior.'[3] This interior, with its superbly coffered dome, is one of man's rare masterpieces. They were right to bury Raphael within it.

Now what has happened in the five-and-a-half centuries between the Parthenon and the Pantheon? Bluntly, architecture has been turned outside-in. Philosophy and religion and politics have combined to alter the shape of the world and man's relationship to it. The world has ceased to be a collection of disjected phenomena, expressed politically by a scatter of city-states; it has become a coherent cosmos, expressed politically by an empire. Its encompassing vault finds a proper symbol in the Pantheon, which stands for Rome just as the objective Parthenon, perched on its Acropolis like a (very distinguished) ornament upon a mantelpiece, stands for Hellas.

13

'My intention had been that this sanctuary of All Gods should produce the likeness of the terrestrial globe and of the stellar sphere, that globe wherein are enclosed the seeds of eternal fire, that hollow sphere containing all.' That is Hadrian speaking of his Pantheon; he is using the words of Madame Yourcenar, but it is the authentic voice. It is the voice of the cosmos, but it is also Hadrian's. And that is of course the nub of the matter. To vary the picture, the Roman Empire was in large measure monolithic; it was a monarchy; its ultimate doctrine was monotheism. But, of no less importance, its monarch was, for good or ill, an intensely human individual, and it discovered its crowning god in a Man.

We are back once more in that milieu wherein the art of portraiture and historical narrative, the cult of particular men and women of all degrees in the circumstances and landscape which environ them, are in context and inevitable. Our hasty journey from the Parthenon to the Pantheon has taken us from the pageant to the personality. Strangely enough, yet quite rationally, the growth and the growing coherence of the civilized world have found a counterpart in the growing importance of the individual. And that – to revert – is why the insides of buildings are now so important. In place of the milling crowd of anonymous spectators outside the temple, the individual devotee now goes inside his *Mithraeum* or his chapel for personal interchange with his deity; and, where old extrovert temples were used for this intimate purpose, the open colonnades were now to be walled up, as in the cathedral church (ex-temple of Athena) at Syracuse (*Ill. 2*), or formerly in the Parthenon itself and the 'Theseum', to ensure privacy within for the mysteries of the initiate. The temples were literally turned outside-in.

And alongside godliness we have the claims of cleanliness – surely a tolerably individual virtue. It has often enough been remarked as an axiom of architectural history that the great public bath-buildings which constituted the social rendezvous of the Roman world were a leading stimulus in the development of spacious and ornate interiors.

2 Temple of Athena, Syracuse, built *c.* 480–460 BC and later converted into a cathedral. The original colonnade is incorporated in the outer wall of the later building, and eight openings pierce the *cella* wall on each side, thus forming a nave and aisles

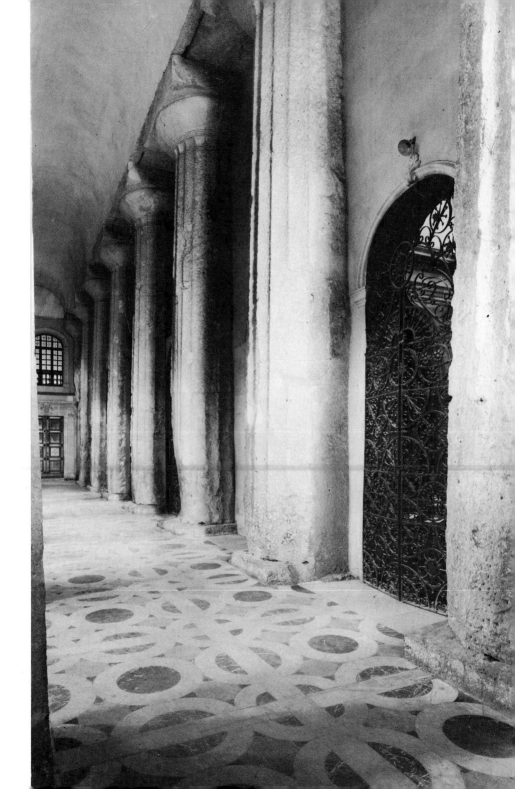

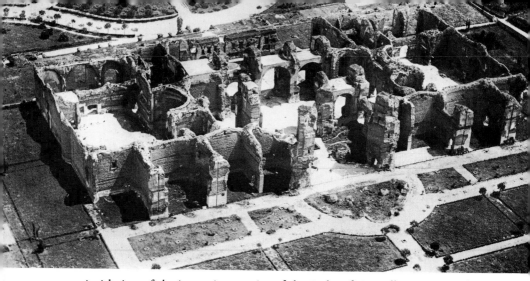

3 Aerial view of the impressive remains of the Baths of Caracalla in Rome. The main building block measured 750 by 380 feet and dates from AD 211–17

You went to the baths in great numbers to talk to and about your friends and to work off the night-before (*Ill. 3*). But one thing you certainly did not do; you never glanced at the untidy complex of domes and gables outside as you entered. (For a small example, we shall see the confusedly functional exterior of the substantially complete 'Hunting Baths' at Lepcis Magna (*Ill. 38*).) It was the inside of the building that mattered, with its towering wall-spaces that stretched the minds of architect and sculptor and gave a sense of self-importance and well-being to patron or client. We may appropriately leave our Roman within the great hall of the Baths of Diocletian, which Michelangelo and Vanvitelli have preserved for us by enshrining it with fitting splendour as Santa Maria degli Angeli in Rome (*Ill. 4*).

In so doing, we are affirming a final emphasis upon the grandest facet of the Roman achievement as a whole: the overall magnitude of its field of thought. Whether in the rehabilitated Baths of Diocletian (*Ill. 5*) or in the aspiring ruins of those of Caracalla or beneath the towering Pont du Gard (*Ill. 132*); whether in the wide sweep of the Vergilian epic or in the cosmic vision of Lucretius; whether in the ultimate legionary fortress of Inchtuthil, away up

16

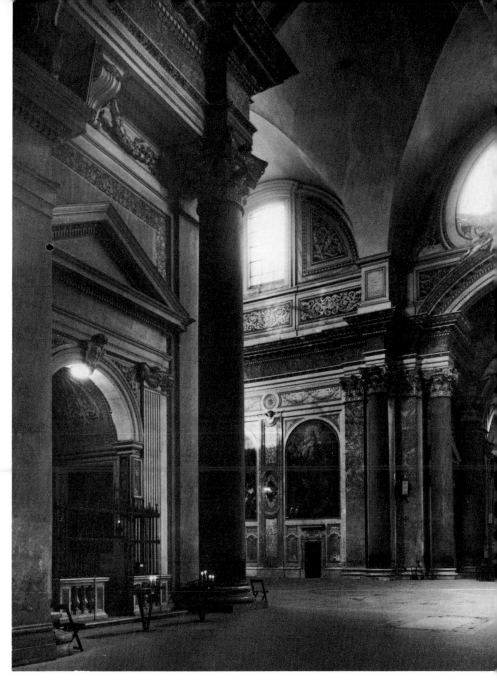

4 S. Maria degli Angeli, Rome. Converted by Michelangelo in 1563 from the *tepidarium* of the Baths of Diocletian (AD 302)

5 Reconstruction of the Baths of Diocletian in Rome (AD 302); view

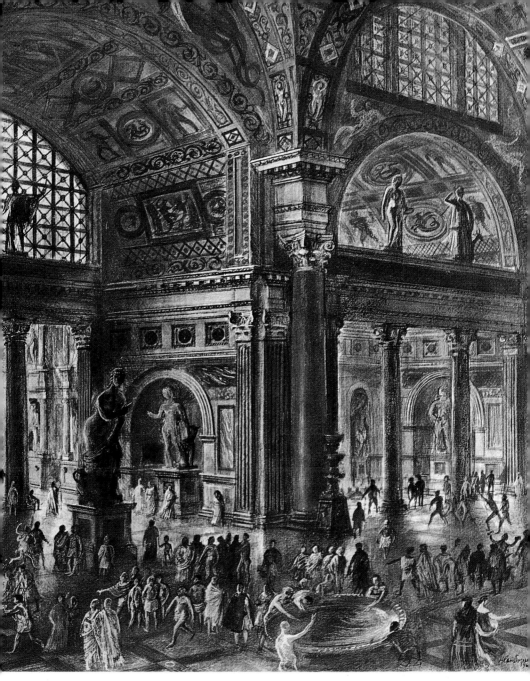

through the *tepidarium* towards the *frigidarium*

there in the bleak Scottish Highlands, or beside the Tuscan trade-goods that emerge abundantly 6,000 miles away amidst the palms of tropical Coromandel; it is the astonishing reach of the Roman mind that compels the imagination. Scope and size. These are a combined quality which in its own right can claim the seal of greatness.

To frame this proposition in its simplest form – What is the quality of an Egyptian pyramid? Precision – but, above all, size. One need but recall those insignificant *little* pyramids, which the Pharaonic builders equally contrived, to appreciate the over-reaching value of magnitude. Or, less simply, imagine New York's Empire State Building bereft of the size and vista that give some sort of status (I suppose) to the actual pile. . . .

No, size is in itself a subtle and substantive quality. Listen to the biologist: 'We shall realize that size, which we are so apt to take for granted, is one of the most serious problems with which evolving life has to cope. . . . Simply magnify an object without changing its shape and, without meaning to, you have changed all its properties.'[4] And not only is this true of evolving life; it is equally true of evolving art and architecture, if indeed these be other than forms of evolving life.

So when our eyes bend upwards, for example, to the crown of those gigantic columns that remain to us from the Temple of Jupiter at Baalbek (*Ill. 6*), we are looking at something more than a piece of inflated Hellenism. Here there is nothing structurally that was not within the compass of the Hellenistic world; indeed, there were two or three Greek temples which, on mere plan though not in elevation, could show a more ambitious footage even than Baalbek; but conceptually this Baalbek temple, which was a-building in the time of Nero,[5] is a world apart. Elsewhere, as we shall recall, new techniques enabled the Romans to exploit this new passion in soaring concrete, but at Baalbek we are not concerned with them; the revolution was no mere matter of techniques. Here we are confronted in uncomplicated fashion with the aggrandizement and transmutation of the

6 The six remaining standing columns of the Temple of Jupiter at Baalbek, about AD 60 The columns are 65 feet high and 7 feet in diameter

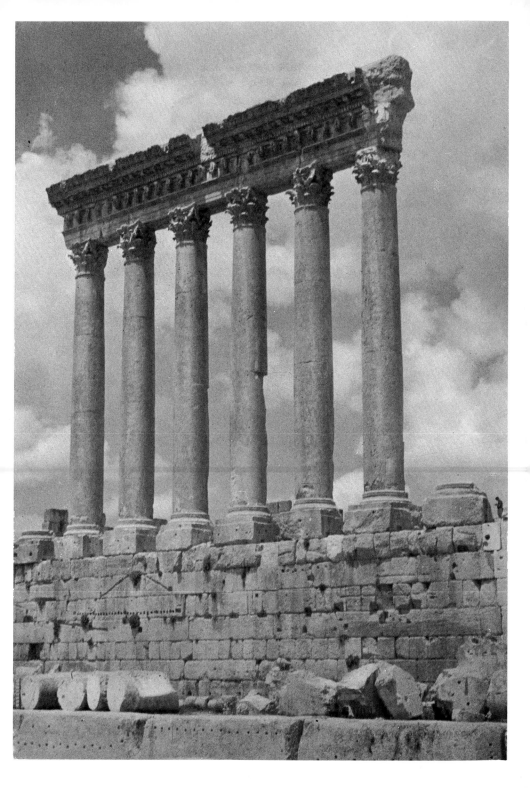

Greek tradition. Even that vast block of ashlar (*Ill. 7*), 60 feet long and weighing 1,500 tons, which still lies idly in the neighbouring quarry, is eloquent of the Roman ethos. Its magnitude is more than mere tonnage. It is creative thinking. If such there still be who can dismiss the art of Rome as 'the decadence of ancient art', or can regard Roman architecture as a sort of rubiginous autumn phase of the Hellenistic tradition, let them ponder again upon that little handful of Latin villages which grew intelligently into an empire 3,000 miles across. In more ways than one, the mind of Rome found new expression for the magnitude and majesty of that achievement.

I have here again stressed the significance of architecture as the overall expression of an evolved civilization, as its 'chamber of consciousness'. I turn now to the circumstances in which this chamber of consciousness assumed its Roman shape.

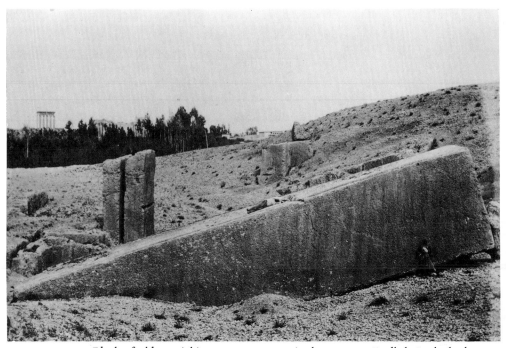

7 Block of ashlar weighing some 1,500 tons in the quarry at Baalbek. In the background are the columns of the Temple of Jupiter

Greece and Rome

'In Greek archaeology, any object you turn up is beautiful: in Roman, you are delighted if you can argue that it is second-rate.'[6] Thus the late Arnold Gomme, who long professed Greek with distinction at Glasgow. There was something more than mere naughtiness in the remark; it reflects a traditional misunderstanding of major issues, and must be traversed at the outset of any account, however summary, of the Roman achievement.

The Hellenist, who is customarily responsible for this kind of misunderstanding, is the heir to a young world in which cultural values were sharp and explicit. There were the Greeks (the most splendid snobs in history), and beyond the Greeks were the Barbarians, the rest. Between the two stretched an intellectual barrier more impenetrable than the social barriers which isolated classes in Victorian England. It is easy enough to draw a pencil-line round the Hellenes and to find within that frame an essential community of aspiration and attainment; even – to use a highly dangerous word – an essential community of race.

Not so with the Romans. Their political genius enabled them to assume control of the civilized West, including Western Asia, to enlarge it to the Danube, the Sahara and the shores of Ocean, and to provide the means and opportunity for an equivalent expansion of ideas and forms. But these ideas and forms were no more theirs, or theirs alone, than were they themselves all Latins or Italians. Indeed the whole concept of Empire, in which Roman politics culminated, had already been given vivid expression by Alexander the Great before he died in 323 BC at the age of thirty-three. His transit marked the end of the old Hellenic isolation before ever the Romans came upon the international scene. It would be more exact to say that by the end of the fourth century BC Western civilization was intellectually ripe for the change of which Alexander and Rome were the successive instruments.

Between 'Greece' and 'Rome', therefore, can be no sort of opposition in any intelligent and historical sense. They are related but sequential phenomena. Roman art and architecture are not *bad* Greek art and architecture; they are different in aim and achievement, based upon evolving, not merely repetitive values. So also within the wide geographical scope of the Roman achievement itself it is wholly fallacious to think, as a former generation of scholars tried to think, in tendentious local terms: to speak of 'the Orient *or* Rome', for example, as though these were viable alternatives in the make-up of Roman culture. Of course they were not. To speak of the Orient *and* Rome would be an over-simplification but would more nearly approach a truth. The 'Roman' emperor himself might be an Italian; he might equally be a Spaniard, a North African, an Illyrian, a Syrian, a Gaul, even a Low Country adventurer or the son of an Arabian brigand. Rome was an amalgam; its importance to us is that of a political label which may conveniently be attached to a great formative phase in the history of thought, a phase in which, at its best, the ideas perfected in their primal shape by fifth- and fourth-century Greece were developed into something new and more complex, though also with new simplifications, as is the proper habit of evolving thought.

In the summary which follows I have begun with the overall shape of the towns, as the nuclear element in classical civilization. Then follows a brief account of some of the public buildings and private houses which were the substance of these towns, with passing reference also to the buildings of the countryside. Thereafter in a narrow space something must be said of the sculpture and painting to which the Roman contribution was of outstanding significance in the broad history of art.

Towns

THE BEGINNING

It is common knowledge that the political focus of the Greek mind, from its emergence somewhere about 700 BC until its adjustment to wider vistas in and after the time of Alexander the Great (died 323 BC), was the individual city. Within the cultural limits of the Greek world, you owed your allegiance to your own paternal city or *polis* and so gave to politics its initial and homely meaning.

When the Romans began to take over the Greek world from Alexander's successors in the second century BC the civic idea was, in form, merely enlarged. You now owed your allegiance to the ultimate city, Rome. But the substance behind the civic idea had changed. You might now be a 'Roman citizen' without ever setting eyes upon the Eternal City. At the same time you remained functionally a citizen of your own particular city or province. A sort of differential focus had entered into your thinking; for even when the Roman Empire had begun to harden into a disciplined universal state, strong local elements continued to dominate and diversify local life behind the formulae which tended, and still tend historically, to overlie and conceal them. Not the least important of these formulae is an astonishingly tenacious adherence to the urban pattern shaped by the Greeks in the early days of Hellenic and more particularly Ionian civilization.

In the classical world there were no pre-Hellenic towns in any viable sense. The Mycenae of Agamemnon, for example, was not a city; it was a fortified feudal palace with little scattered communities of farmers and traders in the surrounding countryside. No doubt Mycenaean Athens was the same. Essentially these were lordly strongholds, with an economy based upon agriculture, commerce and piracy. Not until the eighth or seventh century BC do we encounter visible vestiges of a co-ordinated civic life, and then, perhaps significantly, on the coast of Anatolia: at Old Smyrna,

where a temple and houses defended by a wall and flanked by alternative harbours have been partially excavated by J. M. Cook.[7] The destruction of the town by the Lydian king Alyattes about 600 BC provides a terminal date. There is enough to show that Smyrna in the time of Homer had an orderly civic aspect of a kind and shape remarkably reminiscent of the Phaeacian city of King Alcinous in the *Odyssey*, with its walls, its houses, its market-place (*agora*), its fine stone temple of Poseidon, and 'an excellent harbour on each side'. The persistent tradition that Homer was born in Smyrna fits happily into the picture. In short, on the threshold of the Greek world the literature and archaeology of Ionia converge upon the primary condition of the Hellenic way of life – the city.

It is unnecessary here to pursue the civic idea through the details of its early growth. But the Greek coastline of Asia remains in the picture. At the end of the sixth century planning of a chessboard kind appeared at Olbia in South Russia, a colony of Miletus, and at Miletus itself the famous and eccentric Hippodamus, probably after 466 BC, systematized the chessboard plan; according to Aristotle (*Politica*, II.v), who cannot be strictly correct, he 'invented' the division of cities into blocks. At the invitation of Pericles, he subsequently introduced the principle to the Piraeus – in Aristotle's phrase, he 'carved up' the Piraeus. More immediately relevant to the present context, in 443 BC he accompanied Athenian colonists to Thurii in South Italy and there again applied his chessboard scheme. His work at the Piraeus has not been convincingly identified; at Thurii, Diodorus (XII.10) tells us that 'they divided the city lengthwise by four streets, the first of which they named Heracleia, the second Aphrodisia, the third Olympias, and the fourth Dionysias, and breadthwise they divided it by three streets, of which the first was named Heroa, the second Thuria, and the last Thurina. And since the blocks formed by these streets were filled with dwellings the city had a well-built appearance.' No doubt, in addition to the main streets, the plan was amplified by minor streets and lanes conforming with the overall design.

Strabo (XIV.2.8) avers that Rhodes, founded in 408 BC, was also built by Hippodamus. The time-factor is against this, but air-

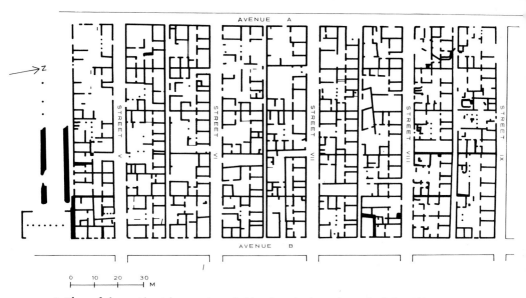

8 Plan of the residential extension of Olynthus, built at the end of the fifth century BC. The *insulae* or blocks of houses measure 99 by 44 yards

photography has shown here in astonishing detail the rectilinear layout of the large Greek town, with blocks about 105 yards by 55 yards in extent.[8] These may be compared with the 99- by 44- yard blocks of the residential extension built at Olynthus in Macedonia also at the end of the fifth century, where, as at Thurii, main streets from north to south were crossed by others from east to west (*Ill. 8*).[9] It is to be presumed that both at Rhodes and at Olynthus the Hippodamian example may be recognized. A century later Priene, beside the Maeander valley opposite Miletus, was rebuilt on the slopes below a sheer acropolis, and its lay-out, a chessboard within the irregular outline of a contour-defence, is the classic example of Hellenistic planning (*Ill. 9*).[10] In the application to a hillside of a geometrical plan more suitable to a level site, Priene constitutes almost a *tour de force*, and emphasizes the prestige which now attached to the conventions of the rigid Hippodamian scheme.

27

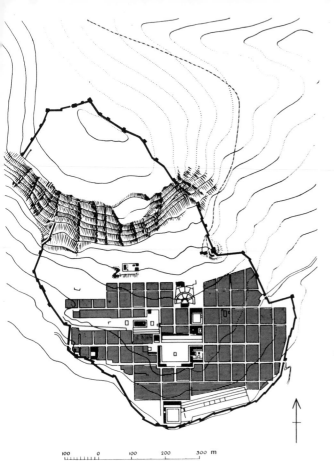

9 Plan of Priene as it was rebuilt at the end of the fourth century BC. The geometrical chessboard pattern is drastically imposed upon a steep hillside in this classic example of Hellenistic town-planning

100 0 100 200 300 m

ITALY

From western Asia Minor to Italy. There in general terms the Graecized south, with its fertile sea-plains, offered a contrast to the Italic centre, with its hills and marshes; a contrast expressed, for example, by Cicero in his *De Lege Agraria* (II.xxxv.95–6). 'The Campanians', he says, 'are inclined to boast of the excellence of their fields and the abundance of their crops, of the healthfulness, orderliness and beauty of their city. . . . They ridicule and despise Rome with its hills and close valleys, its garrets hanging up aloft, its poor roads and miserable lanes, in comparison with their Capua spread upon the level plain and most admirably laid out.' Strabo (V.3.8) a

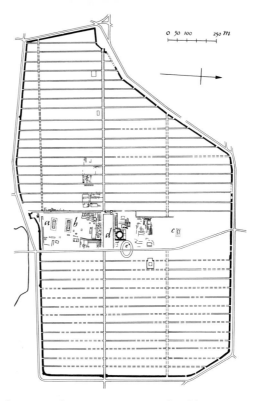

10 Plan of Paestum, a Greek colony taken over by the Romans *c.* 273 BC. The temples known as the 'Basilica' (*a*), the 'Temple of Neptune' (*b*), and the 'Temple of Ceres'(*c*), date from Greek times. The forum (*d*) and amphitheatre (*e*) are Roman

generation later says much the same thing, contrasting the felicitous situation of the Greek cities with the rugged hills and woodlands which, at Rome, stimulated the Roman genius for engineering (roads, sewers, aqueducts, water-pipes) and in the accented environment encouraged the building of tall and risky tenement-buildings from the abundant wood and stone available.

Of the progress of town-planning in the Greek towns of southern Italy from the fifth century BC onwards, our knowledge is at present slight. We have seen that in the latter half of that century Hippodamus himself was at work at Thurii in the extreme south. But at Pompeii in the small nucleus which represents the town prior to the Samnite invasions of the fifth and fourth centuries BC the planning, as known, was sketchy and not up to Hippodamian standards. In contrast, the very symmetrical plan of Paestum (*Ill. 10*), south-east of Salerno, has not been dated but may not be earlier than the planting of the Roman colony there in 273 BC, although Boëthius

would like to date it to the age after the Lucanian invasion, about 400 BC.[11] This earlier date, or something like it, may be right; the very regular elongated insulae recall those of the little town of Marzabotto, far to the north near Bologna, where, within a framework of a broad decumanus from north to south and three broad cardines from east to west, the long narrow blocks or insulae, impeccably laid out as a single unit, are ascribed by their latest excavator to a date before rather than after the middle of the fifth century BC.[12] If this be so, they precociously anticipate by several decades the classic Greek example at Olynthus, though they clearly represent the same distinctive Hellenic tradition and are, in all likelihood, the practised handiwork of an imported Greek surveyor at a time when the cultural flow from Greece to central and southern Italy was impressive.

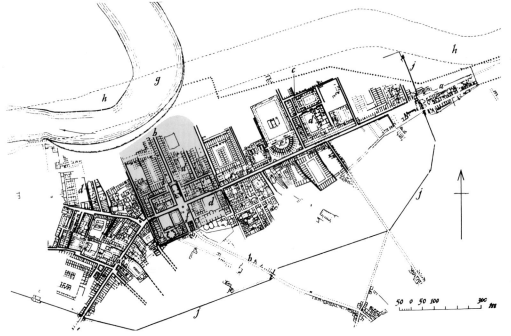

11 Plan of Ostia, the port of Rome. The original castrum or fort is shown as a stippled rectangle. Other features marked are the decumanus maximus (aa), the cardo (bb), the barracks of the vigiles (c), a bath-building (d), the theatre (e), the forum (f), the present (g) and ancient (h) course of the Tiber and the surrounding defensive walls built c. 80 BC (j)

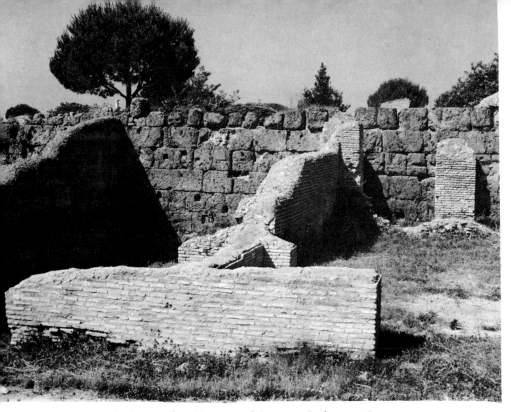

12 The 'castrum' of Ostia, the oldest part of the town; built soon after 349 B C.
It covered an area of some 5½ acres

But for the earliest indubitable example of geometrical 'Roman' planning and its sequel we may profitably look to Ostia, at the mouth of the Tiber (*Ill. 11*). The core of Ostia, the port of Rome, is a fort (the 'castrum') forming a rectangle some 5½ acres in extent. The walls, 5½ feet thick, were of large unmortared blocks of tufa and stood upwards of 20 feet high (*Ill. 12*). Within them, the space was quartered by straight streets which passed out through gates set at or near the centre of each side; otherwise the details of the fort-plan are not known. The date of the work, as reviewed by Russell Meiggs,[13] lies within the years following 349 B C, when Rome was troubled along the coast by Greek raiders. The garrison may have consisted of about 300 military colonists.

This 'castrum' at once brings to a head a question which cannot at present be resolved. We have derived the urban plan of Marzabotto from the Ionian Greek mode. Was the military nucleus of Ostia equally alien, or did it owe something to local (Etruscan or, more vaguely, Italian) elements; influenced perhaps by the procedures of Roman augury, the marking out of oriented squares of sky or ground in which to await signs? In more general terms, did the military plan precede and inform the civil plan, or, as Polybius (VI.31.10) thought, was the military plan derived from the civil plan? Did the Romans on the other hand directly adapt their military planning from that of the Greeks? So Frontinus (IV.1.14), who held that the Romans copied the organized Greek camp of Pyrrhus of Epirus which they captured in south Italy in 275 BC, whereas previously they had been content with mere huts (*mapalia*) for their soldiery. But this event was something like three-quarters of a century *after* Ostia, so that the sequence does not work. We have no firm answer to these queries; indeed there may be no firm answer to seek. True, in detail there were certain rigid elements in Etruscan thinking; notably, the frontal lay-out of the temple, set at the back of its rectilinear precinct. But Etruscan art and architecture were interpenetrated with Greek ideas; other Greek ideas arrived more directly from the Greek colonies of southern Italy, and to both of these formative influences Rome added mutations contributed by its own powerful mind. In these complex circumstances the extent to which (if at all) Roman military planning influenced early Italian town-planning baffles definition.

After Marzabotto, if not nearly contemporary with it, the earliest known rigid urban lay-out in Italy is to be seen at Pompeii (*Ill. 13*). Here, shortly before or after the Samnite raids of the late fifth century, the original Oscan town with its indifferently co-ordinated plan was progressively enlarged by rectilinear suburbs. To the north and north-east two straight main streets (known today as the Via di Nola and the Via dell'Abbondanza) were now laid out and crossed roughly at right angles by lesser streets; so forming square or squarish blocks about 65 yards each way. These blocks are of the Greek fashion, though surveyed with less than Greek precision. To

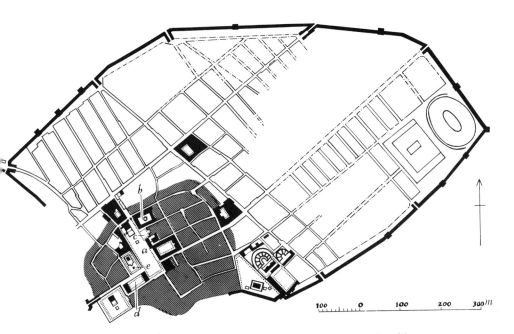

13 Plan of Pompeii, buried by the eruption of Vesuvius in AD 79. The oldest part of the town is indicated by shading. Also marked on the plan are the forum (*a*), market (*b*), Temple of the Lares (*c*), a basilica (*d*) and a temple to Apollo (*e*)

the north-west a separately planned suburb (Region VI), equally based on the Via di Nola, consists of oblong blocks about 35 yards wide and 100 or 160 yards long. Selective digging on modern lines is required to determine the sequence, but the main point is clear. In the development of the town, the older nucleus, including the forum and public buildings, was retained as a peripheral unit; so that we have not here an integral Greek plan comparable with Miletus or Priene. For the rest, the new residential enlargements accorded with the Greek mode. They compare in essence with the residential New Town at Olynthus, built about the same time and in the same presumed Hippodamian tradition.

For the most part, by the beginning of the third century BC the basically Greek plan came naturally to the builders or rebuilders of Roman towns in Italy – using 'Roman' in the widest sense. There is

33

14 The decumanus maximus of Ostia, the main street running east and west. The restored theatre on the left was built in *c.* AD 10 and enlarged *c.* AD 193–217

little, for example, in a plan such as that of the Roman colony founded at Etrurian Cosa in 273 BC[14] that can be ascribed to other than Hellenistic patterns. But for the most ample example of Roman planning at present available on home ground we must return to Rome's port, Ostia.

By the second century BC Ostia had submerged its nuclear 'castrum' and was a burgeoning commercial city. The initial urban development would appear to have been of a gradual and piecemeal character; the resultant plan is a mosaic of partially organized fragments with no over-all scheme. Only in one area was there fully effective co-ordination: east of the castrum, between the main street or decumanus maximus (*Ill. 14*) and the Tiber to the north, stood a regimented group of public buildings, including extensive

blocks of store-houses (*Ill. 15*), and offices of the shipping merchants (*Ill. 17*), baths, the barracks of the vigiles or firemen and, from the time of Augustus, the theatre. Five identical stones along the northern edge of the decumanus proclaimed that this land was under public control; a natural provision since it bordered upon the all-important river. The stones date probably from the latter part of the second century BC. (Writers on Roman planning have customarily applied to towns certain of the technical terms of the Roman land-surveyor: in particular the *decumanus* and the *cardo* for the two axial streets. The decumanus frequently tends to run east–west, the cardo north–south. A well-known inscription at Orange seems to justify the use of cardo, but evidence is slight.)

15 One of the numerous store-houses of Ostia, the 'Horrea Epaga-thiana' with its imposing doorway

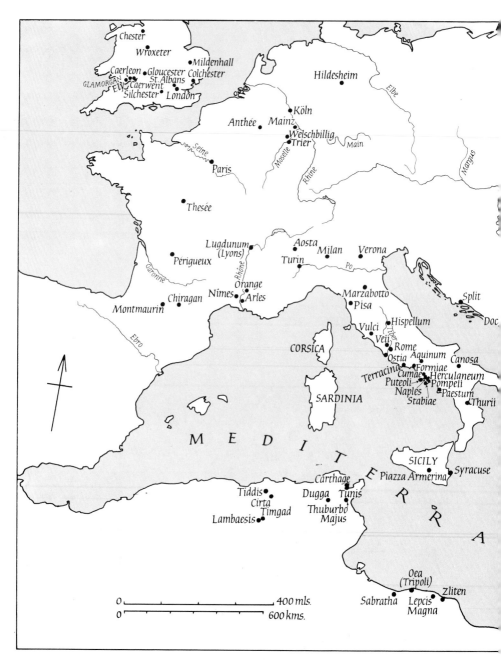

16 Map of the Roman World

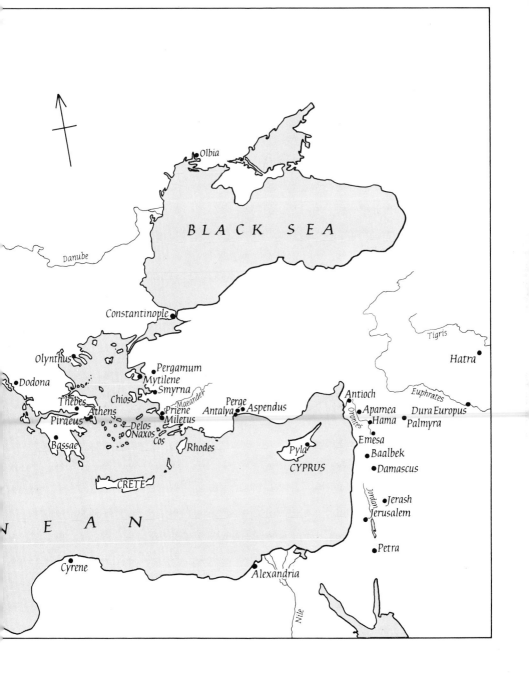

BLACK SEA

Olbia

Danube

Constantinople

Tigris

Olynthus

Pergamum
Mytilene
Smyrna

Dodona

Hatra

Maeander

Chios

Thebes
Athens
Piraeus

Priene
Miletus

Perge
Antalya
Aspendus

Antioch
Apamea
Hama

Euphrates

Orontes

Dura Europus
Palmyra

Bassae

Delos
Naxos
Cos

Rhodes

Pyla

Emesa

Baalbek

CYPRUS

Damascus

CRETE

Jordan

Jerash
Jerusalem

N E A N

Petra

Cyrene

Alexandria

Nile

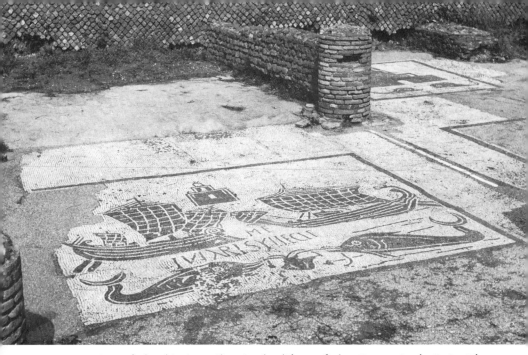

17 One of the shipping offices in the 'Place of the Corporations', Ostia. The mosaic floor shows ships in harbour and the name of the port with which they traded

It may have been in the time of Sulla, about 80 BC, that the town was given the defensive walls which were to serve it for the remainder of its days. By that time it occupied some 160 acres, and the main limits of its growth had, it seems, been determined. Scattered structures of one kind and another, including baths, lay beyond the perimeter, and of course the harbour and its attendant works. But the walled city was about half the size of Roman London and smaller even than Roman Wroxeter, though certainly in Imperial times it contained a considerably larger population. Of its buildings in the Republican period little is at present known. The forum, at any rate in its Imperial shape, is not wholly an original feature. The elongated space was lined with colonnades, and in the time of Hadrian two temples at the northern end were replaced by a single imposing structure, built of brick with marble veneer and set high upon a characteristically Roman podium approached by a broad flight of stairs (*Ill. 18*). It is conjectured to have been the Capitolium, dedicated

38

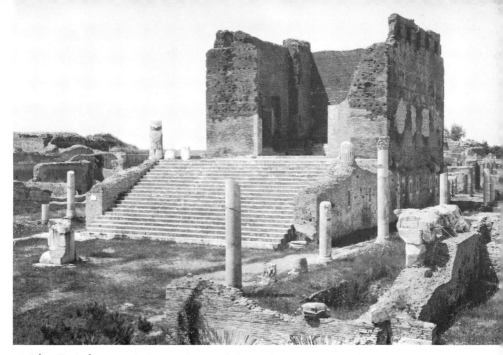

18 The Capitolium at Ostia, raised on a lofty podium and approached by a broad flight of steps, was situated at the northern end of the forum

to Jupiter, Juno and Minerva, though there is no evidence of the usual three shrines. Opposite to it, at the southern end, was the smaller temple of Rome and Augustus which was once entirely of marble.

Of the private houses in Republican times little remains above ground, but they would appear to have approximated to the spacious Pompeiian type with atrium and peristyle garden (*Ill. 106*). With the growth of population under the Empire – including no doubt a considerable proportion of freedmen – these tended to be replaced by blocks of flats (*Ill. 110*), such as also characterized the capital. Residences of one kind or another were of varying quality, but there is no district that can be written off as a 'slum'; no doubt because most of the grades which in a freer society might have produced the slums were absorbed anonymously into the main body politic under the guise of slavery. On the other hand, there is evidence enough of genuine slums in Rome itself.

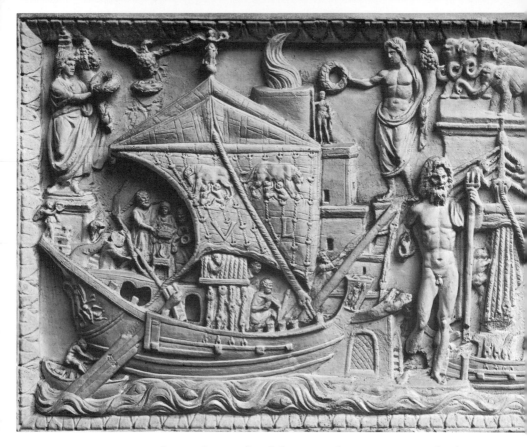

Two miles to the north of the town lay its successive harbours
(*Ill. 19*), rendered necessary under the early Empire by the growing
volume of sea-borne trade. Smaller merchantmen used the river and
even continued their voyages by sailing, rowing or towing to the
wharves of Rome. Larger ships, says Strabo, anchored at sea and
loaded or unloaded by tender. But in AD 42, under Claudius, the
long-projected construction of the Imperial harbour was at last
undertaken. The work was a thousand yards across, with two
curved moles and intervening lighthouse of the usual 'telescope'
type. A canal, possibly two canals, linked the harbour with the Tiber.

This wide Claudian harbour was not, however, gale-proof, and
under Trajan (probably about AD 112) a more compact and sheltered
basin, hexagonal on plan (*Ill. 20*), was constructed at the southern

40

19 Marble relief showing ships in the harbour of Ostia (*c.* AD 200). In the centre is Neptune, symbolizing the sea, and in the background the lighthouse built by Claudius *c.* AD 50

20 Aerial view of the sheltered, hexagonal harbour built at Ostia by Trajan *c.* AD 112

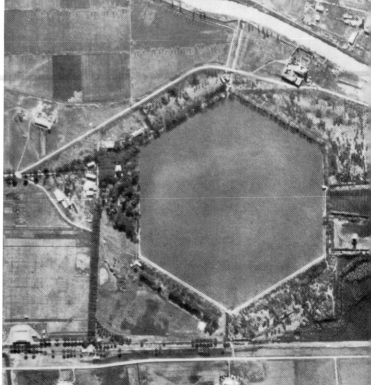

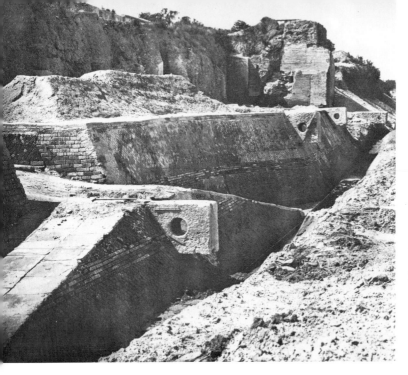

21 Pierced blocks beside the Tiber in Rome to which ships were moored. Similar moorings are found at Ostia and Lepcis Magna

or inner end, with a connecting canal. The new work had sides of 400 yards, and was surrounded by storage barns save on the north-west, where there are traces probably of an Imperial palace, such as may well have been used by the Emperor during his travels and inspections. Along the quays were pierced travertine blocks (*Ill. 21*) to which ships could be moored, recalling the similar provision in the well-preserved harbour at Lepcis Magna in North Africa (*Ill. 37*). At some late Roman period the basin and its adjacent buildings were enclosed by a wall, and in the fourth century the whole complex became a small independent town under the name of Portus. In this character its importance outlasted that of its parental Ostia.

Elsewhere in Italy, type-sites are most readily chosen from the colonies established under the Republic and the Principate (Augustus to Nero) as a means of diverting veterans and disbanded armies – a dangerous potential – into a settled and productive civil life. At the same time these new foundations served a continuing military

42

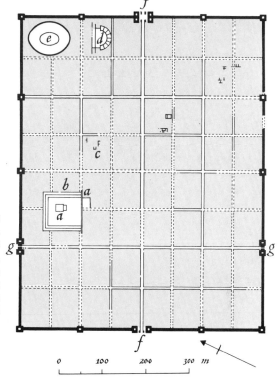

22 Plan of Aosta (*Augusta Praetoria*) founded in 25 BC. Identified buildings include temples (*a*), store-houses (*b*), baths (*c*), a theatre (*d*) and an amphitheatre (*e*). The main gates were situated at each end of the decumanus (*ff*) and the cardo (*gg*)

purpose in tracts of country still liable to disturbance, where a community accustomed to discipline and adequately fenced was an economic substitute for scattered garrisons of serving soldiery. In no instance have we anything approaching a complete town plan; but the evidence is sufficient to indicate that the Greek chessboard tradition, now thoroughly naturalized in Italy, had here been in some measure stiffened by the Roman military mind. Whereas a Hellenistic town like Priene was essentially a civic chessboard within the rambling fortifications of an older tradition, a Roman colony such as Aosta or Turin or Verona was primarily a copybook War Office fortress ameliorated by an urban content.

Aosta (*Augusta Praetoria*)[15] (*Ill. 22*) was founded by Augustus in 25 BC for 3,000 discharged soldiers of the Praetorian Guard. Its situation, 50 miles north of Turin near the foot of Mont Blanc, was of a tactical importance reflected in its severe military outline. The walled colony was about 100 acres in extent and was planned in sixteen large blocks (145 by 180 yards) which were doubtless

43

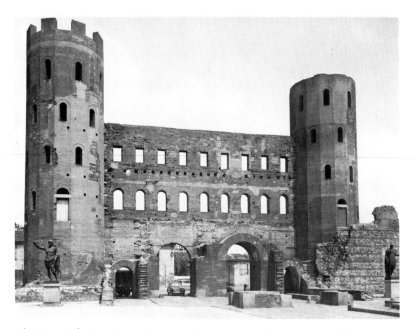

23 The Porta Palatina at Turin (*Augusta Taurinorum*) with its sixteen-sided brick towers. The colony was founded by Augustus in 28 BC

subdivided. The identified buildings include two temples, store-houses, baths, a theatre and an amphitheatre; the last, normally outside the walls, was here placed within them, presumably for local reasons of security on the fringe of the mountainous terrain.

Of Turin (*Augusta Taurinorum*)[16] (*Ill. 23*), founded as a colony by Augustus in 28 BC, less is known. Its outline, nearly a square though with one angle cut off, enclosed about 125 acres, and the general arrangement of its interior has survived in the modern street-plan. Its buildings were partitioned by straight streets into seventy-two blocks, mostly about 80 yards square. Only along the northern side of the main east–west street, the decumanus maximus, were there larger blocks, 80 by 120 yards, no doubt to allow for the forum and other public buildings. Of the town's Augustan architecture, the remarkable Porta Palatina with its sixteen-sided brick towers, the foundations of the east gate, and part of the theatre in the gardens of the Palazzo Chiablesa, are the most notable survivals.

24 (*right*) Polygonal tower at Spello (*Hispellum*) dating from the time of Augustus (Emperor 27 BC–AD 14)

25 (*below*) Aerial view of Verona, planned, perhaps by Vitruvius, in the time of Augustus. The outline of the Roman city is indicated, with the extension built by Gallienus in the mid-third century AD to include the amphitheatre. Since Roman times the course of the River Adige has altered

The unusual polygonal towers recur at Spello (*Hispellum*) (*Ill. 24*), another Augustan colony, in the fertile valley of the Chiaggio.[17] These and other resemblances within the Augustan series have suggested the existence of a school of northern town-planners such as is testified epigraphically elsewhere in Italy, at Puteoli, Cumae, Formiae, and Terracina; whilst another group, perhaps under the great Vitruvius himself, has been suspected at Verona[18] (*Ill. 25*), which was in fact almost a duplicate of Turin. It is likely enough that, in a period of active urban development under official stimulus, regional planning and building would tend to acquire something of a 'Ministry of Works' imprint.

AFRICA

For examples farther afield we may turn first to North Africa, rich in corn and, later, in olives, rich also in the Saharan trade which brought gold and ivory, slaves and show-animals to the Mediterranean ports, and proportionally rich in its urban life. From great Carthage, 1,000 or 1,500 acres in extent, to little towns such as Timgad (originally 34 acres) or Tiddis which, in spite of a mere 9 acres, numbered amongst its citizens Lollius Urbicus the Antonine conqueror of Scotland, its seven provinces teemed with Romanized communities. Indeed, many of these were of small dimensions; but they served adequately as local road-centres where the harvests of the Granary of Rome could be assembled and taxed, and where well-to-do farmers and their families from the country round about could foregather in the environment of a miniature metropolis with neighbourly solidarity and, no doubt, neighbourly disputation. Often enough a Punic or even Berber ancestry shows through the sophisticated Roman guise; as at Dugga (*Ill. 26*), amongst the hills 60 miles south-west of Tunis, or *Thuburbo Majus* 40 miles farther east, where casual and un-Roman streets wind amongst conventional Roman buildings. This mixed environment produced a fair share of the intelligentsia of the Roman world. Behind its southern frontier on the verge of the desert a single legion with auxiliary forces which included two British regiments, infantry and cavalry, long sufficed

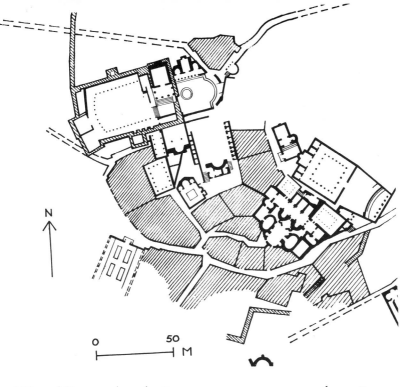

N

26 Plan of Dugga, where the Roman town grew up among the un-Roman winding streets of its Numidian predecessor

to sustain its normally easy discipline and to shield it from nomad raiding. Here a brief sketch of two of its towns must serve to represent one of the most extensive and successful fields of Roman enterprise.

First Timgad: the ancient *Thamugadi*, a dozen miles east of *Lambaesis*, fortress of the IIIrd Augustan Legion, exhibits Roman town-planning in its simplest terms (*Ills. 27, 28*).[19] It was founded as a *colonia* by Trajan in AD 100 and was designed by its legionary architects primarily to house the legion's veterans in a suitably regimented environment. Its familiar shape was at first nearly a square, with rounded corners to its stone defences, main gates in the centre of three (possibly all four) sides, and two posterns. The west gate was later a triumphal arch. Subsequently public and private buildings spread loosely and even untidily about the surrounding

47

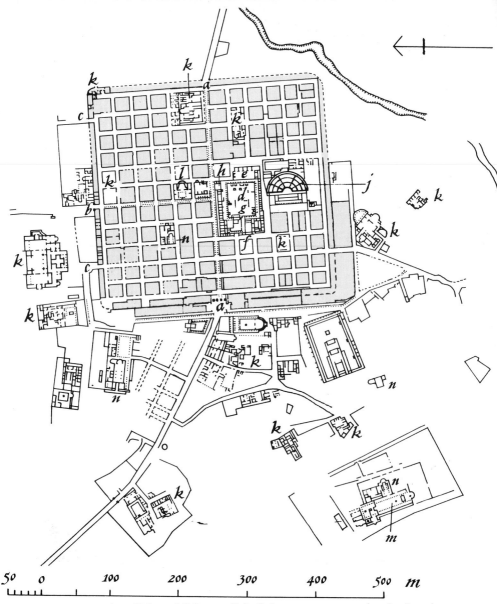

27 Plan of Timgad (*Thamugadi*) built in AD 100 on a regular chessboard pattern. Indicated on the plan are two main gates (*a*), a north gate (*b*), two posterns (*c*), the forum (*d*), town-hall (*e*), curia (*f*), temple (*g*), public lavatory (*h*), theatre (*j*), bath-buildings (*k*), library (*l*), Donatist cathedral (*m*) and fourth-century Christian churches (*n*).

48

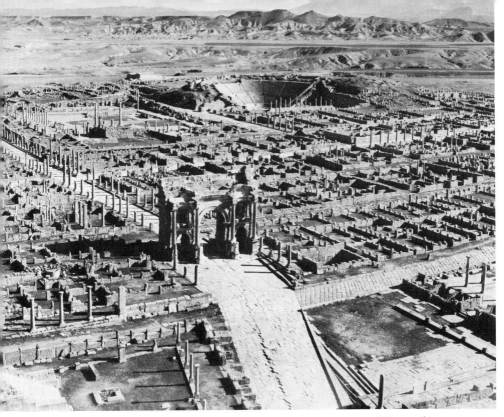

28 View of Timgad, founded as a colonia by Trajan for veterans of the IIIrd Augustan Legion. The triumphal arch stands at the western end of the decumanus maximus. Upper left is the open forum and to the right of it the theatre

landscape in the common fashion of Roman towns; we have seen an early example at Ostia.

Beside the main east–west street (the decumanus maximus) at the centre of the town lay the forum, a large paved rectangular space surrounded by porticos. On its eastern side stood the basilica or town-hall, with an apse at one end and an oblong alcove (probably law-court) at the other. A range of rooms at the back was no doubt the office-accommodation for civic officials. At the opposite end of the courtyard were the *curia* or council-chamber and a temple possibly of Fortune, the latter fronted by a tribunal for pageantry and oratory. The other sides of the courtyard included shops and a public lavatory (*Ill. 29*) containing rows of stone seats sometimes

49

faintly subdivided by arms carved as dolphins but altogether lacking any element of privacy. Sociable latrines of this kind were a normal feature of Roman towns. Near by a step bears a scratched gaming-board and the inscription *venari lavari ludere ridere occ est vivere* – 'to hunt, to bathe, to play, to laugh, that is to live'. In one way and another, the forum was the central and catholic expression of civic life.

Adjoining the forum stood the theatre (*Ill. 30*), cut into a low hill and completed in AD 161–9. It had a seating-capacity of 3,500–4,000, and, as was the habit of provincial theatres, was manifestly designed to accommodate both town and country. Amongst other public buildings within the original town are a large suite of baths and four smaller bath-buildings; and if something like eight other baths added during the external expansion be counted in the total, one at least of the scribbled conditions of the full life would appear to have been adequately fulfilled at Timgad.

The hint of an intellectually fuller life is perhaps contained in an interesting library building which occupies an *insula* or block near

29 Public lavatory near the forum, Timgad. The arm-rests are carved in the form of dolphins

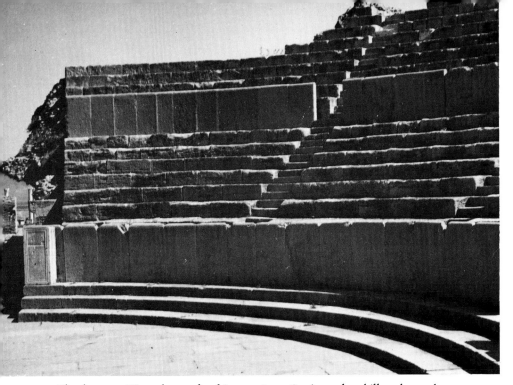

30 The theatre at Timgad, completed in AD 161–9. Cut into a low hill to the south of the forum, it could accommodate 3,500–4,000 spectators

the forum. Behind a forecourt, colonnaded on three sides and flanked by small rooms, opens a hall, formerly half-domed and surrounded by steps (or seats) and niches, and in turn by flanking rooms. The building was of veneered brickwork and was of some pretension; so thought its donor, who advertises the fact that it cost him (at some unspecified date) 400,000 sesterces, which has been equated somewhat speculatively with £10,000–£12,000 sterling. The recesses round the hall were presumably used for storing scrolls or books. One would give much to know the nature of the contents of Timgad's library in its prime. Respect for it was not always universal; there are signs that hopscotch was played in its courtyard, and its columns bear graffiti of a highly unacademic kind.

For the rest, the churches of Timgad form a notable series. They lie mostly outside the original plan, and at least three of them are of

51

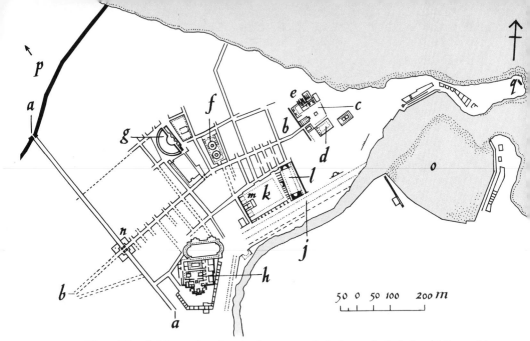

31 Plan of Lepcis Magna showing the decumanus (*aa*), the cardo (*bb*), the old forum (*c*) with its basilica (*d*), temples (*e*), market (*f*) and theatre (*g*), all dating from the time of Augustus and Tiberius. Later constructions are the Hadrianic Baths (*h*), colonnaded street (*j*), Severan forum (*k*) with its basilica (*l*) and temple (*m*), triumphal arch (*n*), harbour (*o*) and lighthouse (*q*). The 'Hunting Baths' (*p*) lie off the plan to the north-west

the third to fifth century; the largest, an aisled basilica 100 yards long, adjoins the house of the bishop, identified as an adherent of the Donatist heresy which arose at Cirta and Carthage after the Diocletianic persecutions at the beginning of the fourth century.

The second of our African examples is the city of *Lepcis Magna*[20] (*Ill. 31*), on the coast of Tripolitania, built on the site of a Phoenician settlement which occupied the promontory by the harbour. The early Roman town was developed on a chessboard pattern in the time of Augustus and his immediate successors. The forum lay at the base of the promontory and was flanked by the basilica which had a four-sided colonnade, no doubt with clerestory, and rectangular exhedras at one end. The opposite side of the forum was occupied by three temples, of which the central was dedicated in AD 14–19 jointly to Rome and to Augustus with other members of the Julio-Claudian family. It had two shrines, and stood on a high podium

which could serve also as a platform for oratory. Farther to the south-west stood the market (9–8 BC) (*Ill. 32*) and the theatre (AD 1–2) (*Ill. 35*), both built by the same benefactor whose munificence is recorded in Latin and Neo-Punic over the two main entrances of the theatre. The market is noteworthy, with its two circular market-halls and its stones bearing the standard measures of length and volume (*Ills. 33, 34*).

These two buildings marked the junction between the earlier chessboard and its southerly extension, which hereabouts changed direction in conformity with the bending line of the main road that was also its cardo. The extension resumed the rectilinear plan with elongated insulae on the new alignment, and shortly absorbed the arterial coast-road (north-west to south-east) as its decumanus maximus. The full southerly extent of the city – then as later – has not been ascertained. Tacitus indicates that there were fortifications as early as AD 69, when the place was besieged by the Garamantes, a powerful Berber tribe operating in alliance with the rival town of *Oea* (Tripoli); and these fortifications have been identified tentatively with a line of earthwork appreciably farther south, no doubt designed to include also the surrounding countryfolk with their livestock.

In AD 109–10 Lepcis received the rank of *colonia*, entitling it to the Italian franchise. Shortly afterwards, under Hadrian (in AD 127), a fine large bath-building on an Imperial scale was erected on yet a new alignment beside the Wadi Lebda on the east of the city (*Ills. 86, 87, 88*). But it is to the time of Septimius Severus that the buildings belong which give the place its outstanding distinction. Severus was born at Lepcis and died at York, his life-span thus literally reflecting the span of his Empire; and he lavished upon his birthplace a wealth of artistry in excess of its economic and political significance. Near the Hadrianic baths a new colonnaded street, of a kind particularly characteristic of the Roman cities of the Near East, is one of several architectural links at the same period with the eastern Mediterranean. Above all, Severus created a new and splendid forum and basilica which are, both architecturally and sculpturally, of outstanding distinction amongst the buildings of the Empire. The

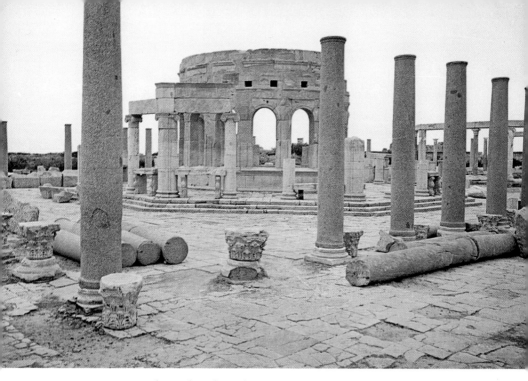

32, 33, 34 The market-place of Lepcis Magna, built in 9–8 BC. Above can be seen one of the circular market-halls and (*below*) stones bearing the standard measures of length (*left*) and volume (*right*)

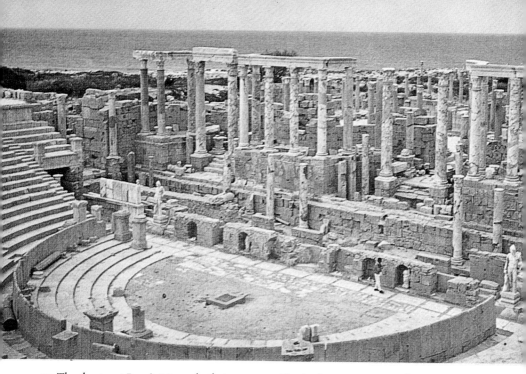

35 The theatre at Lepcis Magna built in AD 1–2. The back-scene or *scaenae frons* and curved rows of seats are well preserved

forum (*Ill. 40*), 1,000 by 600 feet, was surrounded by colonnades, with arches springing from stiff-leafed capitals of an East Mediterranean type. At its south-western end is the podium of a temple of uncertain dedication; at its north-eastern end, set askew as a compromise with the two directions of the main civic plan, is an imposing basilica (*Ill. 36*), a three-aisled hall with an apse at each end and a former height of not less than 100 feet. Its columns were of red Egyptian granite and green Euboean marble; and pilasters of white marble at both ends were carved with the adventures of Dionysus and Hercules, the patron deities of the Severan family. The building was completed by Caracalla in AD 216, and was turned into a church in the sixth century.

Another Severan structure, dating probably from the visit of the emperor to his native city in AD 203, was a four-way triumphal arch

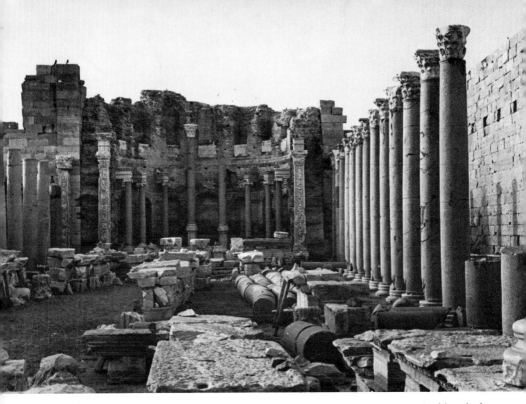

36 The basilica at the north-eastern end of the forum, Lepcis Magna. The building had three aisles and an apse at each end, and was completed in AD 216. In the sixth century it was turned into a Christian church

set across the junction of the cardo with the decumanus maximus (*Ill. 138*). As reconstructed, the arch was of remarkable design, and it carried a notable series of sculptures with sharply drilled and incised carving in a Near Eastern mode.

Yet another architectural achievement of this period of inflated aggrandizement was the reconstruction of the harbour at the mouth of the Wadi Lebda (*Ill. 37*), a basin 24 acres in extent, flanked by quays carrying warehouses, a temple and a watch-tower, with a lighthouse on the northern promontory. But here the city over-reached itself. The pierced mooring-blocks on the quays show no sign of use; the whole scheme was still-born, and the harbour quickly silted up as it is today.

Lastly, the so-called 'Hunting Baths' on the western fringe of the city (*Ill. 38*) are of an architectural interest which far outstrips their small size.[21] Their domes and vaults, disinterred from the dunes which had long protected them, are nearly intact and are untidily functional. A wall-painting in the main barrel-vaulted hall (*Ill. 39*) suggests that the building was the property of a guild of hunters whose trade was to supply wild beasts to local and Italian amphitheatres.

In summary, Lepcis Magna shows the processes of growth which other Roman town-plans have made familiar: a nuclear chessboard with divergent though mostly rectilinear enlargements. Its principal interest to us today arises from the political circumstance which led to its extravagant development under its most distinguished son, Septimius Severus, and made it the greatest surviving example of the transitional art and architecture of his epoch.

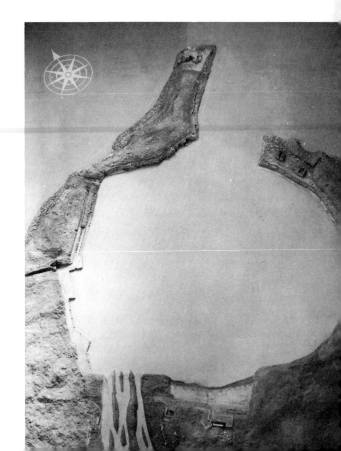

37 Model of the harbour of Lepcis Magna as it was rebuilt at the beginning of the third century AD. Although lavishly equipped with all the necessities of a busy trading port, it quickly silted up and seems hardly to have been used

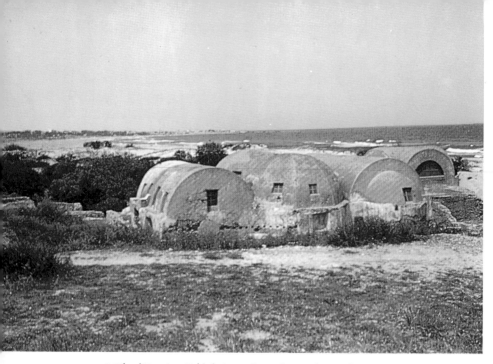

38 The 'Hunting Baths' situated on the outskirts of Lepcis Magna. The untidy assembly of domes and vaults has been remarkably well preserved in the sands for something like 1,750 years

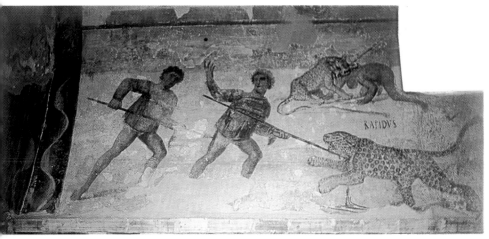

39 Fresco in the main hall of the 'Hunting Baths' at Lepcis Magna. North African hunters supplied wild beasts for local and Italian amphitheatres

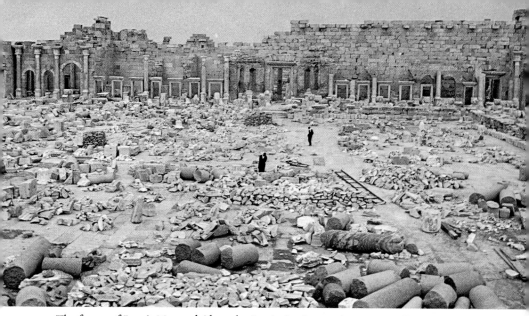

40 The forum of Lepcis Magna, laid out by Septimius Severus in *c.* AD 200. It measures 1,000 by 600 feet and was surrounded by colonnades with arches springing directly from the column-capitals

NEAR EAST

Architectural links between North Africa (Lepcis) and the eastern Mediterranean have already been noticed, and the natural sequel is a Near Eastern example which illustrates the penetration of Roman modes into an oriental environment. Culturally it is fair to say that eastwards the ultimate effective limit of the Roman Empire lay along the further fringe of the Anti-Lebanon range, from the salient oasis of Damascus to Emesa, Hama, Apamea and Antioch. Beyond that line the desert took over, save for a few imperial outposts of which Dura-Europos on the Euphrates is the best known. Far down that river, Hellenistic Seleucia had competed with Parthia for the Eastern trade, but, before the Empire was far advanced, it was already a dwindling Western asset. Only Palmyra, set squarely in the Syrian desert between Damascus and Dura, held successfully for two-and-a-half active centuries from the time of Tiberius, and less firmly for three more, the commercial and cultural balance between East and West. Its famous ruins will serve briefly to demonstrate some of the orientalizing features which in fact characterized many of the

59

eastern cities of the Empire.[22] Like Lepcis, Palmyra owed not a little of its enrichment to Severus whose empress, Julia Domna, was a Syrian of Emesa.

Outstanding amongst the surviving features are the Corinthian colonnades (*Ill. 44*) which still partially line two of the main thoroughfares of the city; vestiges of the porticos which at one time shaded the sidewalks of the principal streets in the universal fashion of the Near East and were not altogether unknown elsewhere in the Roman world. At Palmyra their columns bear mid-shaft brackets which formerly carried bronze memorial statues. This feature is rare in the West, but recurs at Dura, Hatra, Jerash, Pompeiopolis (Mersin) and elsewhere in the Near East, and is reflected occasionally on the small Corinthian pilasters with which the sculptors of far-off Gandhara, in north-western Pakistan, framed their Buddhist reliefs in the early centuries AD. This, with other Roman and Iranian features, represents an eastward spread of the fashion. The columns

41 Plan of Palmyra showing the town walls of Queen Zenobia built *c.* AD 271, the temple of Bel (*b*), the forum (*c*), the theatre (*d*), colonnaded streets (*e*), the fort of Diocletian (*f*), tombs (*g*), wadi (*h*), ancient houses (*j*), earlier fortification wall (*k*) and the site of the modern village (*l*)

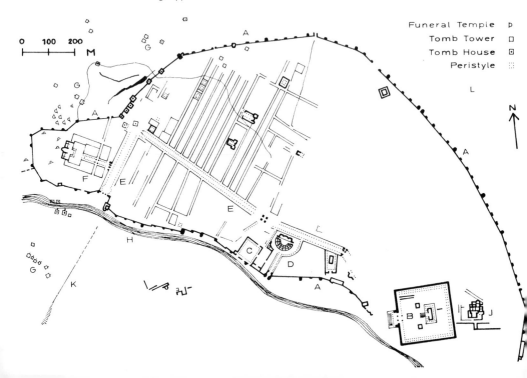

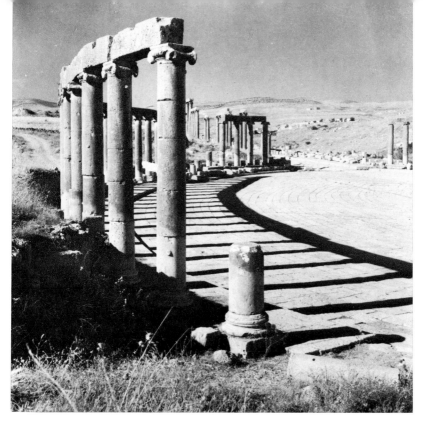

42 The colonnaded *place* at Jerash, which is oval and some 300 feet long

of Palmyra have long lost their statuary; but it is recorded that when the redoubtable Lady Hester Stanhope, in Bedouin dress, rode venturously into the city in 1813, Arab dancing-girls took its place as living and lively statues upon the brackets above the heads of the acclaiming crowds!

As at Lepcis, the street-colonnades belong to the second and third centuries, when the city, originally of mud or mud-brick save for its major public buildings, was being partially reconstructed in stone. From south-west to north-east the broad cardo (if such it may be called in this unconventional plan) now marked with some ostentation the urban continuation of the highway from Damascus. Columns in or related to it bear dates ranging from AD 110 to 139.

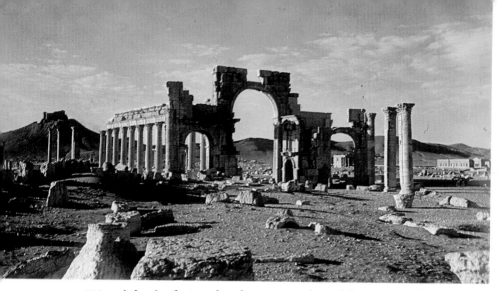

43 Triumphal arch of triangular plan over a colonnaded street in Palmyra. It dates probably from the second century AD

As at Jerash in Jordan, the street broadened at one point into an oval *place* (*Ill. 42*). At right-angles, a rough equivalent of the decumanus accompanied the bluntly zig-zag course of a wadi as a formal approach to the great Temple of Bel (*Ill. 45*), the two changes of direction being masked by a four-way monument and a triumphal arch of triangular plan (*Ill. 43*). This street, or its adornment, was somewhat later; its inscriptions extend from AD 158 to 225, and its main construction may well centre upon the reign of Severus or Caracalla (AD 193–217) who gave the city the honorific rank of *colonia*.

Beside one arm of the decumanus stands the theatre, also of Severan date, and close by is the market-place, abutting on the most readily traceable fortifications of the city. The proximity of the market-place to the ramparts is sufficient to show that the latter are not of the original lay-out. They are in fact made up of re-used masonry and, with their shallow square bastions, have been ascribed either to Queen Zenobia, confronted in 272 by the punitive army of Aurelian and the urgent need for fencing the main quarters of her capital, or (with less probability) to the period immediately following, when the core of the ruined city may have been roughly fenced by the Romans from the remains of public buildings. They are at any

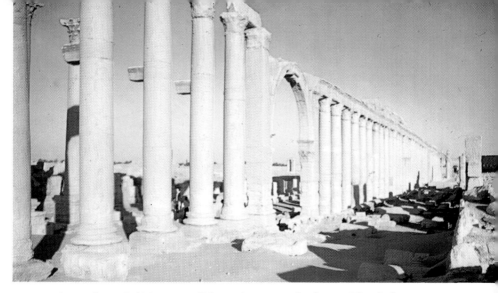

44 Corinthian colonnade lining one of the main streets of Palmyra. The shafts carry brackets for bronze memorial statuary, an Eastern fashion rarely found in Europe

rate prior to Diocletian, who laid out a little fortress within their western salient. Early defences on a far larger perimeter can be partially traced but cannot be rationally interpreted without much further examination. When later, in the sixth century, Justinian refurbished the much-decayed city, he added new round-fronted bastions to the late third-century enceinte, and in consequence the whole work is commonly attributed to him.[23]

The chief temple of the city (*Ill. 45*) is a strangely heterodox and powerful assemblage of good classical and Semitic elements: the great Temple of Bel or Bol, which was dedicated in AD 32 and still, with subsequent modification, dominates the scene. Its enclosure or temenos is some 230 yards square and is raised artificially – in a fashion which recurs at Baalbek and was evidently a Semitic custom – above the surrounding surface. It was approached by a grand staircase and a gatehouse once equipped, as an inscription tells us, with six doors of bronze. It was surrounded internally by Corinthian porticos (three of them double), beneath which one looked out through ornamented windows. In the north-west corner a ramp constructed through the basement gave access to the sacrificial animals. Between this and the temple proper stood the altar of sacrifice.

The shrine itself, within a peristyle of which the capitals were formerly adorned by a metal covering, was set broadside on, its present doorway (as it stands, a secondary work) off-centre in one of the long sides. Within, in the end walls are niches with architectural enrichment, one of them designed to contain the images of Bel and the other two members of the triad, Yarhibol and Aglibol. Narrow staircases in three corner-towers, with a fourth tower (empty) to match, led up apparently to a ceremonial roof-terrace. The whole aspect of the place is, to the classically minded, more than a little bizarre and even a trifle sinister. The transmutation of Roman architecture by alien traditions and usages could scarcely be carried further; unless by the very remarkable tower- and house-tombs which bestrew the surrounding landscape but lie outside the present survey.

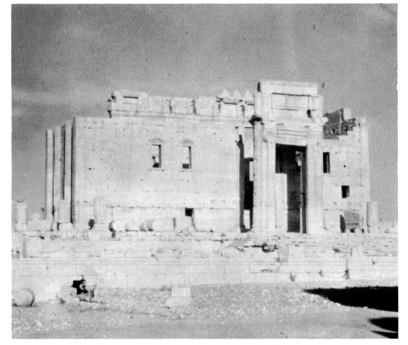

45 The Temple of Bel, Palmyra, dedicated in AD 32. The whole temple enclosure, some 230 yards square, is raised artificially above the surrounding plain

64

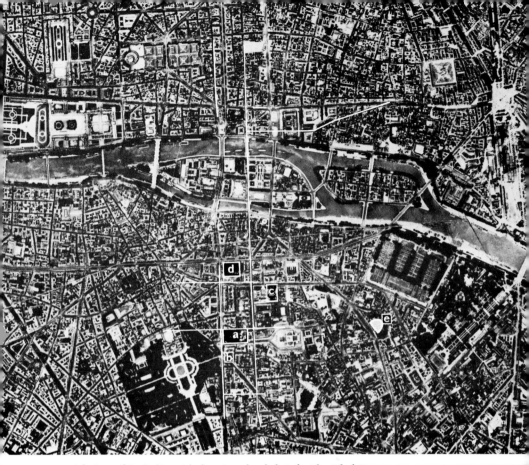

46 Aerial view of Paris (*Lutetia*) showing the definitely identified Roman streets and buildings: the forum (*a*), Forum Baths (*b*), baths beneath the Collège de France (*c*), Cluny Baths (*d*) and amphitheatre (*e*)

GAUL

Unlike London (p. 82), Paris[24] (*Ill. 46*) has an assured pre-Roman ancestry. It enters history in 53 BC when Julius Caesar, with an air of proprietorship, transferred to 'Lutetia, town of the Parisii' his assembly of Gaulish representatives which enabled him periodically to assess the attitude of the tribes to the fluctuating success of Roman arms and diplomacy. The Parisii themselves were neither a large nor a powerful state, but situated around the junction of arterial rivers

they occupied a position of strategic and commercial importance which eventually encouraged the upgrowth of a considerable Roman town and even the inclusion of an Imperial residence. The young Caesar Julian, in command of Gaul and the West, lived here awhile and referred to it as his 'dear Lutetia'. But not until the Merovingian king Clovis I made the place his capital in 508 were its natural advantages fully realized in a political sense.

In Caesar's day, as he tells us, Lutetia was 'an *oppidum* (stronghold) of the Parisii, placed upon an island in the Seine' and connected by bridges with both banks; in fact, the Île de la Cité of the modern map. For a moment in 52 BC it was the centre of a hard-fought battle between a composite Gaulish army and Caesar's lieutenant, Labienus. Thereafter it passed without distinction into the highly Romanized tribal system of Gaul as the *chef lieu* of the Parisii and, like other Gaulish centres of the kind, bequeathed the tribal rather than the local name to later history. If, as is not unlikely, the Parisian canton was perpetuated in the medieval diocese, its area was roughly 1,000 square miles – two-thirds of the size of Kent.

Of the nuclear town on the island, buried now beneath 20 feet of accumulation, nothing is known save for a few fragmentary walls recorded long ago during building operations, and traces of the fortification which was thrown up round the periphery when the principal elements of the population were crowded back on to its island at the time of the Germanic break-through in the third quarter of the third century. Like other Gallic defences of this late period, the wall is itself a museum of architectural debris from earlier structures. But the line of the main north–south street or *cardo* is certain; it followed the lines of the Petit Pont and the Grand Pont (Pont Notre Dame) and between the two is now the Rue de la Cité. Thence on the north it mounted the rising ground towards Senlis, and on the south it proceeded towards Orléans straight up through the Latin Quarter under the Rue St Jacques, where considerable stretches of it have been noted. It was here, on the slopes of Sainte-Geneviève and Montparnasse, that dry ground clear of the marshy fringes of the river attracted urban expansion from the confines of the island. Here in the first, second and early third centuries AD the

principal public buildings of the city were laid out within the framework of a grid-plan; a spacious assemblage of no very great over-all size but not lacking in architectural distinction. A guess would place the population at 6,000–9,000 inhabitants.

West of the Panthéon, between the cardo (Rue St Jacques) and a parallel Roman street represented roughly by the Boulevard St Michel, stood the forum, consisting of a large enclosure, some 530 feet by 330 feet, with a high external wall and internal shops and porticos framing an oblong open court. At one end of the court was the basilica or town-hall with an internal colonnade which presumably carried a clerestory round four sides; towards the opposite end was the podium of a temple of unknown dedication. The whole lay-out is of a recognized imperial type, comparable for example with the fora of Saint Bertrand de Comminges in the Haute Garonne and Augst in Switzerland, and its principles conform nearly enough with the Vitruvian tradition (V.1).

In the next insula to the south lay one of the three public bath-buildings which have been sufficiently preserved by good solid masonry to attract attention. It was some 200 by 80 feet over-all and of a straightforward rectangular plan, so far as recorded. At the eastern end of the insula, beside the cardo, ran the aqueduct which brought water from a source 10 miles to the south.

Of the other two bath-buildings, one lay on the eastern side of the cardo, under the Collège de France, by the Rue des Écoles which represents an east–west Roman street. The plan is incomplete but is known to have included two or three circular rooms with hypocausts. Three hundred yards to the north-west, beside the Boulevard St Michel, stood, and in no small measure stands, one of the most famous Roman buildings of western Europe: the so-called 'Palace of the Baths', known as such since the twelfth century and, as a traditional palace, incorporated at the end of the fifteenth century in a splendid Gothic mansion, the Hôtel de Cluny. The Roman plan, bounded on all four sides by drains or conduits, covered an area approximately 330 by 200 feet, and was roughly symmetrical. Its sequence has recently been examined afresh by P.-M. Duval in the light of renewed excavation. The best-preserved portion, an imposing

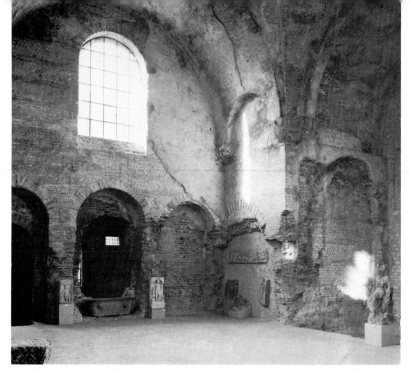

47 The *frigidarium* of the Cluny Baths in Paris with its imposing vaulted ceiling. Corbels at the bases of the vault-angles represent ships' prows laden with military equipment

vaulted central hall (*Ill. 47*) built over cellars, with a cold bath in an alcove, may be recognized as the *frigidarium*, and from it access was obtained to warmed and heated rooms of considerable pretension. An unusual detail at the bases of vault-angles in the *frigidarium* and in another large hall to the south-east of it is a series of corbels representing ships' prows laden with military equipment. Reference has been suggested to the *nautae Parisiaci*, a guild of shippers known to have existed at Paris as early as Tiberius, and it may well be that the sailors of the busy Seine had some special association with the great structure. As to its date, no previous occupation of the site has been detected, but the style of the masonry is unlikely to be earlier than the latter part of the second century. The building would appear to represent an ultimate northern extension of the city to the fringe of the riverside marshes.

Two other public buildings help the picture of a town fully equipped with the normal urban amenities. A hundred yards south-west of the Cluny baths, slight indications of a small theatre – perhaps rather an *odeum* or music-hall – have been observed; and away to the east, 700 yards from the forum, restored remains of a large amphitheatre (*Ill. 48*), capable of holding something like 15,000 spectators, can still be seen beside the Rue Monge. The plan shows a stage on one side of the oval arena; so that the structure falls into the class of 'cock-pit theatres' or '*amphithéâtres à scène*' which is characteristic of central and northern Gaul, with another example at Verulamium in Britain. In Gallia Comata ('Shaggy Gaul') and beyond, the combination of a dual function – stage buffoonery and arena bloodshed – in a single building was no doubt a desirable economy. The absence of brick courses and the use of small squared stones (*petit appareil*) are consistent with a date early in the first century AD for the Paris example; and its deviation from the grid of the forum area implies no more than that, as often, the amphi-theatre, with its charnel-house associations, was placed on the outskirts of the city.

48 Plan of the amphitheatre beside and under the Rue Monge in Paris. It is of a type characteristic of nor-thern and central Gaul and Britain, combining the arena of an amphi-theatre with a lateral stage

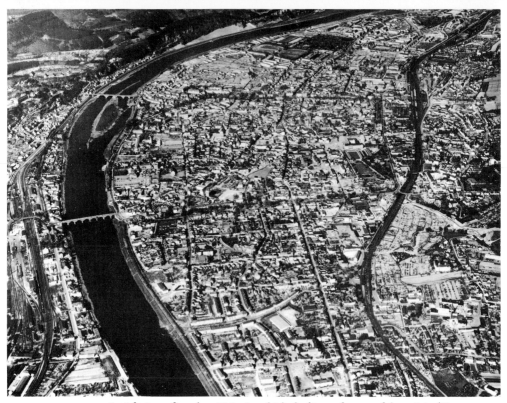

49 Aerial view of modern Trier in which the lines of some of the original Roman streets are still recognizable in the modern plan

Of the private houses of Roman Paris, nothing of value is known. Part of a house found at Montmartre as long ago as 1739 belongs to the countryside. In the absence of town-walls – save on the island, none were built – we are left with an inchoate skeleton of insulae which, in the neighbourhood of the forum, seem to have measured 100 by 600 feet. But their limit to the west cannot be fixed (if at all) until the Luxembourg Gardens are dug up, and to the east we can only say that they stopped short of the amphitheatre and the burials in its neighbourhood. To the south, an extensive cemetery near the Port Royal included many inhumations and must have marked the bounds of occupation in this direction in the second and third centuries, a little short of the summit of Montparnasse and about a mile from the Petit Pont.

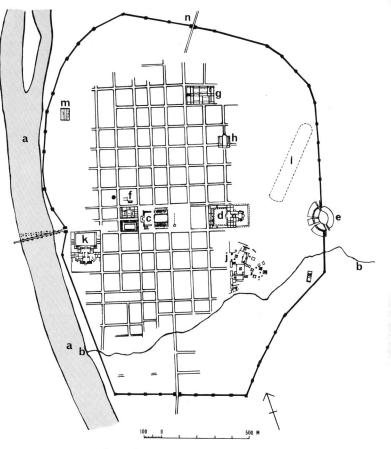

50 Plan of Trier (*Augusta Treverorum*) situated at the junction of the Moselle (*a*) and the Altbach (*b*). Identified buildings are the forum (*c*), Constantinian Baths (*d*), amphitheatre (*e*), house of the Emperor Victorinus (*f*), Constantinian palace (*g*), Aula Palatina (*h*), the temple quarter (*j*), 'Barbara Baths' (*k*), possibly a circus or race-track (*l*), warehouses (*m*) and the Porta Nigra (*n*)

Anciently of far greater magnitude and importance than Paris was Trier, *Augusta Treverorum*, beside the Moselle[25] (*Ills. 49, 50*). It became in effect if not in name the headquarters of the so-called 'Empire of the Gauls' established by Gallienus's general Postumus in AD 258, and was more formally recognized as the capital of the Western provinces when the Caesar Constantius made it his residence in AD 293. The site had been partially occupied in pre-Roman times, and under Augustus a regiment of Spanish cavalry was stationed here. Its special association, however, with the powerful Celto-German tribe of the Treveri was expressed in its name from the outset, and was not forgotten when it was given colonial status shortly after AD 41 by Claudius, in whose reign Pomponius Mela could already describe it as *in Treveris urbs opulentissima*, 'city of great wealth

amongst the Treveri'. Imposing Roman buildings of a later age are still standing, and buried streets and buildings have been noted with diligence by local scholars.

The urban centre, the forum, lay 500 yards east of two successive Roman bridges and occupied four insulae of the colonia, a total space of about 690 by 450 feet. It consisted of an oblong court divided north and south by (vaulted?) arcades from double rows of shops, set back to back. A further courtyard to the west presumably contained the basilica, whilst a rectangular projection at the western end has been speculatively identified as the *curia* or council-house. Adjacent insulae to the west and north-west were occupied by buildings of residential type and considerable pretension. In one of them a mosaic bore the name of M. Piavonius Victorinus, Gallic emperor in AD 268–70.

The early lay-out seems to have extended for nearly a mile southwards from the cathedral and to have covered some 200 acres. It consisted of rectangular insulae which varied appreciably in width, with an average of 330 feet square; most of them were probably subdivided. To the south-east, on the banks of the Altbach, lay a closely built temple quarter in which the dominant type was the so-called Romano-Celtic temple with a square shrine surrounded on all four sides by a portico or verandah. Both the deities worshipped here and the unclassical environment in which they were cultivated hark back to pre-Roman days, though the temples themselves were renewed more than once in the Roman period. The area lay, as might be expected, outside the colonial plan.

In the original scheme the forum area may have been quartered by the cardo and the decumanus maximus, but in the expanded town of the second and later centuries the axes appear to have moved somewhat east and south. In any case they were probably of no special importance. The famous Constantinian Baths on the eastern flank of the city (*Ill. 51*) were centred on the hypothetical decumanus of the colonial lay-out, and approximately in the same line is the amphitheatre, which was built in stone early in the second century perhaps on the site of a timber predecessor. It was 76 yards long and could accommodate some 7,000 spectators. Until

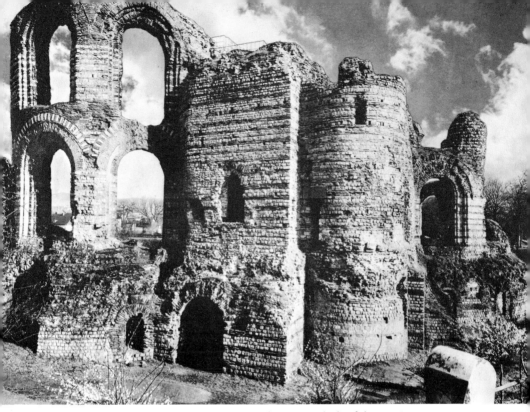

51 The Constantinian Baths in Trier, built on the eastern flank of the city in *c.* AD 300

a relatively late date it continued to fulfil its bloodthirsty function; in the time of the first Christian emperor Frankish prisoners were slaughtered there in shoals, whilst it served also as a strong-point and gateway on the line of the late Roman town-walls. North of it, within the defences is the possible site of the circus, which is said by the Panegyrist in his address to Constantine in AD 310 to have rivalled the Circus Maximus of Rome.

The date of these defences and of their grandest surviving feature – the north gate or Porta Nigra (*Ill. 52*) – has been disputed. They enclosed an area of no less than 700 acres – the largest city of the West. The likelihood is that they were built mostly in the time of the 'Gallic Empire' but that the Porta Nigra is a fourth-century addition, perhaps on slightly earlier foundations.

73

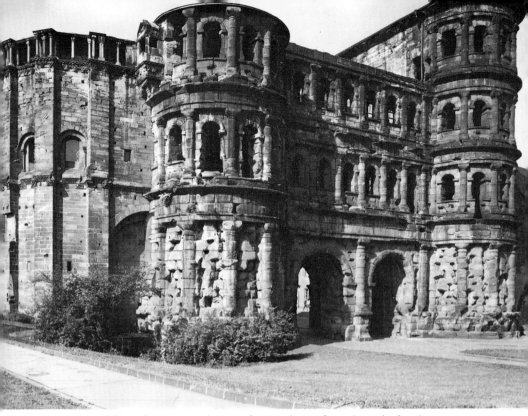

52 The Porta Nigra, the main north gate of Trier, dating from the early fourth century AD

Four other buildings of distinction are included on the plan. Near the successive bridges across the Moselle, and near also to the probable site of the Augustan fort, are the so-called Barbara Baths, an extensive public building of symmetrical plan ascribed to varying dates in the second century. South-east of the cathedral stands the much-patched brick 'basilica', one of the landmarks of the city and now recognized as the *Aula Palatina* or audience-hall of the Constantinian palace (*Ill. 53*). It is an aisleless apsidal building 220 feet long and 106 feet high, heated originally by a hypocaust with wall-flues which opened through the outer walls at the level of the lower of two ranges of windows. The windows of both ranges were fronted by balconies. The external walls were plastered; within they

were covered in part by mosaics and in part by elaborately painted plaster, and there was a mosaic floor. The building was entered at the south end through a forehall, and was flanked by colonnaded courts. Beneath it, forming part of the pre-Constantinian palace which was probably destroyed by the Alemanni in AD 275–6, was a smaller predecessor, also with an apse.

The Constantinian palace extended as far as the present cathedral where, over its remains, the building of a double church with intervening baptistry was begun in AD 326. A not impossible tradition, which was lively in the eleventh century and is faintly traceable to the eighth, had it that Helena, mother of Constantine the Great, gave her palace at Trier to be turned into a church; and parts of the Roman building remain incorporated in the present structure.

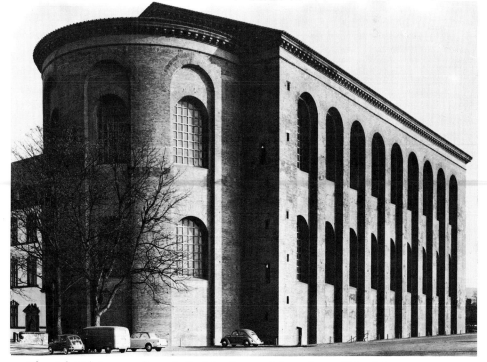

53 The *Aula Palatina* or audience-hall of the Constantinian palace at Trier. It has been much restored but dates originally from *c.* AD 300

Lastly, reference must be made to a pair of Roman *horrea* or warehouses, probably of the fourth century, which have been identified near the river in the north-western quarter. They were each 233 feet long, divided into three aisles by two lines of piers, and two storeys in height; between them was an unroofed court 80 feet wide. Both outer and inner walls were pierced by windows. The type is a normal one, such as occurs at Ostia (*Ill. 15*), Pesch, Köln-Müngersdorf and elsewhere.

In general, Trier expanded symmetrically along the lines of its grid but without overmuch attention to theoretical cardo-decumanus domination. Round the periphery large public buildings grew up in orderly fashion; but finally the defences abandoned all pretence of military tidiness and rambled round the landscape, incorporating river and hills and other vantage-points with the unregimented opportunism of a native *oppidum* or fortified settlement. Once again we may look back through the centuries to Hellenistic prototypes, and find little that is very specifically Roman in the general scheme of a great Roman city.

BRITAIN

From the ultimate north-western province of the Empire, 'beyond the inhabited world' as it seemed to the anxious army of invasion, two very different Roman towns are here taken briefly for their planning. One of them, *Venta Silurum* or the modern Caerwent (Monmouthshire), is tucked away in the western frontier-zone. The other, *Londinium*, was one of the great peripheral ports of the Empire. We begin with Caerwent (*Ill. 54*).

This little town,[26] some 45 acres in extent, lay seven miles behind the frontier-fortress of the IInd Augustan Legion at Caerleon-on-Usk (*Isca*), astride the main road back into the province. Its essentially regular lay-out, framed by an earthen bank ascribed to the first or second century AD, might seem to add point to this proximity, and to recall in principle the conjunction of the fortress of the IIIrd Legion at Lambaesis in North Africa and its cantonment-town twelve miles away at Timgad. The analogy would be only in

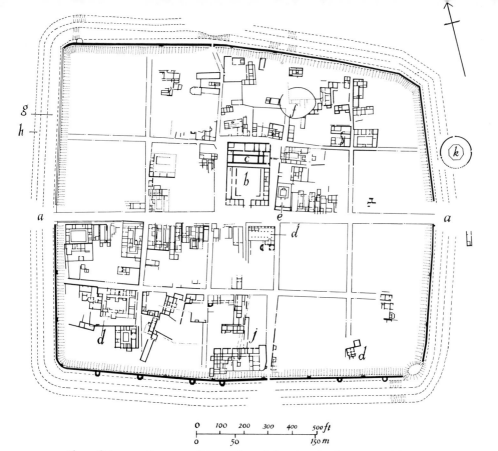

54 Plan of Roman Caerwent (*Venta Silurum*) showing the decumanus (*a*), the forum (*b*), basilica (*c*), baths (*d*), Romano-Celtic temple (*e*), amphitheatre (*f*), inner and outer ditches (*g*, *h*), possibly an inn (*j*), and a polygonal temple (*k*) outside the east gate. The regular lay-out of the town has been ascribed to the first century AD

part correct. Timgad was established as a colony primarily to house retired legionaries amidst urban amenities within a day's walk of the parent fortress. No doubt native and other foreign elements early crept into the population and developed its economy upon self-sufficient lines. But local resources which the townsfolk could have recruited or exploited must always have been extremely limited, and Timgad may be supposed to have survived the eventual removal of the Legion from habit rather than from active volition.

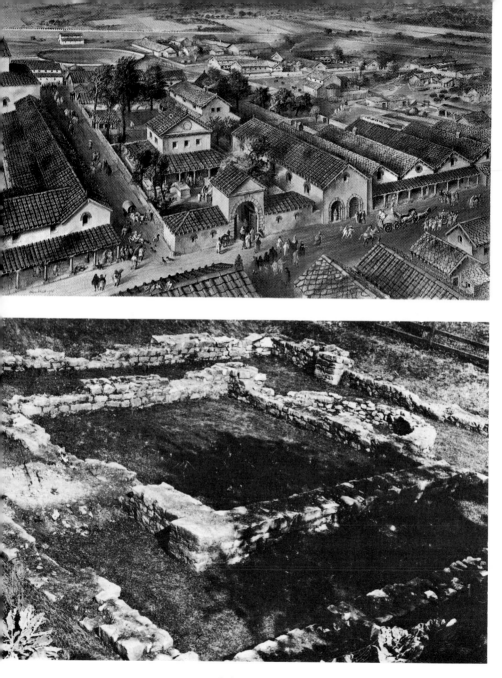

55, 56 Reconstruction of the temple-quarter of Caerwent, and the excavated foundations of the small, square 'Romano-Celtic' temple. It was surrounded by a portico and had an apse at its northern end

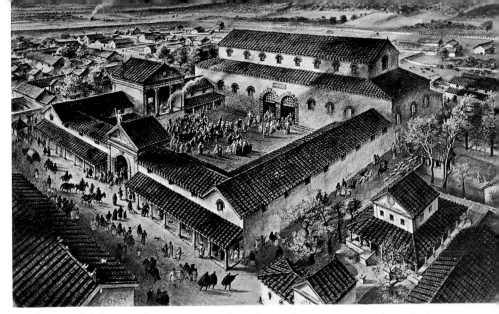

57 The crowded forum of Caerwent seen from the south-east. Opposite the arched entrance from the decumanus maximus stands the basilica, two-aisled and 176 feet long. Porticos and shops surround the forum, and smoke rises from a shrine on its western side

To some extent Caerwent may have been intended to supply a comparable reservoir for legionary overflow from Caerleon. A third-century monument set up in the midst of the little town to a general of the Caerleon Legion, and an altar dedicated by a junior officer, do not carry us very far towards proof. Alternatively there is incomplete evidence of a considerable extramural settlement at Caerleon itself, where there may even (though this is a guess) have been a colonia at some period. But Caerwent never, it seems, rose above the grade of a county town. Its proper and primary function was to provide one of those centres of Romanization whereby, as Tacitus in a famous passage tells us, the native tribesmen were subtly acclimatized to conquest and civilization. In the midst of the hard-fighting Silures, Caerwent, laid out doubtless by legionary surveyors, was nevertheless a part of civil not of military strategy. It was a tribal capital disguised in attractive Roman dress.

79

This preface has been necessary to explain the combined orderliness and casualness of the Caerwent plan – a casualness only in part ascribable to unanalytical record. The oblong enclosure was divided symmetrically by the east–west highway, which formed the decumanus maximus. North and south of it were ten fairly regular insulae, each about 260 feet square. There is no clearly recognizable cardo; the street to the south gate flanks one side of the central forum, whilst that to the north gate flanks the other. The forum itself (*Ill. 57*) is of a widespread provincial type, with an open market-place bordered on three sides by porticos and shops and on the fourth side by the basilica or town-hall. This was 176 feet long, two-aisled, and had rectangular alcoves at each end for judicial or other uses. At the back, a range of six of more rooms may be regarded as municipal offices.

The next block to the east included a small square 'Romano-Celtic' temple (*Ills. 55, 56*), with a northern apse and surrounding portico. Another temple, beyond the east gate of the town, is polygonal within a circular portico. Other public buildings include substantial baths opposite the forum and two other bath-suites elsewhere, recalling that baths were amongst the seductions mentioned by Tacitus as a provincial lure. At a late period, a shoddy little amphitheatre overlay a street within the northern fringe. Shops and workshops, especially in the earlier periods, were undistinguished oblong structures, their longer axes at right-angles to the streets; but the better private houses were of a courtyard plan derived from familiar classical prototypes. A large, rather rambling building beside the south gate is reasonably identified as an inn. The simple bank of the original town-defences was reinforced by a stone wall (*Ill. 59*) at some unascertained date which, on analogy, is likely to have been the end of the second century; and this in turn was armed with hollow polygonal towers not earlier than AD 330 (*Ill. 58*). At some late period, too, when the coastal regions were increasingly harassed by Irish and other raiders, the north and south gates were blocked.

As a whole, the plan of Caerwent presents a surprisingly Mediterranean aspect which may have been stimulated by a number of factors. The environment was certainly too crudely barbaric itself to

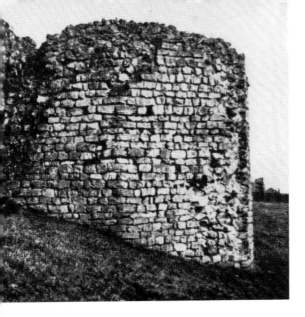

58 One of the hollow polygonal bastions added to the stone defensive wall of Caerwent some time after AD 330

59 The southern defensive wall of Caerwent, built of stone, probably at the end of the second century AD, to reinforce the earlier earthen bank

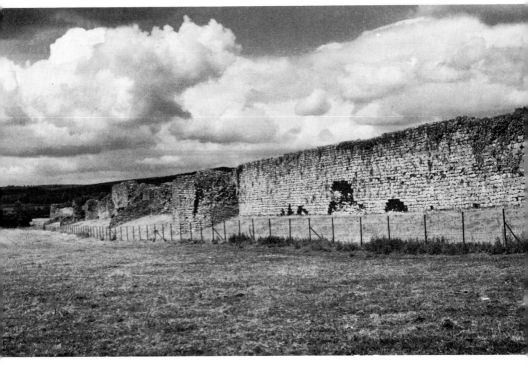

contribute any bias or modification in the application of Roman ideas. The same circumstances may have compelled the Roman town-builders to confine their plan from the outset within compact fortifications which, unlike those for example of Belgo-Roman Silchester in Hampshire, were purely Roman in shape. The resultant constriction induced an early crowding of buildings, particularly along the main road. In one way and another, Caerwent bears the close imprint of official Rome to a degree which is less apparent in the more leisurely pattern of the foundations of the English lowlands.

To turn from this small border-town to Roman London,[27] (*Ill. 60*) with its 330 acres (one of the five largest Roman cities north of the Alps), is to enter a different world. *Londinium* was established beside the Thames at the lowest point at which opposed gravel banks facilitated a permanent crossing; in all probability also at the tidal limit of the period. Here cargoes, brought far inland with a minimum of effort, could be dispersed equally from both banks, linked by an easy bridge. It might indeed be fairly claimed that Londinium began as the parasite of London Bridge. Only one further condition was necessary; the provision and maintenance of highways through the deep woodlands which then imprisoned the London Basin. For these, skills and funds on an Imperial scale were necessary. It is understandable therefore that, for all its Celtic name, there is no conclusive evidence for a pre-Roman Londinium.

Equally it is understandable that the site should have been developed as a first priority of the new province. Hereabouts the army of invasion had crossed on its march towards the great tribal capital at Colchester. To the quick Roman eye the military and commercial advantages of the London passage called for immediate action. Within seventeen years of the Claudian attack, Tacitus could speak of Londinium as 'crowded with traders and a hive of commerce'.

The city at first occupied the hill (Cornhill) north of the river and east of the Walbrook, and its cardo was no doubt a continuation of London Bridge, which was about 60 yards below the present bridge. On the southern bank a bridgehead settlement underlay Southwark. The summit of Cornhill was crowned by the basilica (*Ill. 61*) of

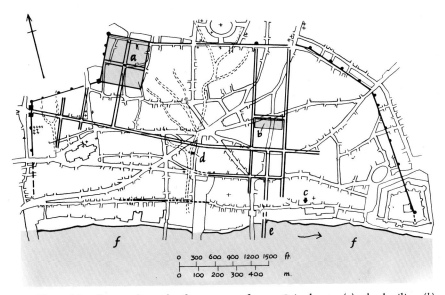

60 Plan of London to show the first-century fort at Cripplegate (*a*), the basilica (*b*), a bath-building (*c*), and the Mithraeum (*d*) beside the Walbrook, indicated by dotted lines. A wooden bridge (*e*) crossed the Thames (*f*) slightly to the east of the present London Bridge

61 Plan of the huge basilica, the administrative centre of Roman London. The building was 500 feet long with three aisles, an apse at the eastern (probably also at the western) end, and a row of offices along the northern side. Its date is uncertain, but it was presumably built after Boudicca's destruction of the old town in AD 60–1

which enough is known to indicate that it was triple-aisled and had the astonishing length of 500 feet. At one end (possibly both) the central aisle or 'nave' ended in an apse, and at the back was a range of some eighteen rooms, probably offices rather than shops. The magnitude of this central official building, combining the functions of town-hall, law-courts and general business centre, is itself sufficiently eloquent of the administrative and commercial importance of Londinium. The great Basilica Ulpia at Rome was a mere 40 feet longer.

Hints here and there show that the city centring upon the basilica was laid out in chessboard pattern, with large insulae some 480 feet square, subdivided perhaps into units of half that width. By the second century, occupation had spread westwards across the Walbrook, along the divergent lines of the main roads and over early cemeteries and kilns in the vicinity of Ludgate Hill. The process of growth may have been stimulated rather than hindered by the celebrated burning of the unwalled city – built mostly, no doubt, of timber – by Boudicca's tribesmen in AD 60–61. But it was scarcely as a sequel to that episode that at the end of the century a fort, 250 by 230 yards or nearly 12 acres in extent, was built on the highest available site in the neighbourhood of Cripplegate, within the purlieus of the growing city. This fort, found by W. F. Grimes in 1949, had walls 4 feet thick, built of ragstone without bonding-courses and backed by an earthen bank. One of the rounded corners retained an internal turret and there were intermediate turrets along the sides; the position of the west and south gates is known, and a wooden bridge had carried the approach-road to the southern gate across an unemphatic ditch.

The specific function of this fort, entrenched in the civilian zone of the province, can only be guessed. We need not however go so far as Rome and its praetorians in search of a parallel. From the time of Tiberius, the Gaulish capital of *Lugdunum* or Lyons had for upwards of two centuries a succession of urban cohorts of 1,000 to 1,200 men, the only permanent garrison in Gaul; and when in AD 197 the XIIIth *Cohors Urbana* took the losing side of Albinus against Septimius Severus in the contest for empire at Lyons, it was replaced

by a new composite unit made up of drafts from the Rhenish legions.[28]

Here we have ample analogy from which to recruit in theory a garrison for the London fort in the first and second centuries. As to its duties, an inscription records that amongst the special functions of the Lyons cohort was the guarding of the mint. Tasks of a parallel kind can be envisaged for a similar unit in London; equally, a military depot at the great port may have been useful as a staging-camp for men and stores in connection with the considerable military activity in progress or prospect at this time along the northern frontiers.

Sometime after AD 180, perhaps in the last years of the century, the city as a whole was walled. The fort was now incorporated in the north-western corner of the new defences, much as the praetorian fort was incorporated as a rectangular projection in the outline of Aurelian's Rome. The two walls of the London fort – the northern and western – which thus formed a salient in the civic scheme, were now doubled in thickness, to approximate to the average 10-foot width of the new urban wall. A coin of Commodus (AD 180–92) lay beneath the reinforcement. Subsequently (extending into the post-Roman period) round-fronted towers were added to the defences.

Amongst other Roman structures which have been observed under the difficult conditions presented by London, the baths which have long been known on the site of the former Coal Exchange, opposite Billingsgate Market and close to the line of the river-wall, may well have been part of a public establishment. But the most notable recent discovery (also by W. F. Grimes, in 1953) is that of a well-preserved Mithraeum (*Ills. 62, 63*) beside the Walbrook near the Mansion House. As the god alike of manliness and fair dealing, the Persian Mithras was no less appropriate to a commercial community than to the soldiery with whom his worship is frequently associated. The Walbrook temple, built probably about AD 180, was 60 feet long by 25 feet wide, with an apse at the western end and a narthex or porch at the eastern. The interior included a nave divided by sleeper-walls from raised aisles, upon which the initiates reclined. The sleeper-walls each carried seven brick columns, perhaps with reference to the seven Mithraic grades. Subsequent changes derived mainly from the

raising of the floor-levels to combat the damp of this streamside site;
and in its final form – after much use, as its worn stone sill indicated,
and after eight successive floors had been added – it was certainly
active until the middle of the fourth century. Whether the burial of
some of the numerous sculptures recovered from it at various depths
reflects ultimate Christian iconoclasm is less certain. But like other
late Roman shrines it would appear that in its latter phases the
Mithraeum accumulated a wide range of divinities and became some-
thing of a pantheon. In addition to the normal evidences of Mithra-
ism, the sculptures included Minerva, Serapis, Mercury and Dionysus,
mostly of marble and of continental workmanship. Actually in the
wall was found a cylindrical silver casket or pyxis bearing scenes of
hunting (*Ill. 64*), perhaps representing Mithras as hunter.

62 (*left*) Reconstruction of the Mithraeum beside the Walbrook in London. Built about AD 180, it was 60 feet long by 25 feet wide with an apse at the western end and a porch at the eastern

63 Reconstruction of the interior of the Walbrook Mithraeum. The nave is divided from raised aisles by sleeper-walls, each of which carried seven brick columns. The temple continued in use at least until the mid-fourth century

The general story of the town plan of Londinium is thus a familiar one. From a nuclear chessboard it spread along the adjacent highways (the details hidden from us) and, at a necessary or suitable moment, the amalgam was enclosed in defences which, with little regard to geometry, compromised between the existing pattern of occupation and tactical command. We have seen something of the sort, with variations, in several of our other samples of planning, beginning with Ostia (*Ill. 11*). And beyond Ostia there are Hellenistic cities which tell much the same tale. Save for a tendency to emphasize the major axes of a plan – and here the influence of the augur and the soldier may be suspected – the Roman planners added surprisingly little in principle to the Greek tradition. It was rather in the design and construction of individual buildings that Roman individuality expressed itself, and to some of these we must now turn.

64 Cylindrical silver pyxis and strainer found in the north wall of the London Mithraeum. It bears hunting scenes, perhaps representing Mithras in the role of pursuer of death and evil. It dates from the late third to fourth centuries AD

Buildings

TEMPLES

From the seventh century BC onwards the typical Greek temple consisted of an oblong sanctum with a porch at one or both ends and a surrounding colonnade. The basis of the building was a low stone platform with continuous steps. Variations on this nuclear plan do not here concern us, nor do the problems of its ancestry. Suffice it that the Greek temple offered an essentially symmetrical all-round elevation with no external emphasis on particular function, save for an adjacent altar.

Similarly generalized, the Roman temple, manifestly derived from the same tradition, was of a very different mind. It was raised upon a lofty podium 9 or 10 feet high (*Ill. 66*), and above this it presented a deep and dominating colonnaded porch, often with no more than a vestigial continuation in the form of attached columns along the sides and back of the shrine. Compared with the Greek pattern, the Roman was two-dimensional. The back was of no account; it might even be masked by an adjacent wall at the extreme inner end of a forum or temenos, which confronted the temple much as the fore-court or atrium was later to confront the Christian church. The expressed function of the Roman temple was to command the assembly in front of it, whether for religious ceremony or for the more secular purposes of public oratory from its towering podium. This might be approached by a central staircase between flanking platforms, or even by almost secret lateral stairs as in the Temple of Rome and Augustus at Lepcis Magna (*Ill. 65*).

It is not profitable to dispute how far these or other variations upon the Hellenic pattern were imposed by Etruscan middlemen or by the 'Romans' themselves in any narrow sense of the term. The differences fall well within the range of specific variation attributable to transplantation from one environment to another. They are no more (or less) mysterious than are the specific and regional variations

89

65 The raised podium of the Temple of Rome and Augustus at Lepcis Magna was reached by these unobtrusive lateral stairs

amongst the medieval Gothic cathedrals of western Europe. The differences may be observed with a proper thankfulness for diversity.

The largest of the early temples of Rome was that which was dedicated in 509 BC to the Capitoline Jupiter in the first days of the Republic[29] (*Ill. 67*). It was often burned and refashioned, but it was apparently about 185 feet wide and 200 feet long, and had a porch of eighteen columns arranged in three rows of six, with a line of columns along each side meeting lateral extensions of the back wall, which was plain. In these flanking colonnades it differed from the Vitruvian type of Tuscan temple, which lacked them. Otherwise it generally resembled the Vitruvian scheme (IV.7), and it had the usual triple shrine of the Capitoline triad, Jupiter, Juno and Minerva. A sculptor named Vulca was called from the Etruscan city of Veii to make terracotta sculptures for its adornment.

Here we have then a Graeco-Etruscan temple planted suddenly in an immature Rome, but already with a hint of that emphasis of the thickly pillared entrance-façade which was to become a characteristic feature of Roman temples.

90

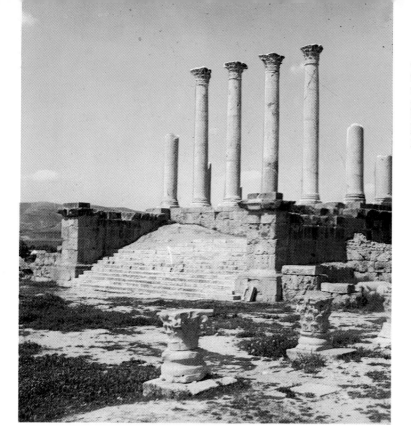

66 An impressive flight of steps leads up to the towering podium of the temple (Capitolium) at Thuburbo Majus, near Tunis

67 Part of the wall of the temple dedicated in 509 BC to the Capitoline Jupiter. This was the largest of Rome's early temples, measuring some 200 by 185 feet

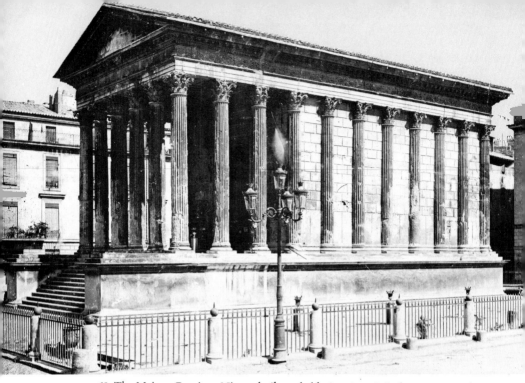

68 The Maison Carrée at Nîmes, built probably in 16 BC. It is the most complete remaining example of temple architecture of the Augustan Age

As a typical example of a later age we may take the well-known temple, the Maison Carrée, at Nîmes in southern France[30] (*Ill. 68*). It was built probably in 16 BC and is externally complete, save that originally the surviving podium stood on a platform surrounded by porticos which framed the forum of the colony. Its deep porch has three open bays on each side, and attached columns extend round the sides and back of the shrine; in other words, it is hexastyle pseudo-peripteral. It is of the Corinthian order, well carved in the local limestone, with an admirable frieze of tendril pattern. The abaci show the band of flute-like leaves which have been observed as characteristic of the early Empire. The whole building is an unimpeachable, if also an unexciting, example of monumental Augustan architecture, when the Corinthian order was beginning to conform with a limited range of conventions.

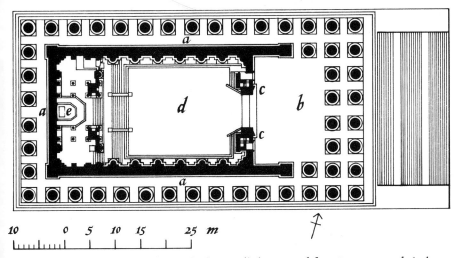

69 Plan of the temple of 'Bacchus' at Baalbek. Unusual for a Roman temple is the surrounding colonnade (*a*). A wide porch (*b*), flanked by staircase-towers (*c*) leads into the *cella* (*d*). At the western end stood the cult image on a platform under a baldachin (*e*)

One other temple of the Graeco-Roman tradition, but very different in detail and implication, may be cited: the so-called temple of 'Bacchus' at Baalbek in the Lebanon[31] (*Ills. 69, 71*). It is in a sufficiently complete state of preservation to enable the visitor to reconstruct it visually, and a very singular building it is. The famous group to which it belongs was completed by the time of Caracalla (AD 211–17), and the temple itself is probably of the middle or second half of the second century. It stands on a high podium; its peripteral colonnade is of unfluted Corinthian columns and it has a deep porch, six fluted columns in width. The surrounding portico (*Ill. 70*) is roofed with a convex ceiling of monolithic blocks richly carved with framed busts of Mars, Ganymede, Ceres, Vulcan, a city-goddess and others. But it is the interior of the building that mostly matters, in contrast with the more austere or extrovert Greek tradition. The entrance, surrounded by almost riotously ornate frames (*Ill. 73*), is flanked by two towers which carry stairs up to the roof level – for what purpose is disputed, though the same feature occurs in a number of temples in the Near East, Sicily and southern Italy.[32] Within (*Ills. 72, 76*), the *cella* is flanked by Corinthian pilasters

93

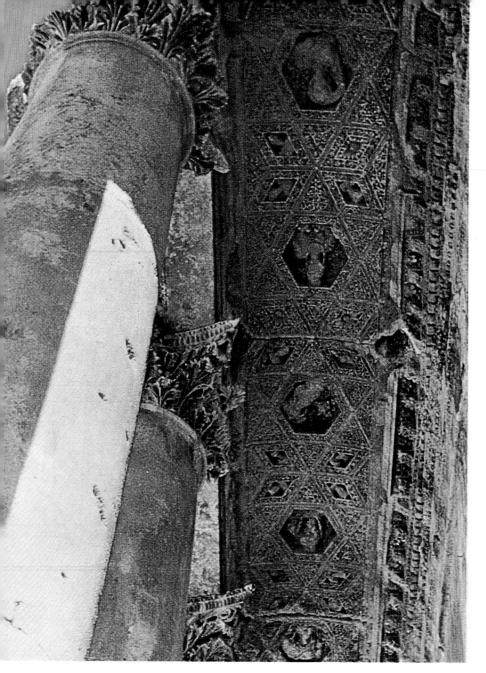

70 The rich carving in the ceiling of the portico surrounding the temple of 'Bacchus' at Baalbek contains framed busts of Mars, Ganymede, Ceres, Vulcan and others

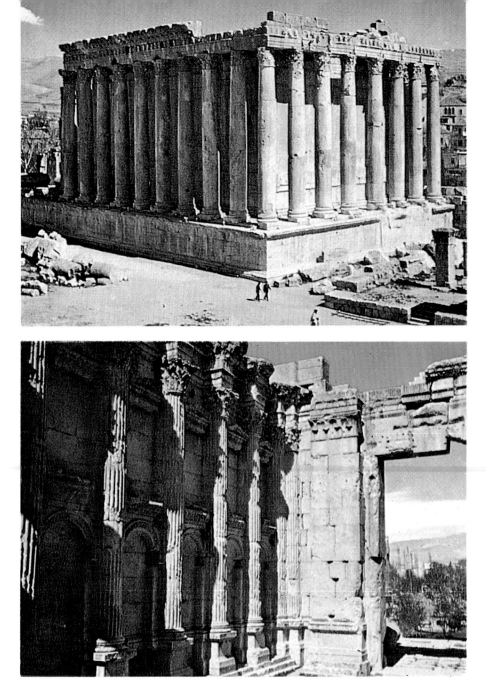

71, 72 (*above*) View of the temple of 'Bacchus', Baalbek. Built *c.* AD 150–200, it stands on a podium surrounded by a colonnade. (*below*) View inside the *cella*

set on a dado and enlarged by fluted Corinthian half-columns on pedestals. Between the pilasters are two tiers of niches, the lower round-headed, the upper with triangular pediments; the higher niches at least formerly contained statuary. At the inner (western) end, a monumental stair approached an elaborate baldachin which framed the cult statue. The whole concept was astonishingly rich – the stone, observed Lamartine, 'groaned beneath the weight of its own luxuriance' – and, as the most nearly complete surviving example of its kind, the building holds a unique place in the history of architecture.

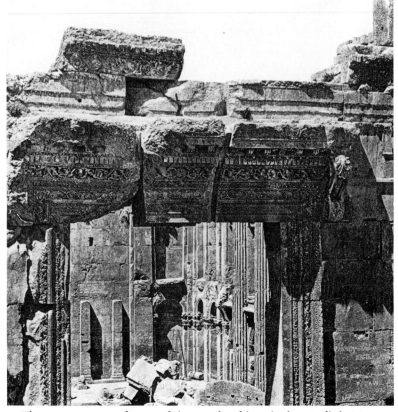

73 The ornate entrance-frames of the temple of 'Bacchus' at Baalbek. Towers on each side carried stairs up to the roof-level

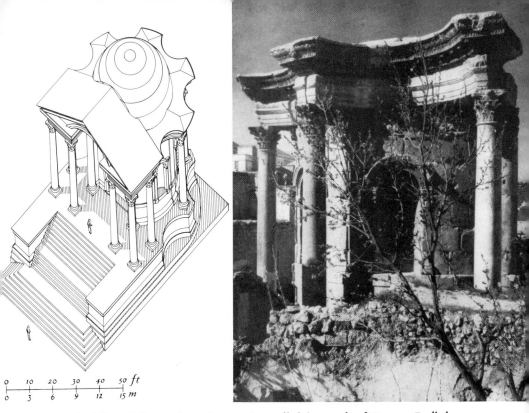

0 10 20 30 40 50 ft
0 3 6 9 12 15 m

74, 75 The delicate little round temple, sometimes called the temple of Venus, at Baalbek, dates from the second or early third century A D. The broken pediment rested on unfluted Corinthian columns, while the *cella* was roofed by a dome

Whilst at Baalbek we may glance at another masterpiece of this autumn phase of classical architecture; an autumn phase which was at the same time full of anticipation. Outside the main temple-group is a small circular shrine of unusual charm (*Ill. 75*), attuned sufficiently to the quality of a later age to reappear in elaborated form as the lantern of Borromini's church of St Ivo in Rome about 1650.[33] The Baalbek shrine, ascribed without evidence to Venus, is of second or early third century date and of a complicated circular plan (*Ill. 74*). The round *cella*, with its doorway in a north-western arc, fronted by a rectangular porch, is encircled by Corinthian columns with five-sided capitals and linked by architraves concave on plan. The building was crowned by a masonry dome, and stands on a podium $9\frac{1}{2}$ feet high. It is a gem.

97

76 Reconstruction of the interior of the temple of 'Bacchus' at Baalbek. One of the most magnificently decorated of all Roman temples, it was turned into a Christian church, probably by the Emperor Theodosius (AD 392–5)

William Suddaby

77 Column-capitals and frieze of the 'Temple of Vesta' at Tivoli. The capitals are of
an individual type copied by Sir John Soane for the façade of the Bank of England

Two other circular temples may be mentioned. The so-called
Temple of Vesta at Tivoli, near Rome (*Ill. 79*), is a good example of
Corinthian of the early first century B C. The frieze was of a normal
Hellenistic type and was adorned with the heads of oxen linked by
garlands. The column-capitals (*Ill. 77*) are an individual variety
which was copied by Sir John Soane in the eighteenth century for
the façade of the Bank of England (*Ill. 80*). It has been improbably
conjectured that the temple was roofed with a concrete dome.

The Tivoli temple was of tufa, travertine and concrete, but the
familiar circular temple, now the little church of S. Maria del Sole
(*Ill. 78*), beside the Tiber at Rome, is of Pentelic marble save for the
tufa podium which, unlike the Tivoli podium, is completely sur-
rounded by steps in the Greek manner. The entablature has gone and
the dating is uncertain; but if, as some have proposed, it is as late as
the early Empire, it must be regarded as an archaism. It is probably
earlier, not later than the middle of the first century B C.[34]

Circular or polygonal temples with surrounding porticos, of the
so-called 'Romano-Celtic' type, occur widely in the provinces under
the Empire. An upstanding example survives in France at Perigueux
and the foundations of several occur in Britain, as at Silchester and

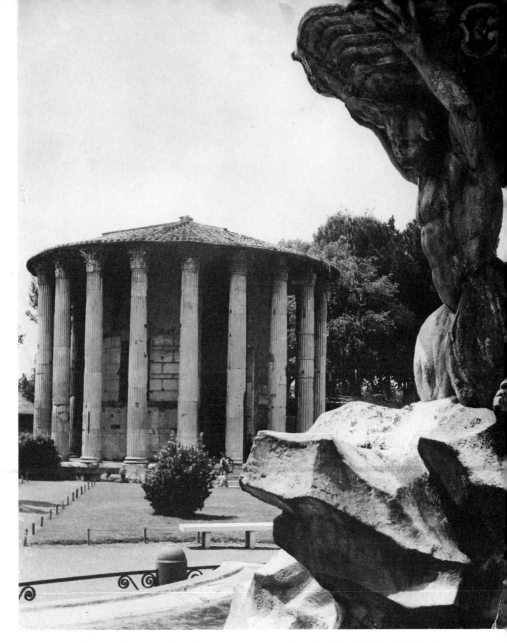

78 The circular temple beside the Tiber in Rome, now the church of S. Maria del Sole. It is built of Pentelic marble on a tufa podium and dates probably from the first century BC

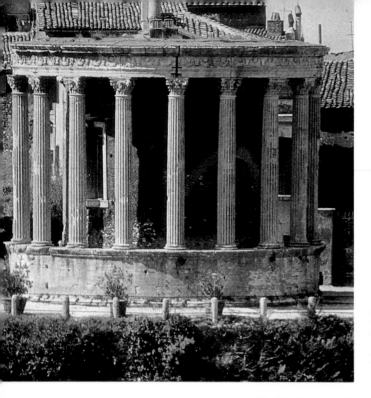

79 (*left*) The round, so-called 'Temple of Vesta' at Tivoli; a good example of the Corinthian order of the early first century BC

81 (*opposite*) Interior of the Pantheon in Rome, painted by Pannini in *c.* 1750. The greatest of all surviving Roman temples, it was built by Hadrian *c.* AD 126

80 The 'Tivoli Corner' of the Bank of England, designed by Sir John Soane at the end of the eighteenth century and based on the 'Temple of Vesta', Tivoli

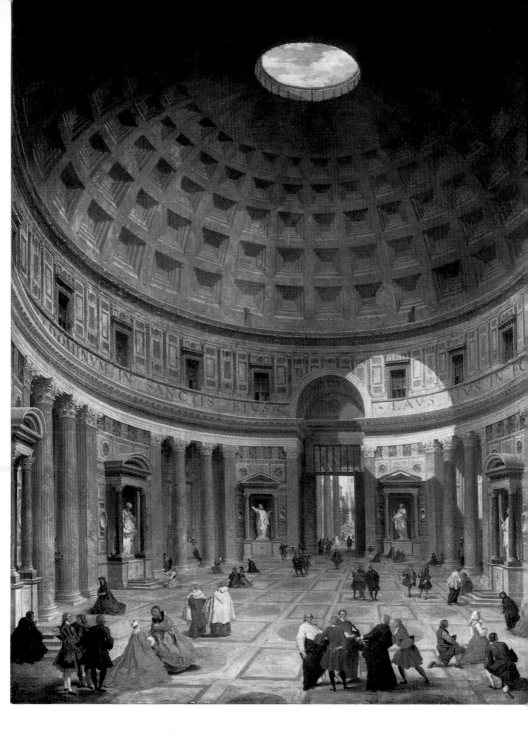

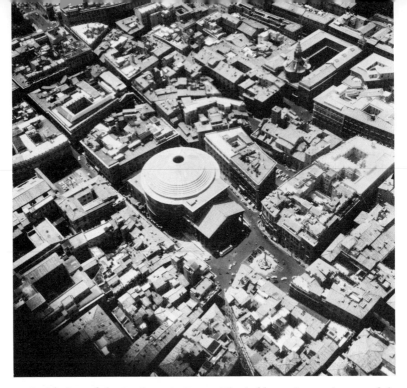

82 Aerial view of the Pantheon in Rome. The bold opening at the top of the dome measures 27 feet in diameter

Caerwent. But in Gaul (outside Provence) and Britain, with sporadic extensions into central Europe, the provincial type is a square shrine flanked on all sides by a portico either with full-size columns down to the floor-level or with small pillars on a breast-high wall. Traces of a pre-Roman building of this shape but of timber were found on the site of London Airport during the 1939–45 war and may be a native prototype, but details are not available.

Of all circular Roman temples, the outstanding survivor is of course the Pantheon at Rome[35] (*Ill. 81*); a building indeed which ranks with the Parthenon and Saint Sophia as one of the landmarks in architectural history. Details of its structure and discussion of the chronology of its parts lie outside this context. It must suffice to record that, approximately as we see it now, the building is the work of Hadrian, about AD 126. It was dedicated to the seven planetary

deities and was in effect an architectural simulacrum of the all-containing cosmos.

Externally, even allowing for the removal of stucco and veneer, it is a building of no special account. The disharmony of portico and rotunda is indeed thoroughly uncomfortable (*Ills. 82, 83*); at best, the portico is acceptable only as an apology to tradition, by its detachment enhancing the originality of the great building which it screens. But as an interior the Pantheon is unsurpassed, and it was as an interior that the structure was conceived. Lightened by its wall-recesses, strong in the powerful lines of its superbly coffered dome, and united with the dome of heaven itself by the bold opening in its summit, this interior is one of man's rare masterpieces. And it is now the first of its kind; something of its quality has been considered above (see p. 12).

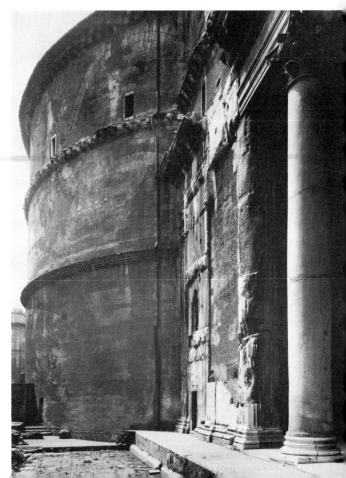

83 Exterior view of the Pantheon in Rome, showing how the traditional portico was attached disharmoniously to the rotunda

Technically, the Pantheon owes its design and quality to the use of concrete and brickwork for the structure of its immense dome. Vaults of masonry, on a small scale, had been constructed here and there by the Greeks or their neighbours as early as the sixth century B C (Pyla in Cyprus), and were used shyly for basements and tombs by the Pergamenes. But the dome was a Roman contrivance, and owes its substantive introduction into architectural design to the development of concrete, or stiffly mortared rubble, in the second century B C. The earliest certain surviving example is in the *frigidarium* of the Stabian Baths at Pompeii (*Ill. 84*), where the conical dome has a circular opening that anticipated the central opening of the Pantheon some two-and-a-half centuries later.

It is an axiom of architectural history that the innumerable public baths of the Roman Empire made an outstanding contribution to the general development of plan and structure.[36] Their elements of course recur in other settings; in basilicae, for example, and other public buildings, and in the palaces of which surviving witness is less ample. But even a small town might well have two or more communal baths on an appreciable and even lavish scale, and the implied assemblage of rooms of varying size and shape within the discipline of a systematized function provided a recurring creative exercise of far-reaching consequence. At first the resultant plan tended to lack coherence; the Stabian Baths themselves illustrate this immaturity (*Ill. 85*), and so do the Forum Baths of Pompeii early in the first century B C, though already with a hint of greater symmetry. It would appear that some time in the first century A D – evidence is incomplete but includes Palladio's plan of the Baths of Nero (A D 62) – the general lines of the vast symmetrical establishments of the middle and later Empire were worked out in principle, and it may be that Apollodorus of Damascus, who was employed by Trajan, had a final hand in this. Certainly by the time of Hadrian the pattern was set; witness his great baths at Lepcis Magna (A D 126–7).

84 Graceful arches adorned with stucco decoration in the Stabian Baths at Pompeii; second century B C

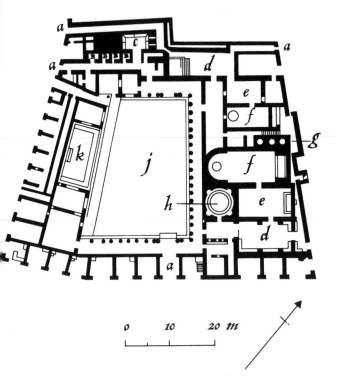

85 The early Stabian Baths at Pompeii were built on an untidy, immature plan. At the north-west corner are two entrances (*a*), small private baths (*b*) and a latrine (*c*). The men's and women's baths on the east side each contained a changing-room (*d*), *tepidarium* (*e*), and *calidarium* (*f*). Other features were the heating plant (*g*), domed *frigidarium* (*h*), palaestra (*j*), and swimming-pool (*k*)

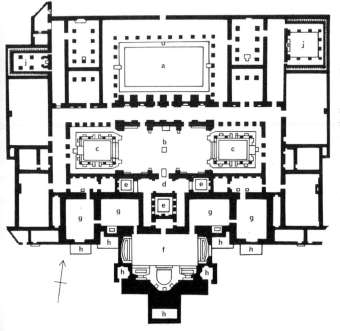

86 Hadrian's Baths at Lepcis Magna (AD 126–7), show a mature and formal plan. The building included an open-air swimming-bath (*a*), *frigidarium* (*b*), plunge-baths (*c*), *tepidarium* (*d*) with a large central and two smaller baths (*e*), *calidarium* (*f*), super-heated rooms (*g*), furnaces (*h*), and latrines (*j*)

This building[37] (*Ill. 86*) may be taken as a sample of the manner in which a succession of interiors of wide diversity was reconciled in an overall harmony by means of vaulted and colonnaded vistas and a wealth of connecting or diverting ornament. The outermost compartment was an open-air swimming-bath surrounded on three sides by Corinthian porticos and flanked by pairs of colonnaded halls. Beyond these on each side was a latrine (*Ill. 87*) in which the occupants sat on marble seats on three sides, regarded by a statue in a niche on the fourth. From the swimming-bath four doors opened on to a corridor surrounding the cold room or *frigidarium* (b), a splendid hall paved and panelled with marble and roofed by three concrete cross-vaults springing from eight Corinthian columns (*Ill. 88*). At each end of the hall arched doorways opened on to cold plunge-baths. A central door at the back connected the hall with the warm room or *tepidarium* (c), with a large central bath and two smaller lateral baths of later date. Beyond again was the hot room or *calidarium* (d), a large barrel-vaulted room with arched windows which were presumably glazed. On each flank was a pair of super-heated rooms (ee) which constituted the *laconica* or sweating-baths.

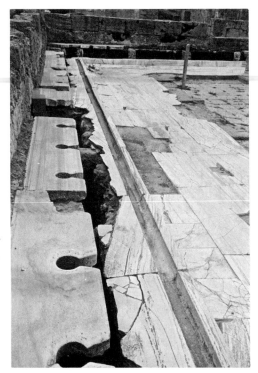

87 One of the latrines of the Hadrianic Baths at Lepcis Magna. The marble seats extend round three sides of the room

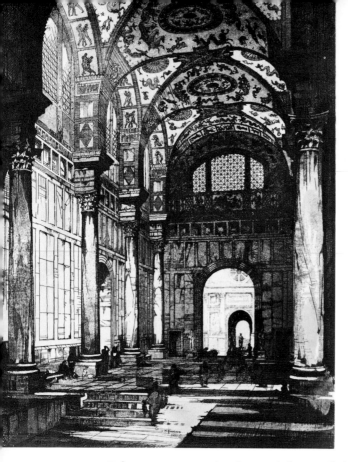

88 Reconstruction of the *frigidarium* of the Hadrianic Baths at Lepcis Magna. The hall was paved and panelled with marble and roofed by concrete cross-vaults

Other apartments in the periphery of the plan are of uncertain purpose, but the greater baths, such as these, not infrequently included a library and exercise-rooms.

FORUM AND BASILICA

The market-place – Greek *agora* and Roman *forum* – was the centre of the business and social life of the classical town, save in so far as the Roman public baths eventually usurped elements of social interchange. In Hellenic times the agora was essentially an open space somewhat untidily diversified by public buildings and monuments and, above all, by *stoae* or colonnaded shelters where conversation might continue undeterred by rain or shine. In the Hellenistic period

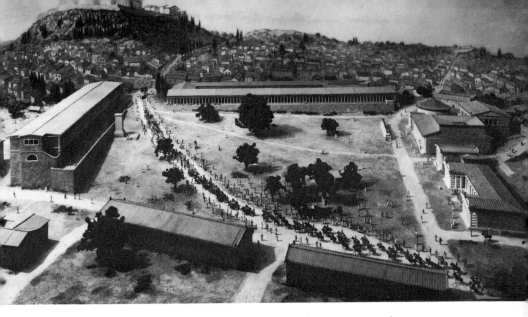

89 Reconstruction of the agora at Athens in the second century BC. Such open spaces, surrounded by colonnaded shelters (*stoae*) developed into the pattern of the Roman forum

these stoae tended to form a more or less geometrical framework to the agora; as at Priene where the agora (before 300 BC) was originally an oblong with a regular portico on three sides, though later a fourth portico of larger size was added on the remaining side. Again at Athens in the second century BC the Stoa of Attalus on the east and the Middle Stoa on the south gave a new geometry to the erratic assemblage which had previously diversified the civic centre (*Ill. 89*).

A certain casualness, however, in the lay-out of the market-place lasted occasionally into the Augustan age. At Lepcis Magna in Tripolitania the Old Forum, near the harbour, occupied a roughly quadrilateral area which nevertheless sloped away asymmetrically towards the north and was not trimmed to a three-sided colonnade until AD 53–4. But normally under the Empire the forum was a symmetrical square or oblong space enclosed by colonnades on three sides and by the basilica or town-hall – in fact a roofed extension of the forum – on the fourth. This provides another example of the Roman tendency to *enclose* places of public assembly; a tendency well illustrated by the evolution of the classical theatre, which began life

under the Greeks as a structure essentially open to the landscape but was turned by the Romans into an enclosed hall by the integration of stage and auditorium.

Colonnaded halls or basilicae were not unknown to the Greeks, but the regular provision of a municipal basilica as an adjunct to the market-place was essentially a Roman innovation. The earliest known examples go back to the formative second century BC, when, as we have seen, the use of concrete and the dome, with the parallel development of ambitious vaulting, marked the beginning of a new era in architectural thinking. In 184 BC the elder Cato added the Basilica Porcia to the Roman forum, and a few years later the Basilica Aemilia was built near by. The latter was an oblong hall with an internal four-sided colonnade which probably carried a clerestory. One of the longer sides of the building opened through a colonnade upon the forum. A similar basilica on a small scale, dating from the middle of the second century, has been excavated at Cosa in southern Etruria (*Ill. 90*); in the back wall, opposite the entrance, was a projecting tribunal for the presiding magistrate. The whole scheme resembles that of the basilica built by Vitruvius at Fano about 27 BC and described by him (V.1.6).

Differing from this 'Vitruvian' model was another series represented by the basilica at Pompeii, built prior to 78 BC (*Ill. 91*). Here the oblong hall with its internal ambulatory is entered through one of the short sides, and the tribunal is demarcated within the far end; so that the functional axis is that of the length, not the breadth, of the hall. The early basilica at Lepcis Magna (before AD 53) is of a similar kind, and it is clear that, whatever their mutual relationship, the two types – the 'Vitruvian' and the 'Pompeiian' – were in vogue side by side at the end of the Republic and the beginning of the Empire.[38]

To these archetypes may be added a number of variations, ranging from the great basilicae of Rome, which might have as many as four internal colonnades and great terminal apses, to relatively modest halls with no internal colonnade at all, as at Doclea in Dalmatia or Timgad in Africa (both second century AD). Or again the two primary types might occasionally be combined, as at Cyrene, where

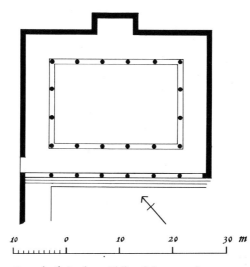

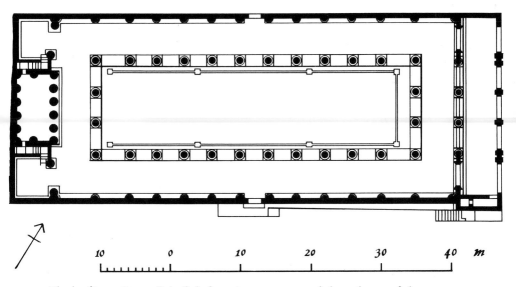

90 The small basilica at Cosa, built in the middle of the second century BC. This was the type described by Vitruvius, with the entrance in one of the long sides and the magistrate's tribunal opposite

91 The basilica at Pompeii, built before 78 BC, was entered through one of the short sides with the tribunal at the opposite end. This 'Pompeiian' type of basilica influenced the design of Christian churches

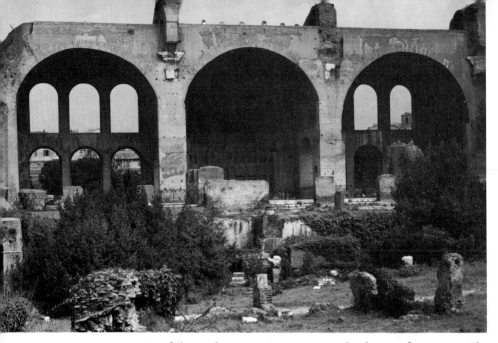

92 Remains of the Basilica Nova in Rome, completed soon after AD 313. The three massive cross-vaults rose 114 feet above the floor

the basilica is laid out on a longitudinal axis with a large apse (Hadrianic) at one of the ends but a continuous colonnade opening on to the forum on one of the long sides. In this case the basilica is in effect an enlarged stoa, and Greek influence is no doubt responsible.

In the western provinces, and not least in Britain, there was a tendency under the Empire to adopt a simple, closely co-ordinated plan, consisting of a square or squarish forum bounded on three sides by porticos and on the fourth by a basilica, its long axis parallel with its side of the forum. The basilica itself would normally have a range of offices at the back, a tribunal (sometimes apsed) at each end, and entrances in the long side facing the forum. This combination of hall and courtyard was likewise the conventional plan of the head-quarters of a Roman fortress, and the respective share of military and civil influences in the evolution of the design is a part of an incon-clusive argument which, indeed, goes back in principle to classical times. It is likely enough that the military headquarters owed its plan to a regimentation of civilian practice; but that in the remoter pro-

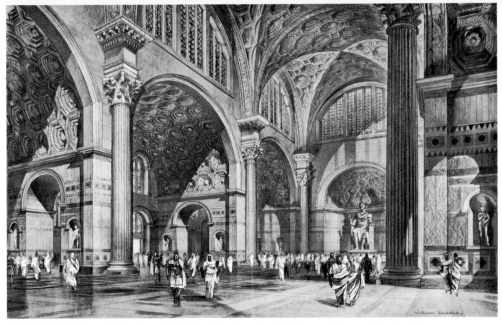

93 Reconstructed interior of the Basilica Nova in the Roman forum. A colossal statue of the Emperor Constantine sits in the apse at the western end of the central hall

vinces, where military engineers must have had a considerable hand in laying out the first civil buildings, it was the military version which provided the standard model.

Of all surviving, or partially surviving, basilicae in Italy the most imposing is the fragment of the great hall, the Basilica Nova, begun by Maxentius and finished after A D 313 by Constantine in the Roman Forum[39] (*Ills. 92, 93*). The three massive cross-vaults of its nave rose to a height of 114 feet above the floor, and their lateral thrust was eased by partitions carried across a broad aisle on each side. The western end was strengthened by an apse, the eastern by a narrow entrance-lobby pierced by five doorways. Externally the roof was shielded and enriched by bronze tiles; internally the original splendour of the structure, when its walls and floor were still veneered with marble and glowed with kaleidoscopic colour in the varying light, must have been a memorable spectacle. Constantine changed the functional axis of the building by adding an apse on the northern side and a formal entrance on the southern.

Briefly, it may be said that the Greek theatre was essentially a structure of the open air, whilst the Roman theatre, whether it had or had not a permanent roof, conformed with the Roman trend towards enclosed interiors. Its *scaenae frons*, the elaborately adorned back wall of the stage, rose to the full height of the semicircular auditorium, and was joined to it by lateral returns, so that audience and actors were entirely withdrawn from the world without. If the theatre was a small one, as were many of the so-called *odea* or concert-halls, it would normally be completed by a timber roof. A large theatre could, when necessary, be sheltered by awnings, and holes for the attachment of the front ropes can frequently be observed in the forward edges of some of the lower tiers of seats. It is possible that masonry corbels, as on the Roman theatre at Orange in Provence (*Ill. 99*), carried masts at the top of the auditorium and stage-buildings for securing the backs of these awnings. In some cases at least there was a permanent pent-roof above the stage.

The orchestra, which in the earlier Greek theatres was circular with a central altar and was used by a part of the cast during the performance, was in Roman theatres reduced to a semicircle, embodied in the auditorium and reserved for movable or semi-permanent 'stalls'. For example, in the theatre at Verulamium (St Albans) in Hertfordshire substantial wooden benches occupied this area at one period.[40] The change from Greek to Roman usage reflects sharp changes in function, with religious ceremony and epic drama on the grand scale at the one end and intimate burlesque at the other. In this sense, although based upon Greek prototypes, the Roman theatre was a Roman creation. For a long time it was restricted structurally to temporary wooden booths and staging; Vitruvius (V.5.7) speaks of 'many theatres set up at Rome every year'. Not until 55 BC was a stone theatre built in the capital – by Pompey, who had been impressed by the Greek theatre at Mytilene. The outstanding feature of the major Imperial theatres was the back-scene, the *scaenae frons*, which, as at Aspendos in Pamphylia (*Ill. 94*) or Sabratha in Tripolitania (*Ill. 95*), or at Orange (*Ill. 99*), might be sumptuously enriched by tiers of colonnaded niches with statuary:

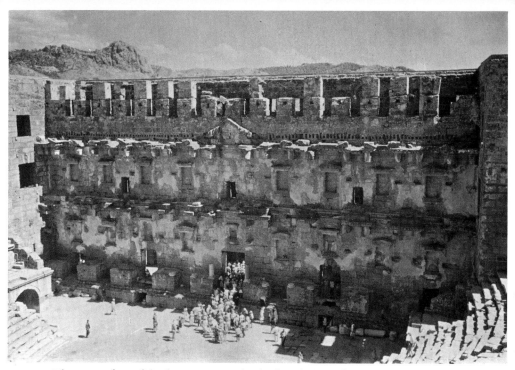

94 The *scaenae frons* of the theatre at Aspendos, built in the second century A D. It is the best-preserved Roman theatre in Asia Minor

an elegant background for what must often have been a not particularly edifying entertainment.

Less edifying still, however, were the spectacles offered in the amphitheatres or oval (rarely circular) enclosures which, under the Empire, were a normal emblem of Romanization outside the more Hellenized eastern provinces where, to the credit of the humane Greek tradition, they never took firm root. (The amphitheatre at Pergamon and the conversion of the Hellenistic theatres at Dodona in Epirus and Xanthos in Lycia into amphitheatres during the Roman period are rare exceptions.) The various forms of brutality for which they were the setting were originally practised in the open market-place (Vitruvius V.I.I), and the earliest structural amphitheatre is that at Pompeii (*Ills. 96, 97, 98*), built after 80 B C. It is a paradox that a part of Italy which had owed much to Greek colonization should have been the pioneer in this matter, but an apologist could fairly

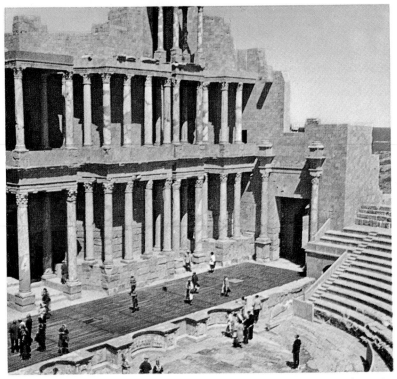

95 The theatre at Sabratha with its elegant colonnaded *scaenae frons*, similar to the other North African example at Lepcis Magna (*Ill. 35*)

emphasize the essentially Oscan and non-Greek elements in the make-up of this Campanian town. Farther south the Lucanians were already painting gladiators and pugilists on their tombs at Paestum in the fourth century BC. The earliest stone amphitheatre at Rome was not built until the time of Augustus; but perhaps the greatest work of architectural engineering left to us by Roman antiquity is Rome's Colosseum (*Ill. 102*), built by the Flavian emperors within the last quarter of the first century AD on the site of the lake of Nero's Golden House. With its tiers of arches, its superimposed orders in the form of half-columns, and its crowning range of pilasters, it was to become a pattern for Renaissance architecture.

Between this vast structure, designed to hold 45,000 spectators, and the little enclosures – some of them scarcely larger than cockpits

118

96 (*right*) Wall-painting from Pompeii showing riots in and around the amphitheatre in AD 59. An awning shielded the spectators from the weather

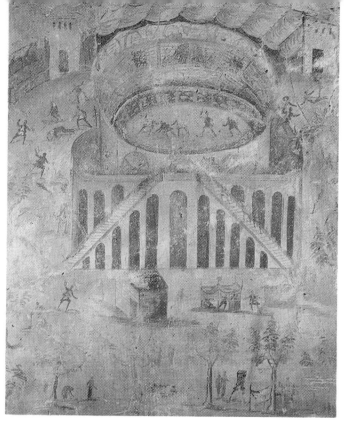

97 (*below*) Exterior of the amphitheatre at Pompeii (built *c.* 80 BC) showing steps which led up to the rows of seats

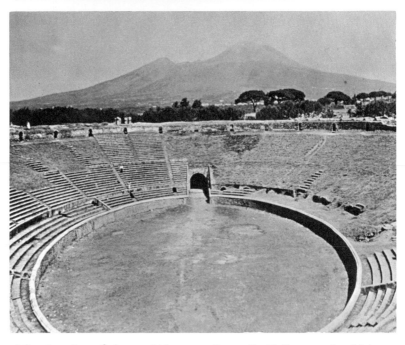

98 Interior view of the amphitheatre at Pompeii. Gladiators and wild beasts entered through tunnels on each side

– which sufficed the needs of soldiery and civilians in the outlands of the Empire, lies a long series of monumental amphitheatres, occasionally still in use for purposes not altogether alien to the original intent. In some instances earthen banks enclosing an oval space and supplemented by timbering or a little masonry were regarded as adequate. Even a legionary fortress like Chester, which eventually had a fine stone structure, might begin with a timber amphitheatre, put up by the garrison in the first days of occupation, just as its modern military successors might hastily improvise a football-ground. These humble provincial versions, however, though important in the history of modes and morals, give place in the history of architecture to the fine, upstanding constructions of concrete and ashlar which can still be seen at Arles or Nîmes or Verona or Lepcis Magna (*Ills. 100, 101*) and, by the exercise of skill in the marshalling of ingenious vaulted substructures (*Ill. 103*) and even in the controlled use of decorative detail, were a recurrent

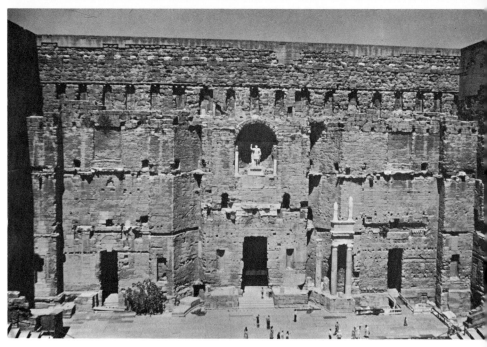

99 *Scaenae frons* of the theatre at Orange. Masonry corbels at the top of the auditorium and stage buildings were probably to secure awnings

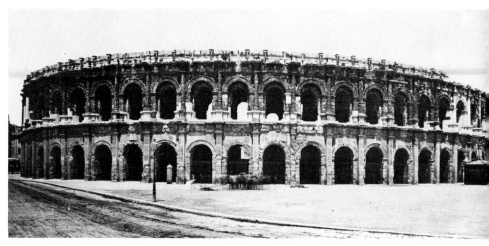

100 The well-preserved amphitheatre at Nîmes, which was built probably soon after 30 BC. Amphitheatres scattered all over Italy and the western provinces of the Roman Empire testify to their great popularity there, but are rare in the more Hellenized East

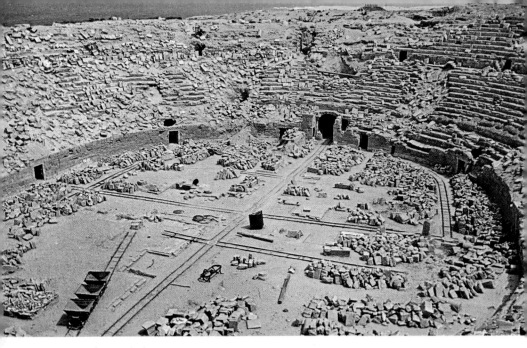

101 The amphitheatre at Lepcis Magna in the course of excavation. It was doubtless supplied with animals by hunters such as those depicted on the walls of the 'Hunting Baths' (*Ill. 39*)

stimulus to the Roman, and indeed the Renaissance, designer and builder. Behind the sorry story of human and animal bloodshed which they represent, these sombre memorials have a positive and creative aspect which may not be ignored.

Of the circuses (*Ill. 105*) little need here be said. Their general shape in Roman times reflected that of their Greek predecessors. Built on large tracts of eligible flat ground, few of them have survived save as the most shadowy of ghosts amidst busy modern streets. One of the best of them can be seen today at Perge (*Ill. 104*), near the southern coast of Turkey, where the sloping stone sub-vaults built probably in the second century AD to carry the seating have survived in a remote countryside, and show the normal plan of the elongated racecourse, rounded at one end and open or squared at the other. Down the centre formerly stood the dividing *spina*, marked by monuments such as still indicate the axis of the famous circus of Constantinople (Istanbul) or, in the form of a monumental pyramid

102 (*right*) The Colosseum or Flavian Amphitheatre in Rome. Built at the end of the first century A D, it could accommodate some 45,000 spectators

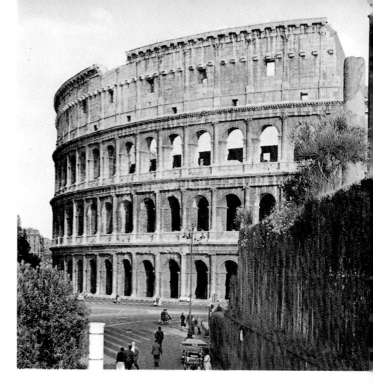

103 (*below*) Interior view of the Colosseum in Rome. The floor has been excavated to reveal its intricate vaulted sub-structures

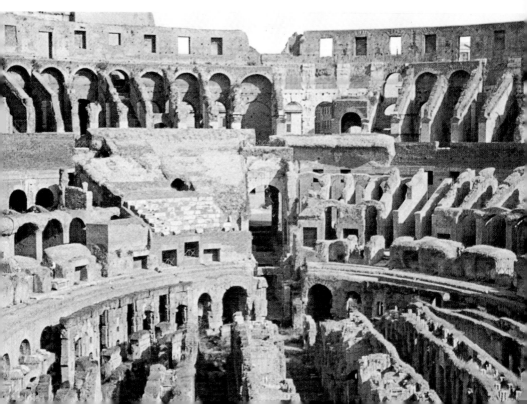

104 The circus at Perge showing the sloping stone sub-vaults which carried rows of seats for the spectators. It was built probably in the second century AD

carried on an arcaded pedestal, that of the circus which underlies a residential suburb of Vienne, south of Lyons.

HOUSES

Roman town-houses represent diverse traditions and adaptations of which only a brief sketch can be attempted here.[41] The basic scheme of the average classical dwelling, as of far earlier houses in the Orient, was that of an unroofed courtyard surrounded by rooms, of which one might be of dominant size. In the present restricted context, Roman variations on this theme, and one or two other types, will be illustrated by examples from key sites.

First, Pompeii. The oldest houses here, going back to about 300 BC, consisted of rooms grouped with an un-Greek symmetry round a court or *atrium*, which usually contained a tank for rain-water (*Ills. 108, 109*). This court was regarded by Varro and Vitruvius as the principal room; though whether it began as a central hall, or whether it was originally an open yard which, as time went by and

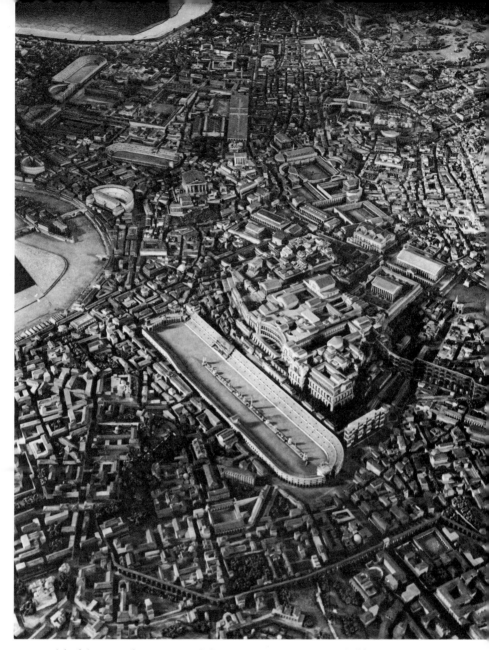

105 Model of the area of Rome around the Circus Maximus as it probably appeared in the fourth century AD. The circus was 2,000 feet long, 650 feet wide and could seat 255,000 spectators

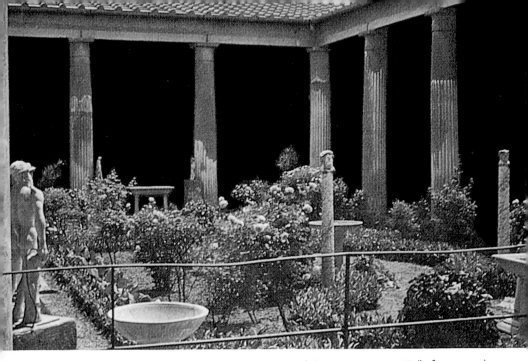

106 The restored garden and peristyle of the House of the Vettii at Pompeii (before AD 79). This is a typical example of the elegant small town-house of the time

urban accommodation became more precious, was covered save for a central opening above the tank, is disputed. A further elaboration was the sensible introduction of four or more columns about the tank, thus producing something of the effect of a Greek portico.

Beyond the atrium was the principal room, the *tablinum*, open-fronted or at most screened by a curtain; and beside this, right and left, were two *alae* or recesses from which access could be obtained to the back rooms without traversing the *tablinum*. Between the *alae* and the front of the house were ranges of private rooms. Except above the *tablinum*, there was an upper storey of limited height, sometimes with balconies, and at the back there might be a small garden. Where, as in the wealthier houses, this garden was a sizeable one (*Ill. 106*), it might in the second century BC or later receive a peristyle in the Greek mode, commonly with rooms around it.

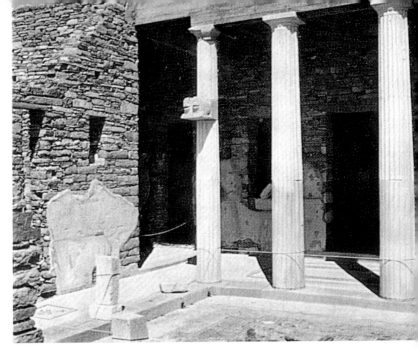

107 A Roman house of Vitruvius's 'Rhodian' type on the island of Delos retains on one of the high columns of the main range a bracket to support the roof of the lower flanking portico

108 The *atrium* of the House of the Wooden Partition in Herculaneum, with, beyond it, the *tablinum*. The tank in the floor was to catch rainwater from a central opening in the roof

109 Opening in the roof over the *atrium* of the House of the Vettii in Pompeii through which rainwater flowed into the tank below

Outside Italy, the 'atrium' house scarcely existed. On Delos, where a considerable community of Roman traders flourished in the trade-boom which followed the capture of Corinth in 146 BC and even survived awhile the destruction of Delos itself by the fleet of Mithradates in 88 BC, the houses of the Roman quarter are of Greek types. Amongst them are good examples of the pattern known to Vitruvius as the 'Rhodian' (*Ill. 107*): in which the inner range of a colonnaded courtyard was higher than the flanking porticos, and the roofs of the latter rested on brackets projecting from its angle-columns. This contrivance emphasized the importance of the inner-most room, which thus in effect equated with the *tablinum* of the Pompeiian scheme.

In the great cities the end of the Republic marked for a time the end of the widespread construction of spacious private houses of the Pompeiian kind. In Rome and Ostia the busy days of the early Empire meant concentrated populations and rising ground-rents,

110 Model reconstruction of a five-storey tenement block at Ostia, occupying an insula of the residential part of the town

and, as in the comparable circumstances of far more modern times, buildings tended to grow vertically rather than laterally. At Rome indeed high tenements were no novelty. They had been known as early as the third century BC, and Vitruvius (II.8.17), remarking upon the use of brick and concrete in their construction (though wood was also freely used, particularly for the upper storeys), considered that they were not only a necessity in the face of a growing population but were at the same time well worthy of the dignity of the capital. Others, including Strabo, held an opposite view. Certainly, dangers from fire and collapse, culminating in the great fire of Nero's principate, had to be countered by building restrictions; Augustus limited the height to 70 feet, Trajan to 60 feet. Even so, blocks of five or six storeys came easily within the law. Whether these had any real affinity with the famous six-storey houses from which, during the last hours of Carthage in 146 BC, the desperate defenders showered missiles upon the Romans in the streets below[42]

129

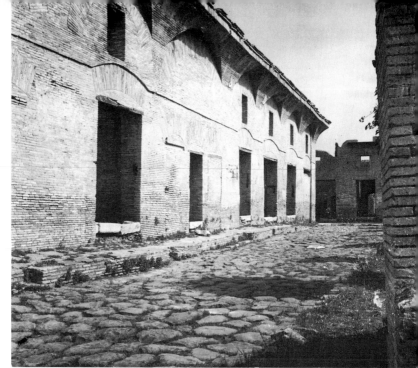

111 The House of Diana in Ostia, a typical tenement-building, was equipped with balconies. In some cases balconies failed to conform with floor-levels and were purely decorative

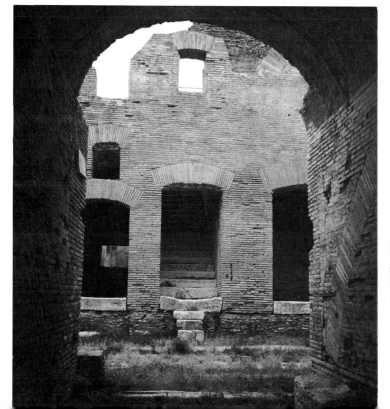

112 The apartments of the House of Diana in Ostia were reached by stairs which led up from the street between ground-floor shops

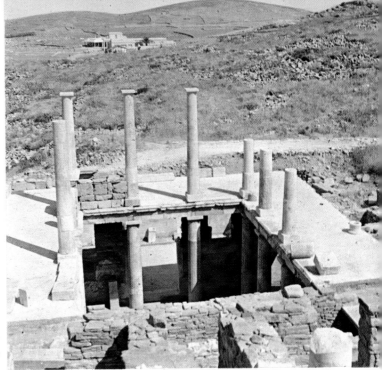

113 A Roman house on the island of Delos which originally stood five storeys high

may perhaps be questioned; there too these towering structures perished in the flames. No doubt tall tenements were not uncommon in the more crowded cities round the Mediterranean – they occur at Herculaneum: and a Roman house on Delos still retains evidence of five storeys (*Ill. 113*), though here the sloping hillside may have been a contributory factor.

It is at Ostia that the most ample material evidence of Roman tenement-buildings survives (*Ill. 110*). Externally their aspect was for the most part severely functional. Normally they were built of unfaced brick which might, however, be enriched on the arches or lintels of doorways and windows by vermilion paint, and might be further varied by a plain string-course and by pillars or pilasters at the main entry. Balconies, carried on projecting timbers or stone corbels, more rarely on brick corbel-vaulting, were also a feature of some of the blocks (*Ill. 111*); though the curious observation has been made that these balconies did not, at least in some instances, conform with floor-levels and were actually non-functional – a

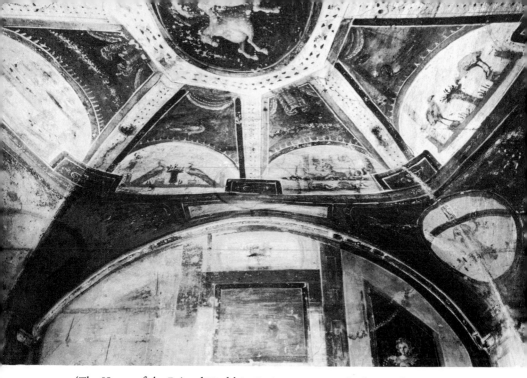

114 'The House of the Painted Vault' in Ostia was so named after its elaborately painted decoration. Its owner was evidently a man of some considerable wealth

whimsy hard to parallel until the days of Edwardian baroque in England. The flats or apartments were reached from courtyards or from the street by stairs often set between ground-floor shops (*Ill. 112*). A recurrent apartment-plan comprises five or six rooms served by a spacious corridor overlooking the street and terminating in a room larger than the rest. Walls and ceilings in the better establishments were elaborately painted (*Ill. 114*), and a fair measure of comfort is implied, though there is an absence of structural heating and, usually, of private sanitation.

When the population-problem began to ease at Ostia under the later Empire, houses of an individual and attractive kind re-appeared in the more peripheral quarters. The opportunist re-use of earlier walls helped to vary their plans, but there are certain common features. Unlike the tenements with their substantial windows, these late houses tend to look inwards and, again unlike the tenements, to

132

have structural heating with wall-flues. They seem normally to have been of a single main storey with minor rooms above. One of the best of those which have survived is the well-known House of Amor and Psyche (*Ill. 115*) in the western part of the town. Its principal feature is a wide central corridor opening on one side through a Corinthian arcade on to a small garden backed by a nymphaeum, which consists of five alternately round and rectangular niches fronted by brick arches springing from smaller Corinthian columns (*Ill. 117*). On the other side of the corridor are small rooms, a staircase and a lavatory (*Ill. 116*); and at the end is a large room with a niche in one wall. The whole effect is one of graciousness, charm and comfort with a hint of the almost eighteenth-century elegance that sometimes marked the later days of the Empire.

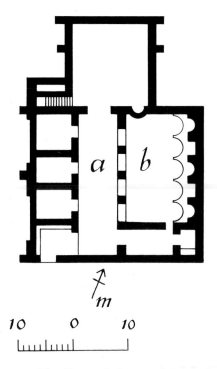

115 The House of Amor and Psyche in Ostia, probably of the fourth century AD, contained a wide central corridor (*a*) opening through an arcade on to a small garden (*b*) backed by a nymphaeum

116 A private lavatory in Ostia. More common were lavatories of the more sociable sort with long rows of stone seats

133

117 The House of Amor and Psyche in Ostia is one of the best preserved of the more luxurious type of private house. Beyond the charming statue group, after which the house is named, is the nymphaeum

From the constricted environs of the city we turn to the country-side. There, ranging from crofts to immense palaces, were the houses of the small farmers, the agents, and the rich owners for whom the country was part occupation and part divertissement, a quiet setting for good food and good talk (*Ill. 118*). As far away as Glamorgan, on the ultimate shores of Ocean, a country-house spread, with its outbuildings, across three-quarters of an acre of coastal plain amidst fields and, no doubt, a great spread of golden gorse. Gaul was particularly rich in large country-houses, and, as late as the fifth century, they live again in the writings of Sidonius Apollinaris. Some of them were almost small towns. The famous establishment at Chiragan, beside the Garonne between Toulouse and Dax, covered 40 acres and is thought to have contained as many as 400 persons of all grades. It comprised a complex residence and three regimented lines of cottages, barns and other outliers, all framed by a long

boundary wall;[43] and from it was recovered a whole museum of sculptures, many of them of high quality. Again, at Anthée, near Namur in Belgium, a country-house with lines of cottages occupied 30 acres.[44] More recently another large establishment, covering something like 45 acres, has been partially excavated near the village of Montmaurin, 12 miles north of St Gaudens in the Haute-Garonne. The main residence constituted an enclosure of about 10 acres with a wide semicircular entrance-court, two rectangular inner courts, and an aggregate of 200 rooms; and its architecture was of a monumental kind. In these great assemblages of squire's mansion and close dependencies has been identified the Roman prototype of many of the medieval and modern French villages, which not infrequently, as it seems, reflect in their names those of their Gallo-Roman proprietors. Thus Frontinus is recognized in Frontignan, Paulus in Pouilly, Paulinus in Paulignan, Albinus in Aubigny, Julius in Juilly, and many more.[45] Admittedly caution must be exercised alike in these identifications and in the interpretation of the historical processes which they seem to imply.

The nuclear plans of these mansions might often include a peristyle but, particularly though by no means exclusively in the less congenial climate of northern Gaul and Britain, were characteristically ranges of rooms fronting upon a corridor, often with terminal wings. In a number of instances, periods of insecurity, such as the Frankish invasions of 275–6 or the Vandal inroad of 408, induced their owners to fortify them in substantial fashion. For example, a Pontius Leontius, as Sidonius (*Carm.* XXII. 117) tells us, built his house so that 'neither engine of war nor opposing *agger* nor heavy catapult-shot nor massed attacks nor scaling ladders could shake the walls'; and the well-known remains of a fortified mansion can still be seen at Thésée, between Tours and Chabris.[46]

Tiny versions of these immense residences observed the same main principles. A little house at Ely, near Cardiff in South Wales, consisted of four or five rooms round a corridor, with a considerable outbuilding for storage and farm-hands, and even with a miniature but complete suite of baths.[47] In the troubled days of *c.* AD 300 the house itself was surrounded by a walled bank and ditch. A standard

example of the small farmhouse is that of Mayen, between Coblenz and Andernach in the Rhineland.[48] It began as an oblong timber hut with central hearth in pre-Roman times; was enlarged in stone early in the Roman period, and shortly afterwards received small wings joined by a verandah; at the end of the first century AD it was further amplified with larger wings and a bathroom. Minor buildings of this sort were subject to variations, such as the inclusion of a cellar, or the elaboration of one or both wings into a tower, but they bear the stamp of Romanization, even to the frequent provision of tessellated or mosaic floors. At the same time, to complete the picture we must visualize here and there upon the landscape a scatter of primitive round huts of the prehistoric kind, where, as in much later centuries, herdsmen and charcoal-burners continued to live traditionally on the fringe of the forests and the downs.

118 Fresco from Pompeii showing a rich country-house with porticos opening towards the sea; before AD 79

119 Detail from mosaic in the 'Room of the Ten Girls' in the Imperial villa near Piazza Armerina, Sicily; late third century AD

PALACES

The residence of Augustus on the Palatine was a relatively simple and seemly structure, in consonance with the studied moderation of the first Emperor. But his successors quickly abandoned this austerity, and the new example spread. Certain of the larger Gaulish mansions might be described as palatial in size and quality, and a large villa of the fourth century at Welschbillig near Trier was in all likelihood built actually as an Imperial country-residence. In the centre of Sicily the villa probably of Maximian near Piazza Armerina, with its diverting mosaics (*Ill. 119*), again sets the Imperial standard of elegant excess. But the most extravagant of all Roman country-palaces was Hadrian's great villa, which stretched for a mile across the slopes below Tivoli, 15 miles from Rome[49] (*Ill. 120*). Stripped and shattered though it be, it remains the most fantastic material creation of the Roman genius: of a particular Roman genius, which had travelled

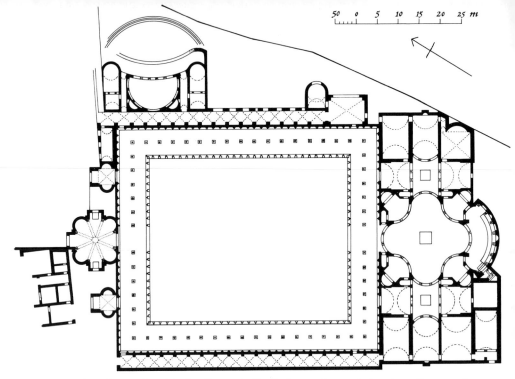

120 Plan of part of Hadrian's villa at Tivoli. The largest feature is the Piazza d'Oro, with its immense colonnaded courtyard. On the left is an eight-sided, domed apartment; on the right a large hall, the dome of which was originally carried on eight piers. Colonnades weave in and out between these piers

far and experienced much, and had learned to temper affairs with sentiment, sentiment with reason. With its 'Poikile' (*Ill. 121*), its 'Prytaneum', its 'Academy', its 'Canopus' (*Ill. 123*), its miniature 'Vale of Tempe', it fed the nostalgia of the ageing Emperor; with its 'Styx' and its 'Elysian Fields', it lent an indulgent melancholy to the prospect of old age. It cannot here be described in any detail, but at every turn it offers interest and intelligence in plan or contrivance.

Isolated notes must suffice. At the ends of an immense colonnaded courtyard known as the Piazza d'Oro are apartments of remarkable plan. One is eight-sided with alternate apsidal and rectangular bays, covered by a dome which, like the Pantheon, has a central opening. Between each bay are piers connected by arches; above each of these is a segment of vaulting which merges into the central dome. In a

138

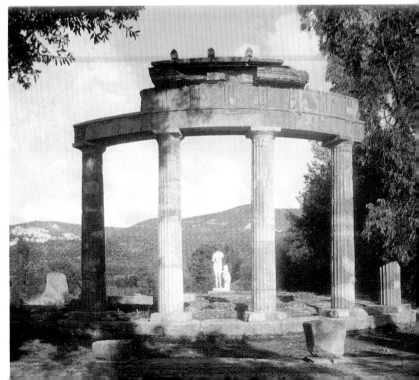

121 (*above*) The swimming-pool in the 'Poikile' of Hadrian's villa. Beyond are the ruins of a suite of halls and courts, and to the left what were probably the Emperor's private quarters

122 (*right*) The ruins of a small, round temple overlooking the 'Vale of Tempe' in Hadrian's villa. The statue is a Roman copy of the Cnidian Venus of Praxiteles

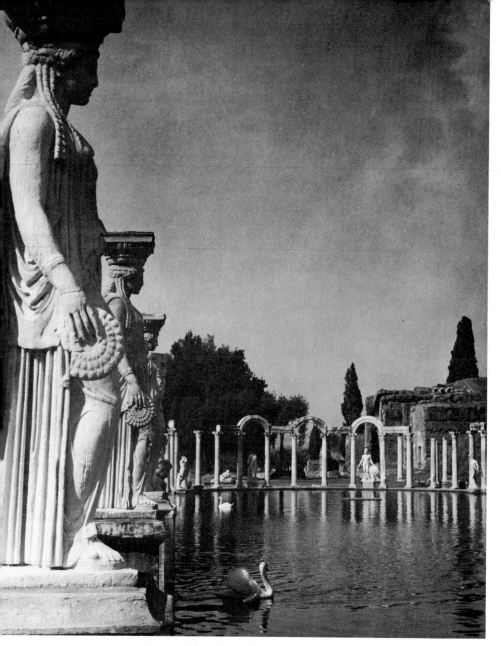

123 The 'Canopus' Canal in Hadrian's villa at Tivoli. The caryatids were adapted from those of the Erechtheum of Athens

124 Reconstructed model of Hadrian's villa at Tivoli built between *c.* AD 125 and AD 138. To the upper left is the Piazza d'Oro; in the foreground the Poikile with the circular Maritime Theatre to the left, and stretching away in the middle distance is the Canopus Canal

daring fashion, the skilful use of concrete replaces more logical construction.

At the other end of the courtyard is a larger hall of equally unusual plan. Eight main piers support arches which must have carried a central dome. Between the pairs of piers are recesses with alternately concave and convex fronts on plan, each front supported by columns which thus waved in and out around the central space. Adjacent rooms assist this decorative alternation of supports to distribute the thrust of the dome.

Another charming feature, adjacent to the 'Poikile', is a small island carrying a building approached by little bridges across a surrounding canal within a marble Ionic peristyle: a cool and private retreat which may have been one of the Emperor's studies (*Ill. 121*). The whole palace was enriched with statuary (*Ill. 122*), much of it no doubt imported from Greek lands, and the combination of new and ingenious craftsmanship with traditional features epitomized the outlook of Hadrian and his epoch.

141

125 An impression of the magnificent Golden House of Nero, which was built by that Emperor in AD 64–8. The Colosseum now stands on the site of the lake

In Rome itself Nero had implanted in AD 64–8 a sprawling country-palace (*Ill. 125*) between the Palatine, Caelian and Esquiline hills amidst an artificial landscape of which a lake on the site of the subsequent Colosseum was a central feature.[50] 'All Rome is transformed into a villa! Romans, flee to Veii, if only the villa does not also spread itself to Veii!' (Suetonius, *Nero*, XXXIX). Nero, apt as ever, observed that here at last he could begin to live as a human being (*quasi hominem*). Alas for vanity, the House with its gilded porticos, the Golden House of Nero, was shortly buried beneath the great baths which Titus and Trajan, as evidence of changing times, built across the site in and before AD 104. But enough remains of its lofty sub-vaults and tunnels to hint at the magnitude and complexity of the place. Colonnades sheltered the open fronts of long ranges of *sellaria* or sitting-rooms, once veneered with marble and adorned with sculptures. Near the centre of the frontage was a bold polygonal recess or sun-court, such as is shown on the familiar wall-painting from the house of Lucretius Fronto at Pompeii (*Ill. 126*). Nearby a

142

polygonal hall was cooled with water which cascaded down stairs, in a fashion which anticipated the amenities of the Moghul palaces and gardens of the sixteenth century. Behind was a peristyle court, a barrel-vaulted hall, a nymphaeum and other rooms and corridors. These inner rooms were faced with stucco paintings which Raphael sent his pupils to study. Some of the paintings were no doubt the work of that Famulus who, attired stiffly in his toga even when at work on a scaffold during the few hours of his working day, has lived through the centuries as a figure of fun in the pages of Pliny. One dining-room is described by Suetonius as a sort of perpetually rotating globe; a somewhat alarming statement too terse for clear interpretation. The historian is less obscure when he speaks of decoration in gems and mother-of-pearl, of ivory ceilings through which flowers were projected upon the guests below, and of other ceilings pierced with pipes for spraying perfumes. In one way and another, Nero's palace had the sort of Press that the Emperor himself would have appreciated. The considerable remains of its lower storey deserve fresh study.

126 Painting from the House of Lucretius Fronto in Pompeii, showing a villa with porticos and sun-court; before AD 79

The successor-palace built by Domitian on the summit of the Palatine is of a less irresponsible sort, though lavish enough in its more conventional and urban way, with successive courts and halls and a great walled garden in the fashion of a hippodrome. But whether relatively constricted by the limits of a hill-top or spread exuberantly across town or country like vast rural mansions, these earlier post-Augustan palaces have one character in common: they belonged to an age of lavish wealth and unquestioning security which were liable to find expression in a cultivated exhibitionism. By the latter part of the third century all this was a thing of the past. The living Emperor had now become a high god and had withdrawn from a secular world which was simultaneously obsequious and unsafe – two qualities which often enough keep unholy company. And this withdrawal is expressed architecturally in a surviving fortress-palace of outstanding interest.

On the coast of Yugoslavia and on the outskirts of the ancient Salona, the older houses and shops of the town of Split or Spalato or Spoleto are crowded within the high defences of the palace to which the Emperor Diocletian retired in AD 305[51] (*Ill. 127*). From the picturesque warren an appreciable portion of the original plan can be disentangled; combining with the apparatus of a remote and splendid pageantry the guarded withdrawal from an increasingly alien world. It is framed by massive fortifications on a rectangular plan, 510 by 600 feet in extent, with walls 60 feet high and 7 feet thick, and with square towers save at the landward gates, where they are octagonal. The enclosure was quartered by broad colonnaded streets, interrupted behind the sea-wall by the Emperor's apartments and by a great hall with a domed vestibule on the line of the north–south street, all built over impressive sub-vaults which have recently been cleared. Between the vestibule and the central crossing the street was flanked by tall Corinthian colonnades with arches springing from the capitals (*Ill. 129*). To the east at this point is the Emperor's Mausoleum, standing on an 11-foot podium and externally octagonal within a peristyle of Corinthian columns on isolated pedestals. The massive walls are reduced internally by deep niches alternately round and rectangular; between the niches Corinthian columns on a

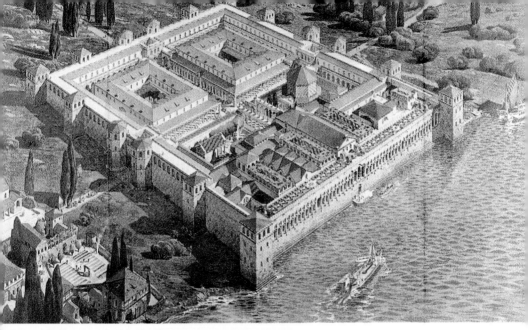

127 (*above*) Reconstruction of the vast fortified Palace of Diocletian at Split. Built about AD 300, it covered an area of some eight acres

128 (*left*) Wall-painting in the Villa of the Mysteries at Pompeii, showing an arch springing directly from capitals; first century BC

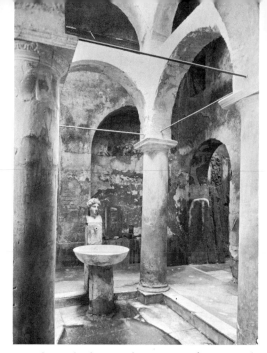

129 Arches springing directly from the capitals of a Corinthian colonnade in the Palace of Diocletian at Split; *c.* AD 300

130 The Suburban Baths at Herculaneum, showing arches springing directly from capitals; before AD 79

circular plan carry the projections of an engaged entablature and are surmounted by smaller columns, alternately Corinthian and Composite. The dome, of elaborate brickwork, is round internally and an octagonal pyramid externally. Opposite the Mausoleum is a tiny tetrastyle prostyle Corinthian temple (probably of Jupiter), standing on a vaulted podium and roofed with a coffered barrel-vault of stone above a richly decorated cornice.

On the southern or seaward face of the enclosure a great gallery extended continuously between the corner towers, with a loggia at each end and in the centre. The gallery had forty-two arched windows; between them plain corbels carried engaged columns of a simplified Corinthian type supporting an entablature normally horizontal but arched at two points. The use of corbelled columns appears here for the first time in the history of architecture. Features such as this, or the adoption on a monumental scale of arches springing direct from capitals – a device in fact shown as early as the

146

first century BC in wall-paintings of the Villa dei Misteri at Pompeii (*Ill. 128*) and represented structurally both at Pompeii (Casa della Fortuna) and at Herculaneum (the Suburban or Shore Baths) (*Ill. 130*) during the following century[52] but not fully exploited until much later – place the Spalato Palace on the threshold of a new phase in architectural thinking. Roman is sensibly merging already into Romanesque.

ARCHES AND ENGINEERING

The borderline between art and architecture on the one hand and functional engineering on the other is liable to be an arbitrary and pedantic one. So it was in the days of Isambard Kingdom Brunel; it was most certainly so in the days of Rome. The Pantheon and the palace at Spalato were clearly enough artistic creations in the fullest sense. Must we exclude the Pont du Gard and the Milvian bridge? The achievement of Roman art and artifice cannot be presented, however summarily, without them.

It has often enough been affirmed that, with unlimited and expendable slave-labour at their disposal, the Romans lacked necessities which might have been the mother of technological invention. That is less than the truth. The slave-owning Greeks before them, in a smaller and less demanding world, had already displayed a roving and entrancingly youthful curiosity which exercised an innate genius for mathematical speculation and sometimes found practical expression. The technological enterprise of an Archimedes in the third century BC included but was not limited to the siege-engines of Syracuse; his mind played with problems. The Roman mind, in so far as it can be isolated from the Greek mind, was in comparison middle-aged. It was of a more confined and materialistic sort; it had a mature and practical mission; it lent itself more readily to major structural application. And here it may be that, once more without over-emphasizing the Etruscan element, we can in fact detect an Etruscan leavening at work.

Attention has been drawn in particular to two Etruscan contributions in this context.[53] One is that of road-construction, which

131 The mouth of the Cloaca Maxima where it empties into the Tiber. Although of Etruscan inspiration, it probably dates in part from the time of Augustus (27 BC–AD 14)

was certainly an Etruscan rather than a Greek technique before it became a Roman one *par excellence*, but does not concern us here. The other relates to hydraulic engineering, in which the Romans were also to become past-masters. The 'Etruscan' Cloaca Maxima (*Ill. 131*), which helped to drain the valleys amongst the hills of Rome, may be partly an Augustan rebuild; but recent exploration has added abundantly to the known examples of indubitably Etruscan rock-cut water-channels, above all of the *cuniculi* or underground conduits near Veii and elsewhere, hewn from a succession of vertical shafts to tap a water-bearing vein. This procedure was presumably derived from the identical *qanats* or *foggars* which have long been familiar in Persia and the adjacent regions: providing perhaps yet another nebulous link between Etruria and Asia. The Romans are not known to have manipulated their own conduits in this fashion, though straightforward rock-cut channels are abundant and have a famous Greek precedent in the great water-tunnel, 1,100 feet long, cut by Polycrates of Samos as an aqueduct in the latter part of the sixth century BC.

148

Here, however, we are concerned not with these subterranean works but with the monumental bridges whereby the Romans carried their urban drinking-water across wide and deep valleys, either by a direct gradient or by an elaborate system of syphons. The application of the principle that water finds its own level is described by Vitruvius (VIII.6). The best material illustrations are provided by the Marcian aqueduct (144 B C) which carried water to Rome, and that which brought water to Lyons across the valleys of the Garonne, Beaunant and Brevenne, where, instead of constructing vast horizontal bridges, the engineers channelled the water down and up the sides of the valleys, splitting it on the slopes into multiple pipes to reduce the pressure.[54] It has been calculated that more than 12,000 tons of lead were used in the process. Whatever the hydraulic system employed, these overland conduits include some of the most imposing structures left to us by antiquity, whether in the form of a procession of lofty, single arches such as at Metz or Tunis (*Ill. 133*), or in that of a double tier of arches as at Segovia[2] north of Madrid (*Ill. 134*), or in that of a triple arcade in perfect vertical proportion as in the greatest of all aqueducts, the Pont du Gard near Nîmes (*Ill. 132*), a monument which stirred Stendhal like 'sublime music'. Here we have the apotheosis of the arch, used with the functional good taste which was a Roman gift and elevated engineering to the level of an art. Neither the Greeks nor the Etruscans were precursors or competitors in this field.[55]

Bridges of the more pedestrian sort display, at their best, a less grandiose but comparable mastery of space. The ordinary Roman bridge consisted of masonry piers supporting a flat timber superstructure. There is some evidence that the Etruscans too used this method.[56] But again it is in the employment of the arch that the Roman bridge-builders transcended basic utility and became artists. Enough of the Milvian or Mulvian bridge at Rome (*Ill. 135*), built in 109 B C, has survived ancient and modern reconstruction to show the strength and grace of its original design. With its formidable cut-waters and its graded arches – the widest 60 feet in diameter – it displays the early maturity of Roman architectural engineering. It was constructed of unmortared tufa and travertine.

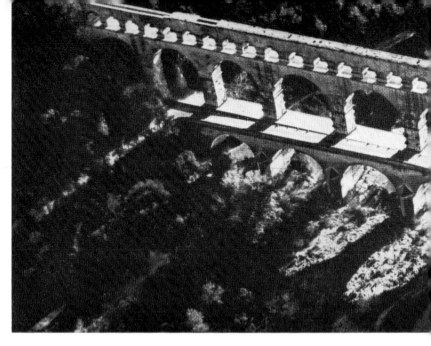

132 The magnificent three-tiered Pont du Gard near Nîmes (built *c.* AD 14). Water was carried above the topmost tier of arches, some 180 feet above the river

133 The lofty single arches of the aqueduct between Zaghouan and Carthage

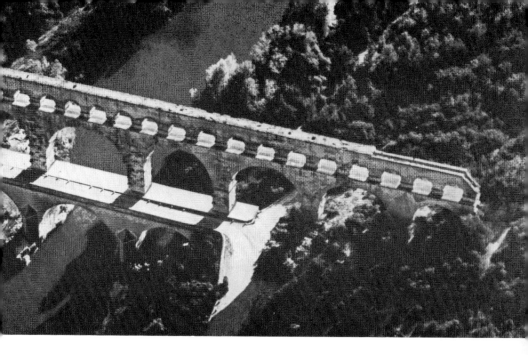

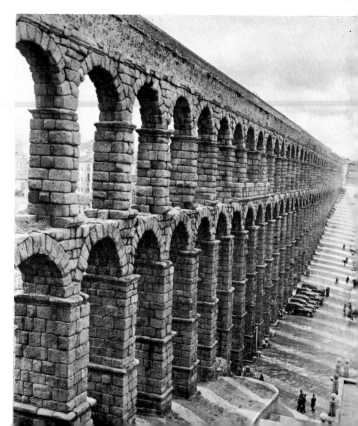

134 The double-arched aqueduct in Segovia, built *c.* AD 10

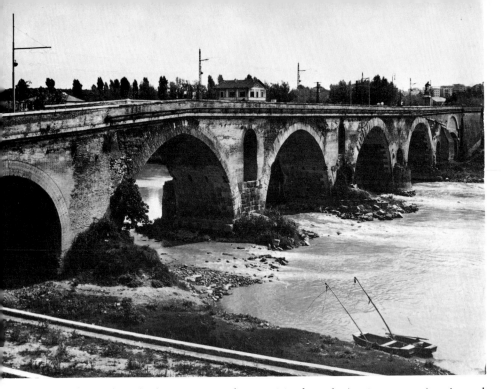

135 The Milvian bridge in Rome with its semicircular arches resting on massive piers and protecting cut-waters. It was built of unmortared tufa and travertine in 109 BC

Less extensively restored is the magnificent granite bridge built across the Tagus at Alcantara (*Ill. 136*), near the border of Spain and Portugal, on the orders of Trajan in AD 106. The two central arches are approximately 90 feet in diameter, and the lateral arches are graded into the sides of the ravine. Across the centre of the viaduct is an arch in honour of Trajan, and at one end is a small temple which may, as an unfounded guess would have it, be the tomb of the bridge's builder, one Gaius Julius Lacer. Let it suffice to say that the bridge itself is a worthy memorial to an honest and forthright imagination.

From the exploitation of the arch in a functional capacity it was but a step for a society so demonstrative and wealthy as the Roman to elaborate it in monumental isolation. 'Triumphal arches' became

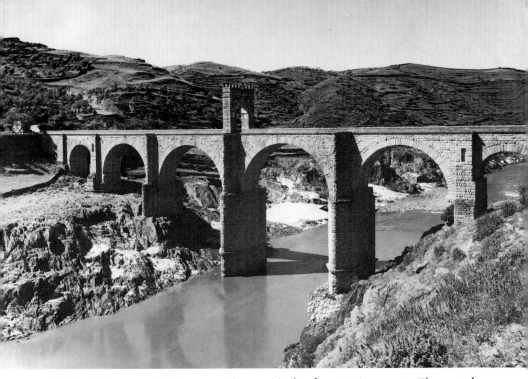

136 The bridge across the Tagus at Alcantara, built of granite in AD 106. The central arches are almost 90 feet in diameter

the symbol of Empire. Travelled Emperors such as Trajan or Hadrian or the Severi left a trail of them across the Roman world. In Rome alone more than fifty are recorded; the Arc de Triomphe and the Marble Arch of London have indeed a teeming ancestry. Time and again their ostentatious inutility has commended these costly ornaments, these towering advertisements, to the *Herrenvolk* mind. To dismiss them, however, in the words of one writer on Roman architecture as 'another individual and unattractive Roman invention' is to underrate their value as an eloquent and powerful expression of period-mentality. With their strongly lettered, severely beautiful dedications, they are a facet of the personality-cult which lies at the heart of the Imperial idea. They have their place in history, and a place by no means without distinction.

153

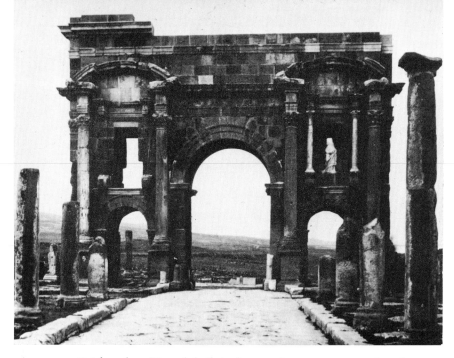

137 Triple arch at Timgad, built in the second century AD to replace the more functional west gate of the colony

They began indeed before the Imperial idea had taken shape, though it was actively in the making. The first recorded commemorative arches are of the second century BC; beginning in 196, when L. Stertinius devoted his Spanish proceeds, as Livy tells us (xxxiii.27), to the setting up of two arches in the Forum Boarium and another in the Circus Maximus. The conception was evidently not a completely new one; the arch in the Circus seems to have been erected on the *spina* or central barrier and so from the outset to have made no pretence to the utilitarian or semi-utilitarian purpose which might be expected in the earliest phase. Three other arches are known from this formative second century – the century, be it recalled, when Carthage and Corinth fell to Rome and new notions of one kind and another (including the revolutionary use of brick and concrete vaults and domes) were germinating in men's minds. But it was not until the principate of Augustus and his immediate successors that the

154

138 Reconstruction of the four-way triumphal Arch of Septimius Severus at Lepcis Magna. It was built *c.* AD 200 and stood at the principal cross-roads

triumphal arch became an established convention and a characteristic feature of the Imperial scene. As late as the third quarter of the first century AD the elder Pliny, writing as an historian, could still describe it as a 'new-fangled invention' (*N.H.*, XXXIV.27).

The non-functional character of these arches may be further stressed, however apt their positioning may on occasion have been. At Timgad in Algeria in an era of peace an open triple arch (*Ill. 137*), probably of Antonine date, replaced the functional west gate of the Trajanic colony. At Antalya in southern Turkey another open triple arch in honour of Hadrian had already replaced the Hellenistic east gate of the town. At Verulamium in Britain a triumphal arch seems to have supplanted each of the two main gates of the Flavian town on the line of the Watling Street, perhaps even before the urban area was formally enlarged within new defences in the latter part of the second century. In these instances a certain amount of traffic must or

can have passed through the arches, though at least at the more southerly arch of Verulamium there was ample metalled space around the structure. Elsewhere (Aosta, Aquino, Canosa, Jerash are examples) an arch bestrides the approach-road at some distance outside the town-walls and may there have coincided with the limit of the *pomerium* or clear space without the defences. In such cases traffic no doubt normally passed beneath the arch. Processions, moreover, such as that depicted on the Arch of Titus in the Roman forum (*Ill. 139*), undoubtedly filed through certain of the arches on their statutory routes. But often enough all major traffic was physically barred. The Arches of Tiberius and Septimius Severus, again in the Roman forum, were shielded by steps. So too was the four-way Arch of Septimius Severus which stands as an island at the principal crossroads of Lepcis Magna in Tripolitania (*Ill. 138*); street traffic circumvented it.[57] At Ancona an arch rises proudly upon the end of the mole and commands the eye from land and sea but is and was no more useful than the symbolical 'Gateway of India' on the quay at Bombay. Examples need not be multiplied. The triumphal arch was in essence merely a decorative adjunct to some particularly frequented spot: *celeberrimo loco*, as the inscription from an Augustan arch formerly at Pisa expresses it.[58]

A majority of the known triumphal arches, particularly in the western half of the Empire, had a single opening (*Ill. 139*). This was flanked by attached or (from the second century AD) detached columns and by sculptured panels, and was surmounted by an attic storey which bore the inscription in cut or bronze letters and carried free-standing figures, commonly of gilded bronze and including a chariot drawn by horses or occasionally by elephants. Early in the Principate a three-arched type (*Ill. 140*) began to appear, at first rarely; as in the Augustan arch of 18 BC in the Roman forum, or the untidy Arch of Tiberius (if that be its date) at Orange. Thereby a longer attic storey was ensured, capable of carrying more extensive sculpture. In the eastern half of the Empire, where spacious propylaea were an established tradition, the triple arch was the more popular of the two forms. An intermediary two-arched variety was sometimes used in the west, but only half a dozen examples are recorded.

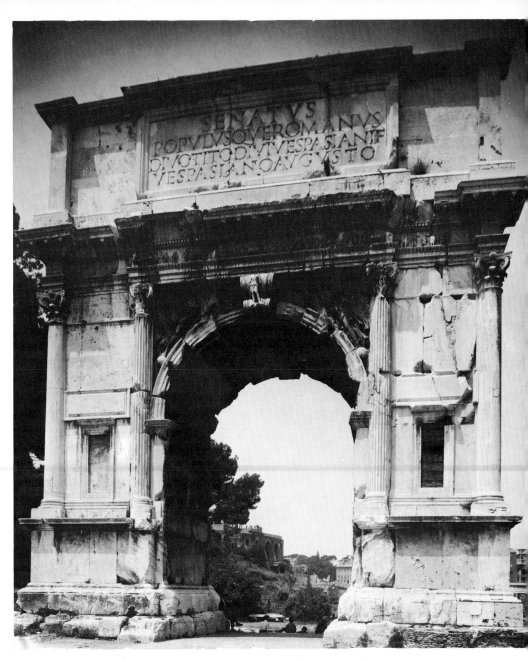

139 The Arch of Titus in Rome, built in *c.* AD 81 with a single opening. The attic storey with its carved dedication was originally surmounted by a bronze quadriga

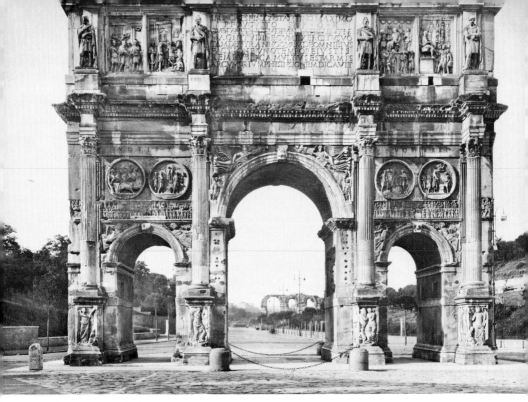

140 The triple Arch of Constantine in Rome (AD 312–15) which includes much earlier sculpture among its decorative reliefs

In one way and another these strange monuments are at the same time typical and a-typical of their place and time. If one were to seek a single emblem for the combined majesty and ostentation of a successful Rome, those monstrous toys the triumphal arches were difficult to deny. It is a thought that a great people, who could drain marshes and make roads that are still our roads, build great aqueducts and shape laws that are written into our modern civilization, and after travail give a great religion and ethical code to the world, could also pause to express and impose their self-gratification in idle contrivances of such grand but nonsensical irrelevance; contrivances which nevertheless continued to impress themselves recurrently upon medieval and Renaissance pattern. The thought adds interest and piquancy to any attempted understanding of the Roman mind.

Aspects of Sculpture and Painting

Roman art, interpreted as sculpture and painting, must here be treated very selectively and summarily,[59] but a glance at certain aspects of it may suffice to hint at something of its quality in its own right and of its contribution to aesthetic evolution. The course of evolution, whether physical or intellectual, never did run straight and smooth; in the process the failures and hesitancies and unsure deviations of Roman art were admittedly as signal (and often as signally interesting) as its successes. But its successes were remarkable and important.

Let it be stressed at the outset that the phrase 'Roman art' is essentially an abstraction and a misnomer. It is a clumsy symbol for the composite effort of minds ranging through a wide variety of environments, from the Atlantic mists to the hard sunlight of Asia and through a changing complex of ideas, from the comfortable fruition of Hellenism to the uneasy aspiration of the Middle Ages. It is really valid only in so far as it represents an epoch and an encompassing economy which assured to that epoch the needed means and opportunity. It has nothing like the simple connotation of the term 'Greek art', which is integrated alike by a narrower geography, a considerable measure of cultural uniformity, and the more restricted aesthetic concepts proper to an earlier phase. In brief, Roman art is the various product of a group of partially creative centres, including Alexandria, Antioch, Athens and, not least, Rome itself, which until the end of the third century served also as universal focus and reflector.

I propose first to select for illustration three of the principal achievements of Roman art in this qualified sense: the development of portraiture, the development of narrative, and the development of landscape. Then something must be said of the Roman patron as a collector of ancient or contemporary works of art and craftsmanship;

and finally of the impact of classical art in Roman times upon the barbarian fringe and upon alien civilizations.

PORTRAITURE

'One cannot imagine any Greek statue carrying on an intelligent conversation.' This traditional *mot* contains an important truth: the Hellenic ideal was the perfect *shape*, with little or no actively intellectual or emotional content. (A Medusa or a centaur might wear a grimace as a sort of theatrical property, just as an actor in a Sophoclean drama might wear an unresponsive tragic mask. But these are not real exceptions.) The handsome young men of the Parthenon frieze are utterly unresponsive; they do not share a mental reaction between them, even when struggling with a refractory bull. They have not forgotten that child-art, to which, for all their technical sophistication, they are still very near, is concerned with generalized outline, not with individual thought. In the following century the Hermes of Praxiteles is still wholly unconscious of the clamouring brat upon his arm.

So too in Hellenic portraiture. The Pericles of Cresilas (*Ill. 141*), as he comes down to us, is intellectually a barber's dummy. He is not the individual creative intellect that gave us fifth-century Athens. The first specific hint of Greek portraiture in any modern sense is, if we may believe a remark doubtfully ascribed to Lucian, the portrait by the fourth-century sculptor Demetrios of the Corinthian general Pellichos, who was represented as 'high-bellied, bald, his clothes half off him, his veins prominent'. Demetrios, adds the so-called Lucian, was a 'maker of men' rather than a 'maker of statues'. If so, he marked a new phase in the evolution of aesthetics.

But he was not alone. The fourth century BC did in fact coincide with a new appreciation of the individual. In 351 some of the foremost Greek sculptors of the day set to work at Halicarnassus upon the great monument to Mausolus, ruler of Caria on the coast of Asia Minor – a monument destined to become one of the 'Seven Wonders of the World'. Amongst surviving vestiges in the British Museum is the fine large statue probably of Mausolus himself, showing his calm,

141 Roman copy of a marble herm of Pericles by the Greek sculptor Cresilas; mid-fifth century BC. The vital documentary art of the Romans is a far cry from such idealized portraiture

strong, majestic presence almost with a Hadrianic verisimilitude. Idealized though the portrait be, we are already moving away from the brain-washed Pericles of Cresilas in the direction of robust factual statement. The trend received a wider sanction a few years later when Lysippus and his colleagues gave universal currency to the aspect of Alexander the Great. His vital features, set upon an abrupt neck beneath a shock of stormy hair, are convincingly those of the destroyer of the nondescript egalitarianism of the Greek city-state and the real architect of the personal authoritarianism of the Roman world-state. Eloquently they bespeak the hero who, as one of the undisputed Personalities of history, held a firm place amongst the variable Nine Worthies of the Middle Ages.

As in so much else, the Hellenistic epoch was to find its logical sequel aesthetically in the later Republic and the Empire of Rome.

It created the climate in which Rome, in the widest sense, was to cultivate the seeds of new ideas. Those seeds were gathered from many sources; of course from Greece itself and from the East, and in uncertain measure from Etruria, which had in turn borrowed and transmuted Greek skills and notions. But once again let there be no attempt to define too closely the origins of the 'Roman' complex. A composition is liable to be something more than the aggregation of its parts: and in any event time and evolutionary change have to be added as controlling if less tangible factors.

So when in Roman portraiture, which is amongst the greatest portraiture in the history of art, some specifically Etruscan inspiration is adduced, as it not infrequently is, we may well be wary. No doubt the oft-quoted Italic custom of storing death-masks was an appreciable contribution to the cult of the portrait. 'In the halls of our ancestors, wax models of faces were displayed to furnish likenesses in funeral processions (*Ill. 142*); so that at a funeral the entire clan was present' (Pliny, *N.H.*, XXXV.2). The custom epitomizes the realistic interest of the Roman in the personality as distinct from the type: an interest which much later, in the second century A D, was to find further expression in the general change-over from cremation to inhumation, thus ingenuously emphasizing 'an intense and passionate conviction as to the reality of individual survival'.[60]

But all this might well have lacked appreciable influence upon the history of art, had it not been for the fact that the mind of the classical world from the latter half of the fourth century B C onwards was increasingly ripe for a new individualism, whether in politics, in religion, or in aesthetics. In philosophy, Aristotle and his successors expressed the same trend. 'After Aristotle Greek philosophy became more and more concentrated on the individual rather than the community.' It was 'mainly concerned with finding the right way of life for individual men'.[61] In terms of aesthetic form, the generalized and idealized outline was beginning to dissolve or evolve quite logically into the more wayward shapes imposed by individual thought and emotion and experience. By the end of the third century B C the Roman portrait had arrived, and thereafter for six centuries there accumulated an astonishing gallery of revealing images of men

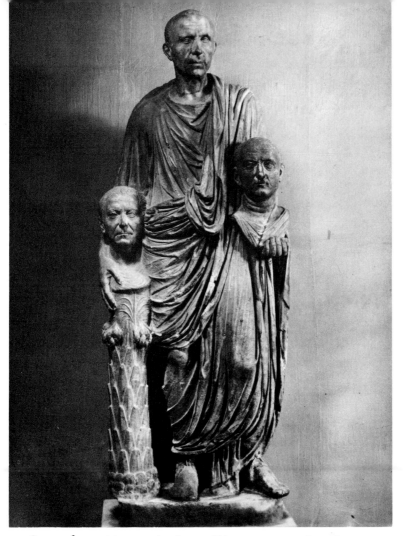

142 Statue of a patrician carrying busts of his ancestors in a funeral procession. The making of such images helped to develop the Roman art of portraiture. First century BC/AD

and women of all degrees, from Emperor to tradesman. A few examples may recall their range and vitality.

(a) The early climax of Roman portraiture cannot be better illustrated than by the reliefs ascribed with probability to the Ara Pacis Augustae, the altar set up on the Campus Martius at Rome

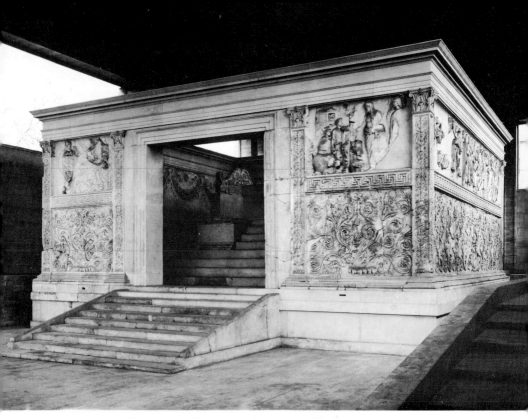

143 The Ara Pacis of Augustus, the great marble altar set up between 13 and 9 BC on the Campus Martius at Rome

between 13 and 9 BC to commemorate the return of Augustus in the former year. The monument (*Ill. 143*) has been effectively reconstructed under cover between the Mausoleum of Augustus and the Tiber, and is substantially complete. It consists of an altar on a podium flanked north and south by tall screens and approached by a stairway from the west. The screens are carved externally with life-size figures, those on the south representing Augustus and the Imperial family, those on the north magistrates, senators and members of religious fraternities, some with wives and children. The figures have paused in their processional advance towards the entrance. Some of them are decorously engaged in conversation; less decorously

perhaps in one instance, where a veiled lady in the background, identified tentatively as the sister of Augustus, places her finger to her lips in silent rebuke to a couple who are chattering in the foreground (*Ill. 146*). The small children are particularly vital in their display of childlike interest or boredom – one little mite grabs the toga of the man next to him and manifestly desires to be picked up (*Ill. 145*). But incidents such as these are all subordinated to the overall dignity of the scene, in which contemporary living people, of whom several can still be identified, are 'caught in marble, just as they were at a given moment on 4 July, 13 BC'.[62]

The reliefs have been described as 'frigid'; they have been said to have found their inspiration 'not in the humble processions of Republican sculpture but in the great Panathenaic procession of the Parthenon'. Both comments are wide of the mark. If frigid, these figures owe their aloofness to the calm, assured, unanxious society which they represent. If they recall the Panathenaic frieze, it is only that both works represent a ceremonial concourse. But the unvarying impersonality of the Parthenon is completely superseded by the intimate similitude of each of the Augustan figures. I repeat what I have said in the preface: the Parthenon is a great religious building bearing a semi-concealed pictograph of a ceremony; the Ara Pacis is essentially a portrait-gallery of celebrants who screen an altar but dominate the scene. The two great works are divided by more than four centuries of evolution. Aesthetically they are poles apart.

The slabs chosen for illustration (*Ills. 144, 145, 146*) show representative groups of officials and their families. The eye travels easily from head to living head, whether in the full relief of the foreground or in the subtly graded low relief of the background. And in the work as a whole there is no dramatic concentration upon the Emperor. With some effort his wreathed and veiled presence can be identified near the western end of the southern screen. He is merely *primus inter pares*; the personality-cult is already with us but has not yet been carried to the melodramatic extremes of later centuries. If we would understand the Augustan period – its quiet good manners and its undemonstrative confidence – in a single document, that document is the Ara Pacis Augustae.

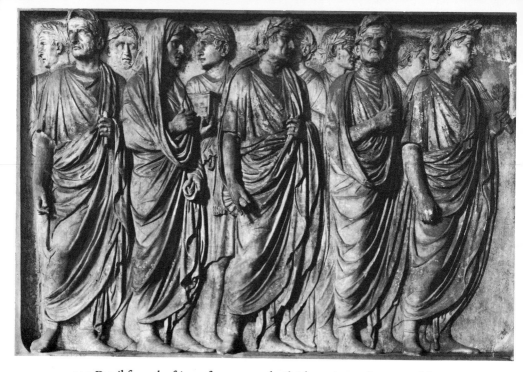

144 Detail from the frieze of senators and officials on the north screen of the Ara Pacis. The sculptor has portrayed his subjects with vivid realism

And here I would add a further word about this all-important matter of the personality-cult. The sculptor of the Ara Pacis is, as I have observed, no more interested in the aspect of the Emperor than in that of Tiberius or Agrippa or the odd priest or senator. A century later the whole perspective is already undergoing a significant and theatrical change. In the Arch of Titus at the head of the Roman Forum (c. AD 81), the Emperor is glorified even above the Victory who crowns him, and his chariot is twisted inorganically to exhibit him in full face (*Ill. 177*). The representation of figures in the background is still graded technically, with success, much as the background figures of the Ara. But here is essentially a new world. And more than a century later, as we shall see (p. 190), the trend is confirmed and amplified in the Severan reliefs at Lepcis Magna in Tripolitania (*Ill. 178*). What has happened?

166

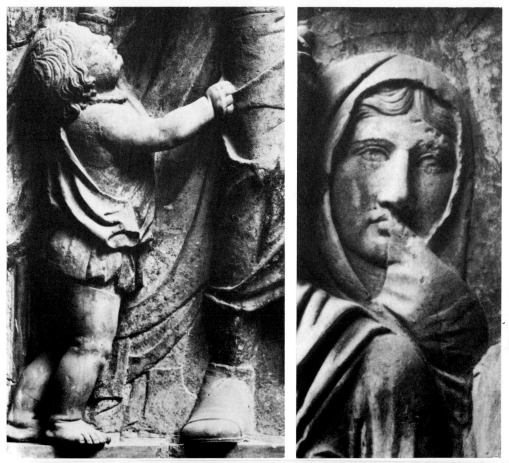

145, 146 Details from the reliefs of the Ara Pacis; a small child grabs the toga of the man next to him and desires to be picked up, while a woman silences a chattering couple with her finger to her lips

The personality-cult of the West has merged in the idolatry of the East. By the time of Severus (*c.* AD 200) this oriental trend is manifesting itself in two ways. First there is the exaggerated build-up of the principal personality by the subordination and convergence of the remaining figures of the tableau. Secondly, and in some measure paradoxically, there is a growing tendency to present all figures frontally to the spectator. Both these traits have their roots in the Orient. They can be seen in the reliefs and paintings of Dura-Europos on the Euphrates at least as early as the first century AD[63].

167

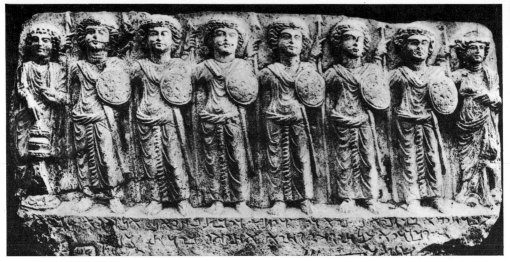

147 Relief from Palmyra (AD 191), illustrating the Parthian convention of frontality

148 Relief from Palmyra dating from the first half of the first century AD. The three gods, Aglibol, Baalshamin and Malakbel, face the viewer in the frontal manner typical of Palmyra

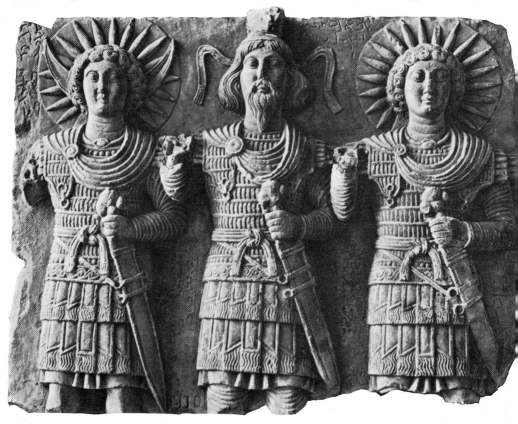

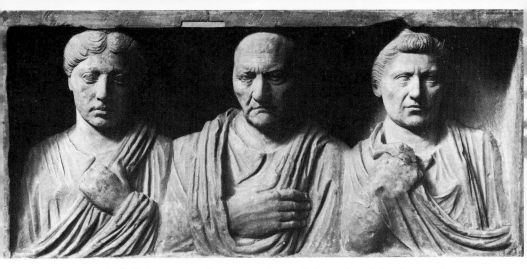

149 Grave-relief of the corn-merchant Ampudius with his wife and daughter. It dates from the first century AD

At Palmyra reliefs exhibit them in or even before the first and second century AD[64] (*Ill. 147*). And now, mingled with Western elements, they characterize the four-way arch of Lepcis in AD 203[65] (*Ill. 138*). By 315 they were to become a major element in some of the contemporary reliefs of the Arch of Constantine. And the transit of the mode was certainly from east to west. Before even the traits can be identified in Parthian Dura they were already becoming manifest far to the east in the Buddhist art of northern India, at Bharhut, Sanchi and elsewhere. They are a part of that 'Asian continuum' which centred upon the environs of the Persian plateau and will be referred to again on other pages.

(b) By way of contrast to the aristocratic assemblage of the Ara Pacis, yet with the same poise and certainty, is the first-century gravestone of the corn-merchant Ampudius with his wife and daughter, now in the British Museum (*Ill. 149*). Indeed, a large picture-gallery could be furnished with the portraits of solid, worthy, prosperous Roman tradesmen, whose patronage must have contributed appreciably to the maintenance of an immense multitude of competent portrait-sculptors throughout the Empire.

(c) A famous example of the almost callously realistic portraiture of the latter part of the first century BC is the head of an ageing

169

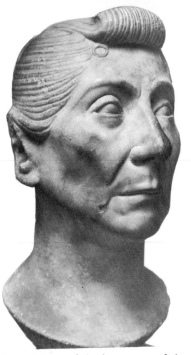

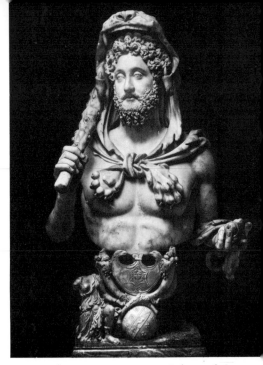

150 Portrait-bust of the latter part of the first century BC. The ageing woman is portrayed in callously realistic style

151 A contemporary portrait-bust of the Emperor Commodus (AD 180–93). He is grotesquely portrayed in the compensating role of Hercules

woman, in the Museo delle Terme at Rome (*Ill. 150*). The uncompromising features are emphasized by the thin hair, which is pulled carefully if stringily to a tight 'bun' at the back of the head.

(d) The bust of Commodus in the Conservatori (about AD 180) is one of the familiar masterpieces of Roman sculpture (*Ill. 151*), enlivened by that conscious touch of the grotesque which has again and again characterized the most vital portraiture, from Augustus to Augustus John. The smooth and effeminate Emperor with his weak arms, his flaccid feeble face in its aureole of drilled and over-barbered hair, reeking of pomade, the property lion-scalp and club and the tiny 'apples of the Hesperides' in that tenuous manicured hand, is delicate but brutally expressive charade. No doubt it delighted, as it revealed, the sadistic pervert whom it has so faithfully immortalized. The sculptor must certainly have felt very sure of his ground, armed by the blind vanity of his subject.

170

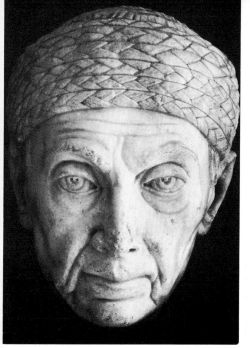

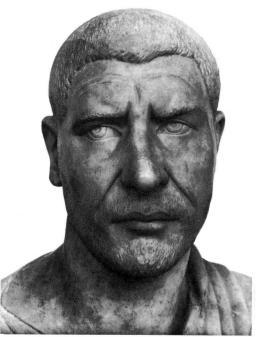

152 The head of an aged woman from Tripolitania is characteristic of the cruder portraiture of the third century AD

153 A revealing contemporary portrait-bust of Philip the Arabian, Emperor of Rome from AD 244 to 249

Incidentally, the skilful if exaggerated use of the drill in the hair and beard is balanced by the increasingly emphatic rendering of the pupils of the eyes which, from now on, frequently indicate the impact of light by means of a solid V-shaped segment.

(e) This device is illustrated by the head of an aged woman (*Ill. 152*), in the Castello Museum at Tripoli (Libya). The head may be ascribed to the third century AD, and is characteristic of the cruder but still expressive work of the period.

(f) If the Roman portraitist was no flatterer, it may sometimes be credited to his subjects that flattery was not exacted. The bust (in the Vatican) of Philip the Arabian (*Ill. 153*), allegedly son of a notorious Arab brigand and Emperor of Rome from AD 244 to 249, mercilessly exhibits the anxious, shifty, opportunist character of the insignificant ruler in whose reign was celebrated the thousandth anniversary of the founding of Rome (21 April 248).

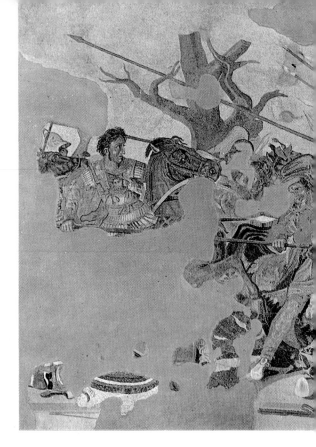

154 Mosaic from the House of the Faun, Pompeii, depicting the Battle of the Issus. It is derived from an original Greek painting of *c.* 330 BC

NARRATIVE

Greek art in celebrating historical events had tended to think in terms of symbolism and analogy. Battles of Athenians against Persians, of Pergamenes against Galatians, had merged in battles of Athenians against Amazons and gods against giants, culminating in the great gigantomachy on the altar of Pergamon, about 180 BC. The Romans, though not averse from the occasional and subordinate use of allegory, were essentially factual, or at least secular, in the depiction of historical events. They were interested above all in the prowess of the supreme Roman, the Emperor, who represented the grandeur that was Rome but was also intensely individual. Rome saw itself in the personal image of the Emperor. Roman narrative sculpture (the equivalent painting has almost entirely vanished) was

thus a particular extension of the trends more widely exhibited in Roman portraiture.

This Roman liking for factual as distinct from symbolical record can, like so much else that we broadly characterize as 'Roman', be traced back to the generation of Alexander the Great. It has long been accepted that the famous mosaic (*Ill. 154*) found in 1831 in the House of the Faun at Pompeii represents the battle of Alexander with Darius III at the Issus in 333 BC, and is derived from a more or less contemporary painting either by Philoxenos or by Aristeides of Thebes, both pupils of the celebrated artist Nicomachos (Pliny, *N.H.*, XXXV. 98–9 and 110). Pliny described Aristeides as 'the first among all painters to paint the soul' and to 'give expression to the

affections of man and to his emotions'. The tumultuous battle-scene is certainly rendered with a vivid sense of drama and a genuine attempt to distinguish the personalities involved. In this mosaic derivative, the skilful use of small tesserae (clumsily patched here and there in ancient times) sensitively renders the pictorial transitions of light and shade within a modest range of dun colours, and the result convincingly reproduces its lost prototype.

An actual fragment apparently from an historical painting of the third century is preserved in the Capitoline Museum;[66] but for the most part we have to fall back upon the literary evidence. Pliny (N.H., XXXV.22) relates that in 264 M'. Valerius Messala exhibited in public a picture of the Sicilian battle in which he had defeated the Carthaginians and Hiero. In 201 the victories of Scipio Africanus in Africa were similarly depicted;[67] and his brother Lucius followed suit after his Asian victory over Antiochus III in 190.[68] Indeed by the second century B C the public uses of historical paintings were so widely accepted that they might on occasion be employed in what amounted to an election campaign; as when Mancinus, who commanded the Roman fleet in the Third Punic War and was the first to break into Carthage, displayed in the forum pictures showing the siege and in person narrated the details of it to the spectators – a piece of publicity (comitas) which, says Pliny (N.H., XXXV.23), won him the consulship at the next election!

Nor was this documentary art confined to painting. A hint of actuality may have been given by some of the sculptors employed at Pergamon in the latter part of the third century B C by Attalus I to celebrate his victories over the Gauls or Galatians. But even if the famous 'Dying Gaul' and other works showing heroic Gaulish types are indeed copies of the Attalid series, as they well may be, they do not constitute true precedents for Roman historic sculpture. For this, one of the earliest antecedents which has survived is the frieze set up at Delphi to commemorate the victory of L. Aemilius Paullus over Perseus of Macedon at Pydna in 168 B C.[69] It distinguishes the national dress and equipment of the participants, and is to that extent factual, but it is still an essentially conventional battle-scene in the Greek heroic tradition.

The artists employed in all this documentary or semi-documentary work were certainly in many cases Greeks or Greek-trained. But it may again be emphasized that this matter of nationality was by that time increasingly unimportant. The overriding factors were two: first that, in the logical course of aesthetic evolution, art was now arriving at a stage when the aspect and prowess of the individual had become its proper concern; and secondly that at the same time the aspect and prowess of the individual were precisely the everyday concern of the Roman patron, absorbed as he was in re-sizing and re-shaping the world about him and himself within it. The one factor was of course a facet of the other. Inevitably the new documentary or narrative art drew upon the Greek experience, which was ancestral to it. But at the same time it was escaping from the Greek conventions alike in spirit and expression; it was veritably Roman in the wide sense in which that name is historically valid.

In sculpture it achieved to full competence, as we have seen, within the latter half of the first century BC. Thereafter it is represented by a long series of reliefs, many of them still on the triumphal arches which became a natural home for them, others in museums, and mostly familiar in a multitude of reproductions. Here I do not propose to retread this worn path save for a moment and in one direction.

In the course of its search for new freedoms, Roman historical art seized upon and perfected a convention familiar to art-history as the 'continuous style'. Again, it was not in any literal sense a Roman innovation; the first certain germ of it in the Mediterranean world takes us back to the fruitful soil of Pergamon in Asia Minor. There, on the colonnade which surrounded the great altar of Zeus (180 BC), a minor frieze related the story of Telephus, legendary founder of the city, by repeating the same character from scene to scene in a single undivided composition; a sort of petrified strip-cartoon. This more nearly approximates to the succession of anecdotes defined by the art-historian Wickhoff as the 'pseudo-continuous' style, in which the hero is repeated in isolated though undivided episodes not closely continuous in time. The convention recurs in Roman reliefs, particularly in mythological stories on sarcophagi of the second and third

175

155 Sarcophagus relief in the 'anecdotal' style, showing successive episodes in the upbringing of a child from infancy to school-age

centuries AD (*Ill. 155*). As distinct from the pure 'continuous' convention, in which a history is unfolded with something like a true continuity in space and time, these juxtaposed episodes may perhaps better be described as 'anecdotal' rather than 'pseudo-continuous'. The distinction, however, is a nice one and need not be further pursued in the present context.[70]

In one form or the other, the 'continuous style' may – or may not – have been encouraged in the West by the use of the *rotulus* or scroll-book for the recording of narrative. But the idea behind it was pretty certainly derived from the East; perhaps from a somewhat hypothetical common centre in Iran, beyond which it occurs in the Buddhist art of India at least as early as the second century BC.[71] Later it was at home in Jewish painting of the third century AD at Dura-Europos on the Euphrates,[72] and found its way into Christian illustration.

Meanwhile it had provided the makings of a convention after the Roman heart. Immensely elaborated and translated to the historic plane, it was capable of reproducing in breathless and truly continuous narrative the mounting sequence of a great Imperial progress. And this purpose in fact, whether we are or are not allergic to the convention, is unquestionably accomplished in its greatest manifestation nearly three centuries after the Telephus frieze.

Trajan's 100-foot Column with its famous carved band which winds spirally for 215 yards up the shaft was erected in the Roman forum in AD 113 to commemorate and illustrate the Emperor's two Dacian campaigns (*Ill. 156*). It marks the moment when the Empire

176

156 Trajan's Column, erected in the Roman forum in AD 113. Reliefs illustrating the Emperor's Dacian campaigns are carved in the continuous style on the spiral band which winds for 215 yards up the column

reached its vastest extent and, within the limits of its conventions, is the masterpiece of Roman historical art. Its conventions were in fact less exacting than today they may appear to be; it must be remembered that anciently the great relief was tricked out with colour (traces are said to have been visible as recently as 1833), and that it could be seen at easier range from the roofs of two adjacent libraries.

Its chronicle begins at the foot with the emergence of the Roman army from a fortified city and the crossing of the Danube in two columns, one of them led by Trajan himself (*Ill. 157*). The busy life of the river is vividly shown, surveyed unostentatiously by Father Danube from a nearby cave. Then the Emperor is seen outside his camp. A few moments later he is holding a council of war. Thereafter, veiled as a Pontifex or High Priest, he is present at the solemn sacrifice which marks the beginning of the campaign. He is on an eminence giving orders and surveying the scene. He harangues his troops whilst fortifications are being built beside the river. He is in the fortress; he leaves it on reconnaissance; a captured spy is brought before him. And so on, through a long succession of mounting episodes in which the details of the campaign down to the most ordinary routine are shown with an authority and liveliness that incidentally have taught us more about the Roman army in the field than any other single document (*Ill. 158*). Action flows unhesitatingly from episode to episode, and the stone-cutting shows a complete sureness and much sensibility. The strange convention of the 'continuous style' works; so too does that other convention whereby the further figures rise head and shoulders above the nearer ones. Indeed, all perspective is at sixes and sevens, but the curious effect of this is to add to the tumultuous vivacity of the scene. We find ourselves committed to the midst of a crowd of men hurrying about their ordered and urgent business, always with the calm, commanding figure of the Emperor close at hand. It is history scribed around the presence of one great man – the apotheosis of the individual.

157 The first four bands of Trajan's Column in Rome. The god of the river Danube surveys the Roman army as Trajan leads it out from a fortified city

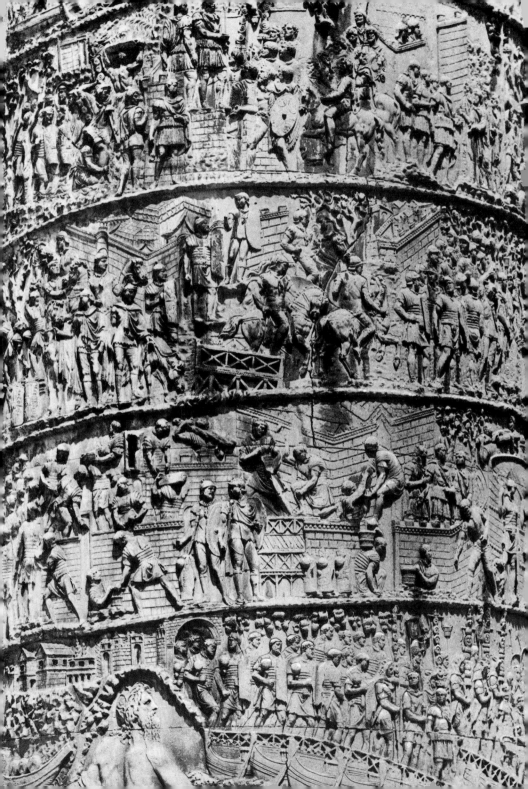

158 (*left*) Detail from near the top of Trajan's Column with scenes of the Dacian wars. Altogether the reliefs contain some 2,500 human figures

159 (*below*) Part of the 'Great Trajanic Frieze' (early second century AD) incorporated in the Arch of Constantine at Rome in AD 312. The features of the mounted Trajan were altered to resemble those of Constantine

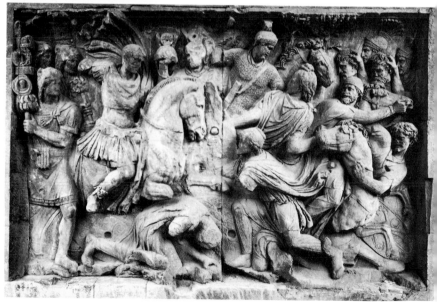

Within the more normal horizontal frame, the same conventions recur in the so-called 'Great Trajanic Frieze' (*Ill. 159*), parts of which are incorporated in the Arch of Constantine at Rome.[73] The frieze may have come originally from the Temple of the Deified Trajan. It also depicts the Dacian wars, but in a somewhat more monumental and constrained manner; it has brilliant passages but suffers from overcrowding and a lack of the easy continuity that marks the Column. Never again, in our knowledge, was the full mastery of that Column repeated, though as late as Arcadius (d. 408) a column of the same kind was erected at Constantinople,[74] and the 'continuous style' itself lingered on as an archaism into the Middle Ages and later. In the cathedral of Hildesheim, Hanover, a bronze pillar made in 1022 (*Ill. 160*) bears a spiral relief illustrating the life of Christ, in conscious imitation of the Trajanic prototype,[75] and the Vendôme Column in Paris (*Ill. 161*) revives the device in the time of Napoleon.

160 Bronze pillar in the cathedral at Hildesheim, made in 1022 in imitation of Trajan's Column at Rome. The spiral relief illustrates the life of Christ

161 The Vendôme Column in Paris, erected by Napoleon in 1806–10 to illustrate the campaigns of the Grand Army. Its reliefs imitate the continuous style of Trajan's Column

The cult of the individual implies an awareness of the individual's spatial setting. The high gods can be envisaged in an airy environment of nothingness; not so the butcher, the baker, the candlestickmaker, nor even – save in some moment of theatrical apotheosis – the Emperor himself. Landscape, in however subordinate a role, is an inevitable counterpart of the portrait and the historical narrative.

Not that the Romans *invented* landscape, any more than they invented portraits. As early as the Old Kingdom the Egyptians had used landscape on a sufficient scale to indicate the lifetime preoccupations of their dead: cutting a field of corn, fishing in the river, shooting wildfowl in the marshes. But here landscape was little more than a sort of pictograph, designed to convey a message rather than an aesthetic impression, and the difference is a substantial one. The fifth-century Greek artist was not interested in landscape. It was not until the fourth to third century BC that landscape began to enter into the consciousness of the poet and the artist in its own right, as an active element in the mental or sentimental reactions of their characters. Note how closely these developments tally in time: the emergence of portraiture and the new status of the individual; the New Comedy and idyllic poetry; and over all the personality-cult of a supreme ruler.

It has been conjectured that Alexandria took a lead in the new appreciation of Nature. This may be so, though the evidence is very incomplete. True, Alexandria was already the cultural centre of the Mediterranean. Hither came Theocritus from the vivid life of his Sicilian hills and pastures to the no less vivid life of the Alexandrian streets. Here in due course all manner of craftsmanship flourished, including the making of great Nilotic mosaics (*Ill. 170*) – landscapes indeed – and, in all probability, the stone wall-panels of which a number survive in museums, showing in shallow, pictorial relief secular scenes or assemblages from the minor mythology in a considerable landscape setting (*Ill. 162*).

And with the advent of the Empire this trend continued apace. The *emblemata* or central panels of mosaic, made by skilled artists in specialized workshops and traded for setting in locally made mosaic

162 Wall-panel from Alexandria, perhaps showing Dionysus visiting Icarus. The landscape behind the figures is indicated in shallow pictorial relief

floors, might illustrate farm-scenes (as in the Roman villa at Zliten on the coast of Tripolitania)[76] (*Ills. 171, 172*) or more rugged landscapes (good examples from Hadrian's villa in the Vatican Museum) (*Ills. 173, 174*). Behind the *emblemata* lie vanished paintings, represented by fragments here and there (e.g. in the Trier Museum, Western Germany, in the Tripoli Museum, north Africa (*Ill. 171*), and, above all, in the Naples Museum, from Pompeii and Stabiae), and by one masterpiece. This is the great Augustan fresco of the so-called Garden of Livia (*Ill. 166*), from the villa of Livia at Prima Porta and now in a room at the Museo delle Terme. It shows a gentle if somewhat sombre woodland beyond a low garden-paling, and its subtle gradation of blues and greens, with birds here and there amongst the leaves, has something of the melancholy graciousness of the age of Corot. Bernard Berenson in his diary wrote of it: 'How dewy,

183

163 (*above*) Painting of a domestic landscape with a group
of huts and figures

164, 165 (*centre and below*) Wall-paintings from Pompeii showing spacious country villas with porticos, such as Pliny described; before AD 79

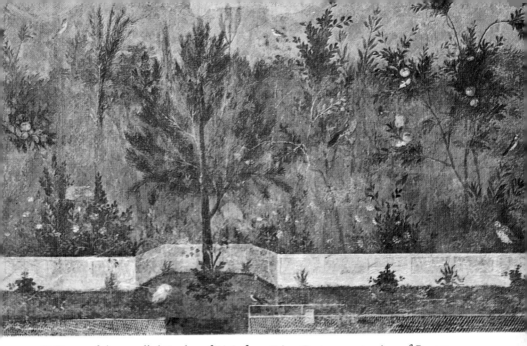

166 Fresco of the so-called Garden of Livia from Prima Porta: a masterpiece of Roman landscape painting

how penetratingly fresh the grass and trees and flowers, how coruscating the fruit. Pomegranates as Renoir painted them. Bird songs charm one's ears. The distance in the "Garden of Livia" room remains magically impenetrable, veiled as it was in the gardens of Lithuania where I lived when I first came to awareness.'[77] Such gentle landscapes were indeed the mode of the time; no doubt with excessive precision, Pliny (*N.H.*, XXXV.16) ascribes to a certain Spurius Tadius, in the time of Augustus, the introduction of 'the pleasant fashion of painting walls with pictures of country-houses and porticos, landscape gardens, groves, hills, fish-ponds, canals, rivers, coasts . . . with sketches of people going for a stroll or sailing, and approaching country-houses on asses or in carriages, and fishing or fowling or hunting or gathering the vintage. . .' (*Ills. 163, 164, 165*).

Here and there indeed, amongst the carved and painted landscapes of the end of the Republic and the earlier Empire, we have something strangely akin to the Romantic Movement of the eighteenth

and early nineteenth centuries. There can of course be no complete identity between one age and another; but the conscious cult of Nature, seen somewhat as an elegant curiosity from the window of a comfortable and sophisticated room, is in harmony with the spirit of both 'Augustan' periods. A very literal example of this mode is provided by a tall, dark, vaulted corridor in the Golden House of Nero on the Esquiline of Rome (*Ill. 168*). Here there was no natural lighting, but imitation windows show romantic landscapes painted upon plaster panels within a series of blind recesses (*Ill. 167*). Park scenery, often with elements of fantasy, had become a normal part of the genteel environment.

Not that all Roman landscape fits of course into this romantic frame. A remarkable relief showing an Italian hill-town (now in the Villa Torlonia)[78] might just do so (*Ill. 169*); on the other hand another relief (*Ill. 175*), from the Ara Pietatis of Tiberius, has as its background the temple of Magna Mater merely as a local feature of a particular scene of sacrifice,[79] just as, on the Trajan Column, landscape is throughout integrated with the figures as a necessary part of the narrative. But the strange failure of classical art to work out the mechanism of perspective, even when as under the early Empire the time was aesthetically ripe for it, no doubt helped a little to impede the further development of landscape as a mode in its own right. This failure is the more remarkable in that as far back as the fifth century B C the mathematical ingenuity of the Greek mind had nearly solved the problem. Vitruvius (VII, Preface, 11, and cf. Plato, *Republic*, X. 602) records how Agatharchus, concerned with the mounting of a tragedy of Aeschylus, had discussed the matter, and how his ideas were developed by the philosophers Democritus and Anaxagoras. The words of Vitruvius are difficult but may be rendered as follows: 'It behoved that a certain spot should be determined as the centre in respect of the line of sight and the convergence of lines (*ad aciem oculorum radiorumque extentionem*), and we should follow these lines in accordance with a natural law, so that the appearance of buildings may be rendered conventionally in stage-scenery and that what is figured on simple plane surfaces may seem to be in some cases receding, in others projecting.'

186

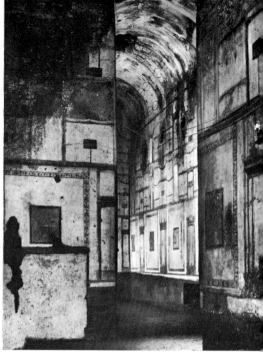

167 (*above*) One of the false windows in the Golden House of Nero, painted with landscape scenery

169 (*below*) Marble relief showing a walled Italian hill-town. Outside the walls stand spacious country-houses

168 A tall, vaulted corridor in the Golden House of Nero, built on the Esquiline at Rome in A D 65

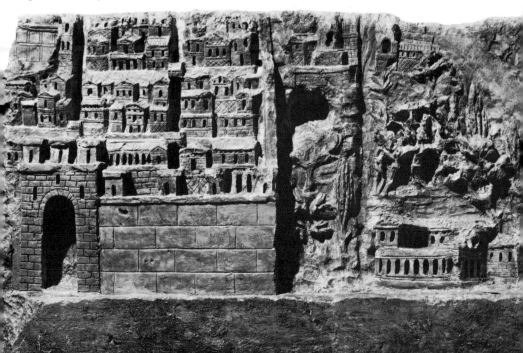

170 (*above*) Nilotic mosaic with hippopotamus, crocodile and ducks. Such mosaics show the influence of Alexandria on Roman art

171 (*left*) Mosaic from the Roman villa at Zliten in Tripolitania showing horses and cattle threshing corn. It dates probably from *c.* AD 200

172 (*right*) Detail of a mosaic from Zliten showing small birds in a nest. Such mosaic panels would be made in skilled workshops and set in locally made floors: *c.* AD 200

173, 174 Mosaics from Hadrian's villa at Tivoli, *c.* AD 130. The lively action of the lion attacking a bull and the more peaceful pastoral scene with goats and a goatherd are both set in convincing, rugged landscapes

175 Relief reconstructed from casts of fragments from the Ara Pietatis of Tiberius; early first century AD. Behind the scene of sacrifice stands the temple of Magna Mater

That, however interpreted in detail, appears to have been a near miss. And in practice very much later it seemed again for a moment that the discovery was about to be achieved. In the famous reliefs of the Arch of Titus in the Roman forum (AD 81) the triumphal procession swinging through the depicted triumphal gate, shown in three-quarter view, is nearly right; and the figures behind the front series are shown effectively in sensitive low relief (*Ill. 176*). But the opposite panel (*Ill. 177*), with the Imperial chariot facing to the front and its horses in awkward echelon, fails utterly to comprehend the spatial problem. The failure was final. In a real sense the chariot of Titus marks a turning-point in classical art. The incongruity recurs emphatically at the beginning of the third century at Lepcis Magna in the chariot of Severus who, like Titus, confronts the viewer from a similarly distorted vehicle (*Ill. 178*); thus incidentally, with the flanking figures, conforming with the principle of frontality which, under Eastern pressures, was already anticipating the universal convention of a subsequent age. And the adjacent figures are projected upwards in serried rows in accordance with a usage that in the West was as old as Trajan and had longer obtained in the East.[80] It

190

176 Relief in the passage of the Arch of Titus in Rome, built in AD 81. Soldiers parade through the arch, bearing spoils from the Jewish wars of AD 70

was now for centuries to remain an unquestioned convention of Western art.

But before we leave the questions of space and depth as they confronted and sometimes confounded the painter or sculptor of the early Empire, there is another and livelier aspect of his problem which commands attention. The modern mind is not over-impressed by the importance of mathematical linear perspective; today the device is liable to savour a little, perhaps, of creeds outworn, of the scholastic accomplishment of a past or passing age. After all, art got on well enough without it before Uccello and has not done too badly without it since Picasso. There is no *prima facie* reason why the Pompeiian painter should have been unduly hampered by the wayward mechanism of his muddled vanishing-points and lines of sight. Nor, in certain circumstances, was he. Within his last century or less, he tackled space from two other and diverse directions: on the one hand he created the fantastic vistas of a fairy world, with rules of its own; and on the other hand he preserved in bold, earthy, impressionist fashion the atmosphere and movement of the world about him. At his best, his vivid Campanian landscapes or

177 Relief from the passage of the Arch of Titus in Rome showing the Emperor's triumph after his conquest of Judaea in AD 71. Here the sculptor has made an incomplete attempt at perspective, and there is a hint of the frontality which is more evident in *Ill. 178*

townscapes, sometimes in an astonishingly modern idiom, are the culmination of the 'Roman' trend of which we have been speaking.

Here again we have to recognize that dual character of which a little was said in the preface of this book. In the immense gallery of paintings, all before AD 79, which have been recovered from the stifled ruins of Pompeii, Herculaneum and Stabiae, two main streams (and several lesser ones) can be discriminated. Broadly, the one stream flows directly from Hellenic and Hellenistic painting as inferred from secondary evidence; it bears all the signs of a repetitive, academic tradition. The second stream springs more nearly from the age and environment to which it belongs. Of course, older and remoter sources contributed to this too; of course it was not the unaided inspiration of little towns on the bay of Naples, or even of Naples itself, or yet of that far-off metropolis, Alexandria, which in our ignorance of Alexandrian things we are always ready to regard as *fons et origo*. But it represents a living, experimental endeavour as

178 Relief from the Arch of Septimius Severus at Lepcis Magna, built *c.* AD 200. The Emperor in his chariot and his attendants confront the viewer, conforming with the Eastern principle of frontality

distinct from the predictable reproduction of vanished master-types, and so is of special interest to the art-historian.

Before leaving, however, the predictable reproductions of scenes from epic and mythology, let us be just to them. Within their academic framework they are not altogether lacking in the vital spark. For example, the well-known painting of 'Achilles revealed by Diomedes and Odysseus in Scyros' (*Ill. 179*), from the House of the Dioscuri at Pompeii and now at Naples, displays an Achilles with a gross and vigorous visage which suggests the portrayal of some ham-actor from the local stage, or perhaps even the patron himself in heroic character; I suspect the head in any case to be a painting or re-painting by a different artist. Diversions of this kind are rare and the conventional puppetry is for the most part unredeemed. But occasionally the heroic or mythical subject is brought to life in the more impressionistic manner of our second category, and at once ceases to be an academic set-piece.

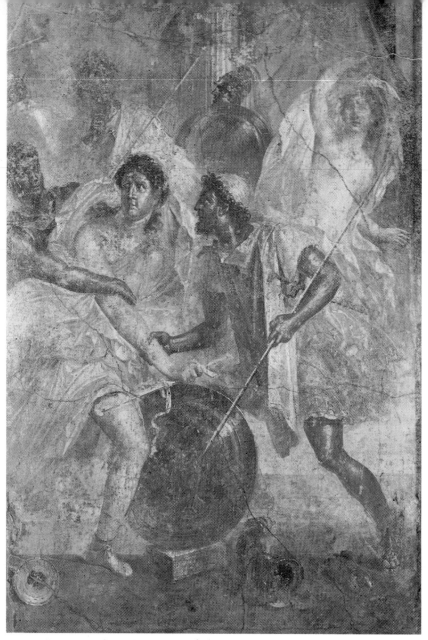

179 Wall-painting from the House of the Dioscuri at Pompeii, depicting 'Achilles revealed by Diomedes and Odysseus in Scyros': before AD 79

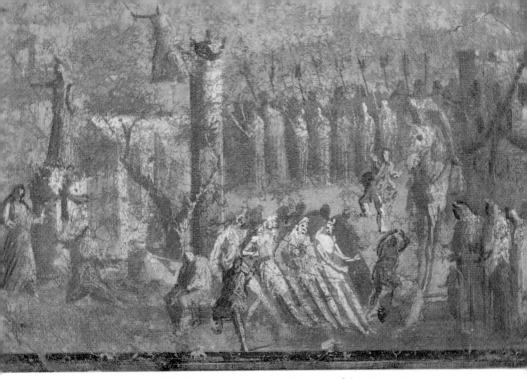

180 Wall-painting from Pompeii (before AD 79) showing the story of the Trojan Horse. The bold use of colour and economy of detail give great force to the composition

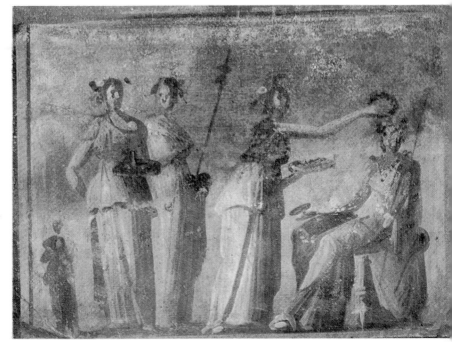

181 Wall-painting from Herculaneum (before AD 79) showing in highly impressionistic style the bringing of offerings to Dionysus

A notable example of this is the painting of the Trojan Horse, from Pompeii and now at Naples (*Ill. 180*). The middle of the picture shows four Trojans pulling the wooden horse towards the town; they are leaning their whole weight rhythmically into the effort and, as the functional centre of the scene, the light is focused upon them. They are boldly splashed in with gleaming colour and with the utmost economy of detail, and are contrasted effectively with the dimmer static figures of the wondering Trojan army in the background. These spectators are nevertheless linked with the protagonists by a single emphatic figure which, running towards the mysterious horse, helps to concentrate attention and to co-ordinate the composition. On the right the forepart of the horse stands with its legs sturdily splayed forwards as though to emphasize the strain, and on the left a lightly sketched Cassandra moves inwards towards the centre from the battlemented walls. The crowded scene is little more than a sketch, but it vividly displays the episode, and the leaning figures in the foreground are strikingly impressive.

Again, a painting from Herculaneum (at Naples) shows three women and a small girl bringing offerings to a seated Dionysus (*Ill. 181*) who, with a graceful indifference, permits one of them to crown him with a laurel wreath whilst the others stand back in unstudied attitudes. The whole group is sketched in with a summary assurance, a sense of light and space, that is almost reminiscent of Augustus John. Pompeii – 'Rome' – as in so much else is here looking, not backward to Hellenic Greece, but forward with easy mastery across and beyond the Middle Ages.

It is however, once more, in the landscapes that this modernity is most evident: not the polite scenery which sometimes fills out academic groups with thin trees and cardboard rocks and architecture suggestive of theatrical properties, but good solid landscapes which stand robustly on their own merits. There is a surprising number of these, if they are sought, and they seem on the whole to belong to the last years before the Vesuvian eruption in AD 79, when restoration and replacement were in active progress after the great earthquake of AD 63. A notable example of this period from Pompeii (at Naples) shows a cluster of houses bathed in strong light with

182 Wall-painting from the villa of Agrippa Postumus near Pompeii (before AD 79). Figures sit and stroll in a romantic landscape with trees and buildings in the background

black shadow, with similarly black-and-white figures sketched vigorously here and there in the foreground, and is a modest masterpiece of impressionism which might hold its place in a modern setting (*Ill. 183*). Another vivid, if artistically less striking, work is a townscape of a port, from Stabiae (at Naples), showing the quays, wharves and shipping, the adjacent warehouses, market-halls and monuments – many of them columns carrying statues – which display the lively interest of artist and patron in the daily scene (*Ill. 185*). More self-conscious, indeed consciously romantic, landscapes (*Ills. 182, 184*) bring first-century Pompeii close to eighteenth-century England: shrines and other buildings in park-scenery, often with a rugged hill on the horizon and, in the foreground, herds and rustics engaged upon their bucolic avocations. Here once more we are reminded of the Romantic Movement of more recent centuries.

183 (*above*) Wall-painting of houses at noon from Pompeii (before A D 79). The strong contrasts of light and shade are a masterpiece of impressionism

184 (*left*) Wall-painting of a pastoral scene in the romantic style, from Pompeii; before A D 79

185 Wall-painting of a harbour from Stabiae (before AD 79). The busy life of the harbour is shown with striking force and with great economy of line

Alongside all this direct or sentimental interest in the countryside, and contemporary with it, is the fantastic baroque of the so-called Fourth Style of Pompeii: a style in which architectural fantasies of an airy, unsubstantial kind and of an unbelievable elaboration were contrived to lighten and enlarge the rooms of the sophisticated town-house. The style was an appreciable time – some two centuries – in the making, and the process no doubt involved contributions from beyond the immediate Italian horizons, though its history is not clear. Amongst surviving examples none is better known than the famous fragment from Herculaneum (at Naples) showing a porch sustained, somewhat inorganically, by gilded columns and carrying pegasi, dolphins, hippocamps and a dramatic mask (*Ill. 190*). Beyond recede interior vistas loaded with ornament, and with a sufficient sense of perspective both in line and in colour to suggest endless distances. Maiuri asks: 'Might this not be a *maquette* of the decor designed for some gala performance at a court theatre by one of those famous Baroque scenic artists of the seventeenth century, Ferdinando, Giuseppe or Carlo Bibiena ? . . . In fact it brings to mind one of those palaces which arose as if by magic on the stage at the first night of some eighteenth-century opera. For this mural, like other fourth-style Pompeiian paintings, drew its inspiration quite literally from the theatres.'[81] Theatrical they certainly were in a modern sense, though whether the Roman theatre of the first century AD went to these lengths in its staging is less certain. It may well be that we are sometimes inclined to underrate the achievement of the classical scene-painter and scene-carpenter. A circumstantial reference to the accomplishment of Agatharchus at Athens in the fifth century BC indicates the use of scenery in some sort of perspective at that early date (above, p. 185); and wall-paintings in the recently excavated buildings of Augustus, beside the house of Livia on the Palatine at Rome,[82] show in advanced examples of the so-called 'Style II' (*Ill. 187*) an evolved stage scene with the conventional three doors in a considerable pictorial setting, such as was then or shortly afterwards beginning to take more substantial shape as an architectural *scaenae frons*. But in the fantastic Herculaneum example one thing at least is indubitable: here all that was Hellenic in the

186 Mosaic of drinking doves from Hadrian's villa at Tivoli (built after AD 124). It is a copy of a Greek original by Sosus, much admired by Pliny

making of the Roman world has been left behind, and the organic world itself forgotten. We are in a fairyland that belongs to 'Rome' as I have defined the term.

These visionary perspectives of the Pompeiian Second and Fourth Styles have momentarily diverted us from the contemporary landscapes and townscapes which are the subject of this section. It may be averred that the Roman delight in the natural vista is properly extended to the architectural vista, and particularly to the architectural interior, in which the Roman mind took a particular and fruitful interest. Something has been said of this elsewhere. Meanwhile as an appendix to this section a note may be added on another, if minor, manifestation of the close and universal concern of the Roman artist in his immediate environment. I refer to his interest in the minutiae of his household.

187 Still-life painting from Herculaneum (before AD 79); kingfisher, vase, trident and sea-fish

188 (*left*) Still-life wall-painting from the House of Julia Felix, Pompeii (before AD 79); thrushes, eggs and domestic utensils

189 (*below left*) Wall-painting from the House of Julia Felix at Pompeii (before AD 79); still life with fruit-bowl and amphora

190 (*opposite*) Fourth Style painting from Herculaneum; shortly before AD 79. The fantastically elaborate architectural decoration is probably derived from the theatre

191 Mosaic floor of an 'unswept room' found on the Aventine in Rome. Perhaps a copy of the original laid at Pergamon by Sosus

Some of the most easily attractive of the paintings and mosaics of the Campanian towns are still-lifes or kindred domestic subjects (*Ills. 187, 188, 189*). The best of them have been compared, without excessive exaggeration, to the Dutch equivalents of a later age. It cannot be claimed that they represent any very notably intellectual exercise; indeed, on the whole they are near to the childlike mind, and are expressions of skill rather than of any higher faculty. No doubt they go well back, with only modest change, into the Hellenistic consciousness, as indeed the literary tradition suggests. But they are also related to more modern thinking, and at their best they are worthy of a passing recognition.

Pliny (*N.H.*, XXXVI.184) tells a familiar story of a mosaic-worker named Sosus who at Pergamon laid the floor of an *asaroton oecon* or 'unswept room' on which, by means of small tinted cubes

he represented the refuse from the dinner-table and other sweepings, as though they had been left there (*Ill. 191*). He also showed a pigeon drinking and casting its shadow on the water, whilst others sunned and preened themselves on the brim of a *cantharus* or wine-vessel (*Ill. 186*). Another artist (*N.H.*, XXXV.112) painted barbers' shops and cobblers' stalls, asses, viands and the like, and so received the Greek name of *rhyparographos*, 'painter of commonplace subjects'. Nevertheless he gave great pleasure, and his pictures fetched higher prices than the largest works of many painters. The continuing demand for little works of this kind is freely indicated at Pompeii, and needs no further comment here. It illustrates the developing and essentially modern recognition by the Roman artist of the world about him as a field of study in its own right, even in its more secular and trivial aspects.

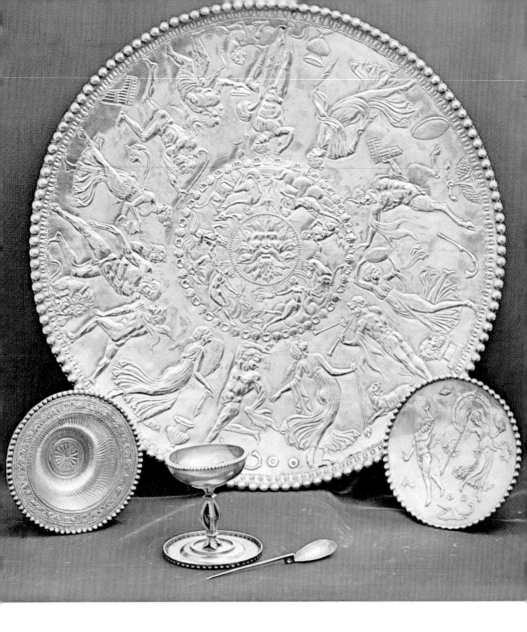

192 Part of the great silver treasure found at Mildenhall. The complete hoard consists of thirty-four objects and dates from the fourth century AD

Other aspects of Roman art

If we turn from the more creative achievements of Roman art, in portraiture, narrative and landscape, there remain certain secondary aspects which cannot be ignored in a general appraisal of the Roman contribution. One of these derives from the Roman urge to collect. As an essentially nouveau-riche society, itself perpetually renewed, the Romans had a passion for acquisition, with the civilized world as an almost unlimited provider. How far did this passion and this facility affect intelligent values?

Then again, to what extent did classical Roman art penetrate on the one hand into the more metropolitan societies abroad and, on the other, into the less cultivated fringes of the Empire, and what was the significance of that penetration?

And in that wider landscape in which Roman trafficking reached far beyond the Imperial frontiers, what was the impact of Roman art upon alien minds?

These questions are relevant to any appreciation, however summary, of Rome's position in the history of art and taste.

THE ROMANS AS COLLECTORS AND CONNOISSEURS

The wholesale plundering of Greek works of art, alike in Republican and Imperial times, is a familiar fact of history. Cicero's reiterated requests to Atticus in Athens for statuary and reliefs to decorate his establishments in Italy (e.g. *Letters* 1, 4, 8 and 10) come readily to mind: 'the more the merrier and as soon as possible. . . . For I'm so carried away by my eagerness in this matter that I almost lay myself open to ridicule, though I know you'll help me.' So too the vogue for the wholesale reproduction or imitation of Greek works by Graeco-Roman copyists and adaptors. The consequent flooding of the Roman environment with Greek and particularly Hellenistic

antiques or replicas did much both to inform and to hamper the Roman expression. It encouraged a wide level of good taste but hindered rather than helped original thinking. It produced indeed in the Roman artistic achievement as a whole that dualism or dichotomy to which reference has been made in the preface.

From time to time, particularly in the earlier days, the conservative element in the Roman character sought – not necessarily for the right reasons – to stem this foreign flood. Cato in 195 BC inveighed strenuously against it. 'The better and the happier becomes the fortune of our commonwealth day by day and the greater our dominion grows – and already we have crossed into Greece and Asia, both filled with the allurements of vice, and we are laying our hands upon the treasures of kings – the more I fear that those things will capture us rather than we them. Like a hostile army were statues brought from Syracuse to this city [by Marcellus in 212 BC]. Already I hear too many people praising and admiring the artistry of Corinth and Athens, and laughing at the traditional terracottas of our Roman temples' (Livy, XXXIV.iv). But Cato and his like fought a losing battle, and the education of Roman taste – which inevitably meant at first its Hellenization – continued apace. Rome had to learn before she could teach; it may be that her education was over-protracted.

To retrace here yet again the general history of Roman taste could be to exceed the limits of this book. But the place of the collector in the Roman scene demands illustration, if only as an antithesis to the more original achievements of which something has been said. For this limited purpose no readier example could be chosen than that of the ornamented silver plate (*Ill. 192*) which became a sort of status-symbol in the later Republic and the Empire, accumulated with an avidity that drew the angry regret of Pliny (*N.H.*, XXXIII.liii, etc.), who almost echoed Cato in preferring, or professing to prefer, the frugality of an earlier Rome. A surprising quantity of this plate has survived.

Once more the second century BC is our starting-point, for it was then that suddenly from the ends of the Mediterranean wealth and artistry poured into Italy. From the conclusion of the Second Punic War (202 BC) the silver-mines of Spain worked for Rome, and for

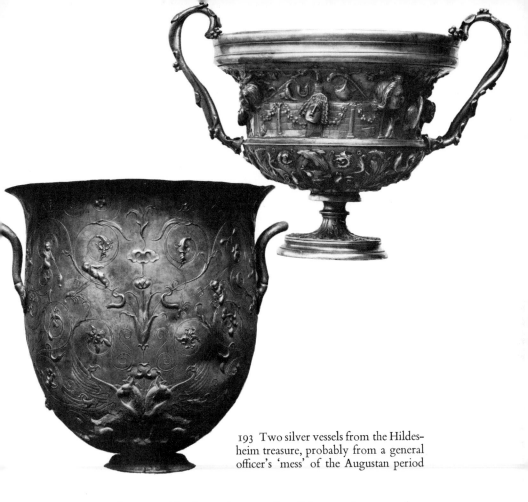

193 Two silver vessels from the Hildesheim treasure, probably from a general officer's 'mess' of the Augustan period

the first time the capital had a major supply of the precious metal at its disposal. Influx from elsewhere displayed its uses. In 189 Lucius Scipio, fresh from his victory over Antiochus of Syria, 'brought luxury to Italy'; the furnishings of his triumph included 1,400 lbs of ornamented silverware and 1,500 lbs of gold vases. In 146 the fall of Corinth delivered to Rome the wealth of Greece, and, by a 'fatal coincidence' (Pliny), the same year saw the destruction of Carthage, and its riches broadcast; the younger Africanus exhibited 4,370 lbs of silver in his triumphal procession. Fourteen years later the royal treasury of Pergamon – of Asia Minor – was auctioned in the capital.

A result of this continuous inpouring, and of the wealth that it symbolized, was that by the first century BC every well-appointed mansion may be assumed to have had its service of silver plate. Cicero could accuse the egregious Verres in his social round of regularly appropriating his hosts' silver, or at least of pulling off and purloining its decoration (*In C. Verrem*, II.14.22). In the following century a mere slave who was steward of Nearer Spain to the Emperor Claudius had a silver dish weighing 500 lbs and eight others of 250 lbs. In the time of Nero the room of Trimalchio's steward, as might be expected, was packed with plate. Nor was all this display restricted to the static household. It has been suspected that the famous hoard of silver vessels from Hildesheim, near Hanover (*Ill. 193*), may represent the luxury equipment of a general officer's 'mess' of the Augustan period. At Kaiseraugst near Basle in Switzerland a fourth-century hoard of silver vessels was found recently hidden in the wall of a Roman fort and has a clearer claim to have been the commander's ceremonial tableware. Pliny refers to a Pompeius Paulinus, son of a mere 'skin-clad Gaul', who took 12,000 lbs weight of silver plate with him on campaign against wild tribesmen. He recounts with shame – *heu mores!* – how the generals of his own day were rewarded with gifts of silver and how away back nearer the beginning of the silver boom, in 101 BC, Gaius Marius celebrated his final victory over the barbarian Cimbri by drinking from Bacchic tankards – he, the ploughman of Arpinum who from a common soldier had risen to the rank of imperator! Certainly by the first century BC the possession of plate had become a social convention.

Silver was the metal that mattered. Artistic work in gold, says Pliny, brought renown to no one, whereas artists in silver were known and numerous. Of the considerable number of precious vessels found in the graves and other deposits of Germania beyond the Imperial frontiers, only one is of gold, though the silver is often gilded or tricked out with gilt. Incidentally, these barbarian graves provide some evidence as to the composition of a minimum table-set (*ministerium* or *synthesis*) of plate. For example, at Hoby on the south coast of the Danish island of Laaland the grave of a wealthy

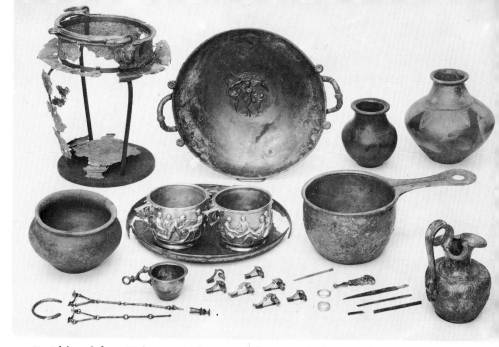

194 Burial hoard from Hoby comprising Roman bronze and silver vessels and other indigenous objects in a native burial; first century BC/AD

middle-aged man in the time of Augustus included two joints of pork and a dinner-service consisting of a pair (the usual number) of decorated Graeco-Roman silver cups on a tinned bronze tray, a plain silver ladle, a bronze *situla* or wine-bucket, a bronze *patera* or sauce-pan, and a pleasantly decorated bronze jug (*Ill. 194*). (Dishes, at least of metal, seem to have been lacking.) The cups were two-handled *scyphi* bearing in skilled relief the visit of Priam to Achilles and a scene from the legend of Philoctetes, based probably on the lost play by Euripides.

The collection may have been obtained as loot or, more probably, as a diplomatic gift of a kind for which there is good historical evidence.[83] Both cups are signed in stippled letters by a maker with the Greek name of Cheirisophos, the one in Greek lettering, the other in Roman though with the Greek spelling. The Philoctetes cup also bears, as these vessels often do, an indication of the total weight of the pair; and finally a graffito on the base of both gives *Silius* as the

name presumably of a former owner. Two comparable *scyphi* (*Ill. 195*) were in the great treasure entombed at Boscoreale, outside Pompeii, by the Vesuvian eruption of AD 79, and similarly bear weights and names. So too did the silver dishes on Trimalchio's sideboard.

Manifestly the sheer bulk of the silver was itself a source of gratification, particularly amongst the more vulgar exhibitionists of the Trimalchio kind. But there was also an element of discriminating taste abroad; Pliny makes it clear that weight of metal was not always the only consideration: good craftsmanship was also of account, to the extent that old plate might be preferred to new even when the decoration was so worn as to be no longer distinguishable (XXXIII.liii and lv). There were knowledgeable connoisseurs who could recognize the 'authority' (*auctoritas*) of a good piece.

Now where was this great wealth of ornamented silverware produced? In general terms the answer is tolerably clear. The craft burgeoned first amongst the Hellenistic kingdoms of the eastern Mediterranean; thence it spread to Campania and ultimately, in the second and third centuries, to Gaul. Glass-making (*Ill. 198*) followed the same route at much the same times. The more local achievement of each of these main regions is matter of dispute inadequately supported by evidence. Pliny speaks of the coastlands of Asia Minor and the neighbouring islands of Rhodes and Mitylene. Antioch no doubt made an appreciable contribution. More certainty attaches to the leadership of Alexandria which, when taken over by Rome in 30 BC, was the cultural focus of the Mediterranean. It was also becoming the principal western entrepôt of an increasing interchange by sea and land with India and the Far East. Under the Roman Principate its influence upon aspects of Asian art was, as we shall see, of profound importance.

In the absence of any extensive exploration of Alexandria itself, our estimate of the Alexandrian contribution to the art or craft of the silversmith is necessarily circumstantial. But it is sufficiently convincing. Inventories of plate which have been preserved on Egyptian papyri[84] are on the whole a tribute to the preservative qualities of the Egyptian climate rather than positive evidence for Alexandrian

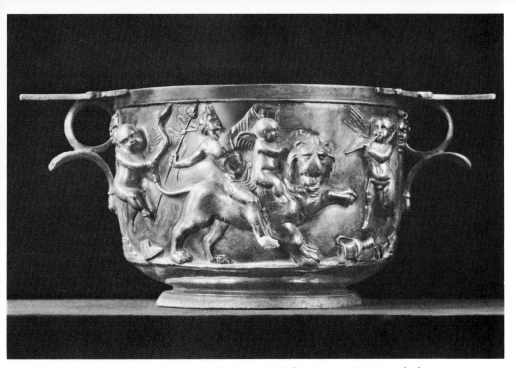

195 Silver *scyphus* from the Boscoreale treasure; before AD 79. It is inscribed, like many such vessels, with its weight and the maker's name

production, though they help to condition our thinking. The considerable quantity of Graeco-Roman silver plate found in Egypt – at Hermopolis, Mendes, Tuk el-Garmus, Karnak, and elsewhere as far afield as Meroe in the Sudan[85] – would be naturally but not inevitably explained by factories at the Egyptian capital. The internal evidence of undocumented silver vessels in some of our museums – notably, those vessels bearing fishing-scenes of a kind familiar on mosaics which assuredly stem from Alexandria – has a more objective value.[86] But the conclusive witness is that of the moulds and models which went to the making of this silverware: matrices of stone and, above all, plaster prototypes such as can be seen in the museum of Alexandria and are widely familiar within what may be called the Alexandrian range, from Tripolitania in the West to Afghanistan in the East! And for good material reasons the primary centre of plasterwork in the ancient world was Alexandria.

The coastline for many miles to the west of the city is a great bank of gypsum or 'plaster' which shines like sunlit snow against the deep ultramarine of the sea. From the foundation of Alexandria onwards this ready and abundant material was used extensively by the Ptolemaic sculptors as a partial substitute for the traditional white marble, which does not occur naturally in Egypt and was a costly import. Amongst other uses, plaster became the staple medium for the manufacture of the careful models from which, usually by casting and with subsequent chasing, much of the silverwork now in question was produced.

An archetype of this large class of stucco models is the Berlin prototype for a beaker (*Ill. 196*), found long ago in the Egyptian Delta.[87] Its central figure is Isis seated against a sphinx, with the child Harpocrates or Horus beside her. Offerings are brought, and torch-bearers stand behind her, whilst the background shows a town or temple and includes a palm tree and (seemingly) an acrobat balancing upon a dromedary. The scene is Egyptian but the figures are classical, and the two elements combine in the Alexandrian mode.

196 Stucco prototype of a beaker from the Nile Delta. The Classical figures and Egyptian scene combine in the Alexandrian mode

197 Stucco mould of Alexandrian workmanship for the *emblema* of a dish. The figure of Aphrodite surrounded by *erotes* is purely classical

198 Examples of Roman glass dating from the first to fourth centuries A D. They are from such widely scattered provenances as Cologne, Cyzicus and Syria

More often the motif is entirely classical, and ascription to Alexandria is thereby rendered more tentative, though occasionally the find-spot helps. Thus the fragment of a plaster model for a silver vessel from Egypt (now in the Louvre) shows the purely classical subject of Cassandra seeking asylum at the Palladium, and is no doubt Alexandrian workmanship. So too, at first or second hand, is a stucco mould for the central design or *emblema* of a dish, representing a purely classical Aphrodite surrounded by *erotes* (*Ill. 197*), found at Sabratha on the African coast and now in the museum there. And no doubt the critics are often enough right in the unproven attribution of some of the plate found at Pompeii and other sites remote from Alexandria to an Alexandrian origin. This brings us to the question of the range of classical art under the Roman régime.

199 Bronze ornaments from Stanwick dating from the mid-first century AD. They represent human faces transformed in the Celtic manner into curvilinear patterns

200 Ornamental bronze from Stanwick—a highly stylized horse's head

ROMAN ART ON THE CELTIC FRINGE

Before turning to the more fructuous East, we may glance at the very different problems which confront the student of the art of the Roman period in the Celtic West: roughly, north of Provence and north and west of the Alps, with the British Isles as an ultimate and obstinate outlier. Broadly, this art might be of three kinds. It might be purely classical work *in partibus*, it might be essentially local work, or it might be an attempted mingling of the two. The last was rarely a fertile cross; the bases of classical and of Celtic art were specifically different and incompatible.

Classical art, as a product of the amiable climate of the Mediterranean, was actively and uninhibitedly concerned with the human body, exposed or lightly clad. The Celtic artist, in the damp and hostile gloom of the northern forests, gave little thought to shivering, encased humanity. His mind turned from unattractive reality to abstract pattern, and his idiosyncrasy was for bold and eccentric curves, pivoted upon emphatic points of design or colour. If, as on rare occasions, a reminiscence of human or animal form found its way into this kaleidoscope, it was twisted at once into conformity with the abstract rhythm. A typical illustration of this process is provided by certain of the bronzes of the mid-first century AD from Stanwick, in north-east Yorkshire, which include a highly stylized horse's head and a moustachioed human face transformed into curvilinear pattern[88] (*Ills. 199, 200*).

216

Under the impact of the Mediterranean tradition, this northern décor eventually, for the most part, gave up the struggle and lapsed into childish inefficacy. Rarely, it accepted the challenge and produced a recognizably Roman head with recognizably Celtic elements. The most notable example is probably the well-known stone head from Roman Gloucester (*Ill. 202*), with its schematized ears and its embossed eyes. Our admiration for this esoteric masterpiece is probably not altogether uninfluenced by certain modern trends.

Nearer to late classical genre but still with a free touch suggestive of enterprising provincial authorship is the small bronze representation of a dog (*Ill. 201*), found long ago beside the temple of the obscure god Nodens at Lydney in Gloucestershire.[89] The abrupt, realistic gesture of the back-turned head, and the bold rendering of the coat, broken decoratively and almost in a Celtic idiom at the main joints, give the little work an unusual distinction amongst the innumerable animal-figurines scattered throughout the Roman world.

201 Small bronze dog from Lydney. Details, such as the rendering of the coat, suggest local or Gaulish workmanship

Generally, indeed, it was in purely decorative metalwork that Celtic art survived here and there as islets amid the Roman flood. An interesting and wayward example is the curvilinear bronze equipment (*Ill. 203*) with marked Celtic affinities, which still occurs in the second and third centuries AD along the Roman frontier in Germany and found its way by troop-movement to distant Dura-Europos on the Euphrates, 2,000 miles away, between *c.* AD 165 and 256[90] – partly, perhaps, in the kit of the IIIrd Gallic Legion, which seems to have had at least a vexillation there under Severus or Caracalla.

202 Limestone head of a man from Gloucester; first century AD. The basically Roman head contains recognizably Celtic elements and the sculpture is evidently a local product

203 Decorative curvilinear metalwork with Celtic affinities, from Dura-Europos on the Euphrates. It dates from *c.* AD 165–256

ROMAN ART IN THE EAST

This takes us into inner Asia and introduces other factors. Dura-Europos, with Palmyra and that strange Arab capital, Hatra, in the midst of Iraq, provide at present the most ample vestiges of the remarkable art which was developed under the Parthians between the end of the first century BC and the middle of the third century AD from an admixture of foreign elements and native genius. Both Iranian and Roman or Graeco-Roman traditions contributed to the mélange, and the result was dominated by a dry decorative mannerism which, at its best, has a certain brittle dignity. In the present context, one of the more interesting features is the occurrence, as early as the first and second centuries AD (Dura and Palmyra), of the rigid 'frontality' (*Ills 147-8*) – the tendency for the figures to ignore one another and to face the spectator with an unblinking stare – to which referance has already been made as an Eastern intrusion into the Western art of the Middle Empire. Later, in and after the fifth century, this Parthian 'frontality' was to pass into the fabric of Byzantine art by ways and means and motives which require further exploration, perhaps with some special reference to Armenia. Towards the Iranian east, when Parthian leadership was replaced by Sassanian in the third century, 'frontality' made little progress; it occurs but is not habitual in the archaizing Sassanian art.[91] Nevertheless it is found again farther east (true, at unknown dates) in the Buddhist 'Gandhara' art of the Afghan–Pakistan borderlands (*Ill. 205*), to which, in view of its discontinuity in Iran, the mode

219

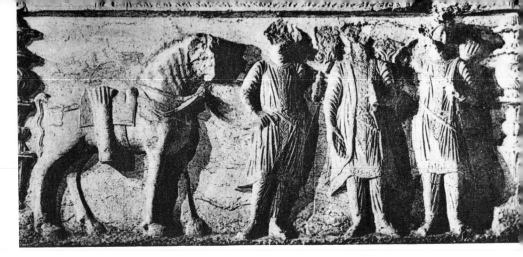

204, 205 Similarities of costume and technique link the Palmyrene relief (*above*) with the 'Buddhist' relief of the second-third century AD from Gandhara on the Pakistan–Afghan border (*far right*)

may have penetrated rather by way of the Persian Gulf than by overland transmission (see below).

First, however, it is necessary to return to the Roman silverware, and to recall an interesting point which emerges in regard to it. Its primary function is admitted to have been display, not use. Indeed some of it was decorated internally in such high relief as to be unusable; for example, the bust on one of the Boscoreale dishes (*Ill. 206*), showing a so-called 'Cleopatra' or 'Africa' wearing an elephant headdress, projects in the round above the sides of the salver of which it is the centrepiece. 'Though our tables are loaded with silver vessels,' declares Vitruvius (VIII.6), 'yet everybody uses earthenware for the sake of purity of taste.' Amongst this earthenware was the celebrated 'Arretine' ware (*Ill. 208*) made in great quantities at Arezzo in Tuscany and elsewhere in Italy in the time of Augustus and Tiberius (about 30 BC to AD 40), with offshoots of similar or later date in Britain, Gaul, Germany and the eastern Mediterranean. This hard, bright, red ware, with or without impressed or applied decoration, might indeed be regarded as a material symbol of the earlier centuries of the Roman Empire. It was based closely upon metal prototypes and, at its best, added grace and

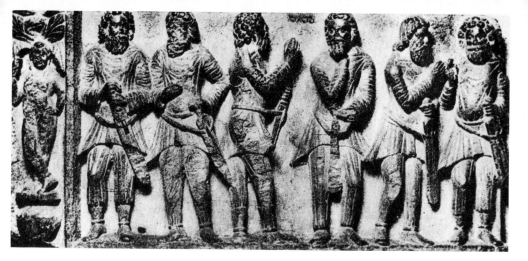

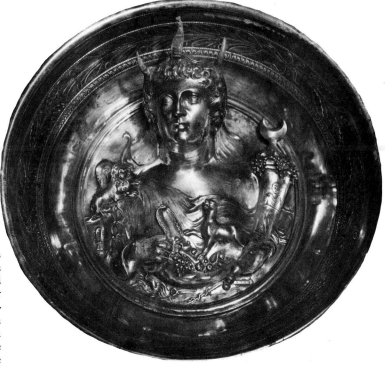

206 Silver dish from Boscoreale with bust of a so-called 'Cleopatra' or 'Africa'. Such decoration in high relief made the dish quite unsuitable for practical use

gaiety to the Roman table from Britain to Hither Asia. It can be picked up in the wild hinterland of South Arabia.[92] I have found it as far afield as the coast of the Bay of Bengal where, at Arikamedu, the ancient Podouke south of Pondicherry, it was exchanged for the gems and spices and calicos which India supplied to the Roman market through Greek, Arab, Indian and Italian intermediaries. In considering the vast expanse of the Roman world, it is a vivid thought that, amidst the woods and fields of Gloucestershire, Hertfordshire or Essex, can be dug up Italic wares identical in kind and origin with those which have been found 6,000 miles away on the Coromandel Coast.

But this widely traced pottery, skilful and attractive though it not infrequently is, had little effect upon the transfusion of ideas in the Eastern regions – whether southern Arabia or southern India – to which it penetrated. It pleased its Arab or Indian recipients and was therefore a useful barter-commodity. Here and there it had a slight reaction upon local crafts but did not significantly reshape them. Very different was the impact of luxury trade-goods far away to the north, on and beyond the north-west frontier of Indo-Pakistan. And the reason is one of some interest.

From the west coast of India, northwards through this north-west frontier region, ran a well-trodden route which linked the West deviously with China: the purpose of the deviation being the avoidance of the hostile Parthian régime of the Persian plateau and its environs. China had at this time a monopoly of silk, and silk was sought greedily by the wealthy societies of Rome and the Empire. But the Chinese were exacting patrons, and demanded in return something more valuable or at least more exciting than the dishes and wine-jars which satisfied the pepper-growers and cotton-manufacturers of the south. In comparison, the China-trade was a luxury-trade. Along the silk-route, caravans bearing an astonishing assortment of goods made their way from local capital to local capital, shedding a proportion of their rich cargoes at the successive customs-barriers. Two of the local capitals are well known; and at both of them the participation of Alexandria in this immense enterprise is clearly to be seen.

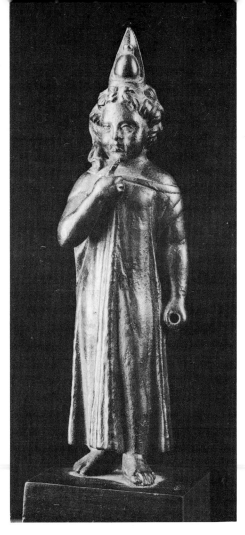

207 Bronze statuette of Horus-Harpocrates, found at Taxila. It almost certainly stems from Alexandria

One of the two is the famous city of Taxila, near Rawalpindi in Pakistan. This was rebuilt in the first centuries BC–AD under the semi-Hellenized or Romanized auspices of an outlying and approachable branch of the Parthian peoples; and amongst a great mass of material excavated here are many Western products: amongst them, glass and gems, an *emblema* in the form of a Bacchic head from the inner base of a silver dish, and a charming little bronze statuette of Horus-Harpocrates (*Ill. 207*), as usual with his finger to his lips –

assuredly an Alexandrian export. But more impressive still is the well-known evidence recovered in 1937 and 1939 from Begram, the former local capital of Kapisa, 50 miles north of Kabul in Afghanistan and 250 miles north-west of Taxila, on the same arterial trade-route. Here two rooms in a public building of some kind had been walled up anciently and were found to contain a great collection of assorted goods derived from India, China and the West, no doubt the accumulated rake-off or customs-dues from passing caravans. This astonishing discovery has now been fully illustrated.[93]

The Western contribution to this amalgam included glassware (*Ill. 209*) of the highest quality (some at least of the first century AD), bronze vessels and statuettes, and a very notable series of circular plaster models for *emblemata* of the sort which we have been discussing (*Ill. 210*). These last were typical of their Graeco-Roman kind: for example, a relief bust of Athena, a scene of grape-harvesting, a male portrait-head recalling the occasional use of portraits as a decoration on silver dishes in the West.[94] And apart from the appropriateness of this plasterwork to an Alexandrian source, two of the bronze statuettes point specifically to Alexandria: another figurine of Horus-Harpocrates in purely classical form, and a variation of Hercules, again purely classical but wearing the *calathus* or basket-headdress which is otherwise associated with the Alexandrian deity Serapis (*Ill. 211*).

In the heart of Asia, then, we are confronted during the first two centuries AD with a vigorous East–West relationship having an Alexandrian bias. This was not of course the first relationship of the kind. Alexander the Great had, in 327 BC, brought the Greek 'ethos', however vaguely and incompletely, into the same part of the world. The sequel is familiar. In the third century BC a Graeco-Bactrian régime ruled to the north of the Hindu Kush, and in the second century BC Indo-Greek kings ruled to the south of it. But, apart from a famous Hellenistic coinage and the partial use of Greek as an official language, together with the ultimate adaptation of the Greek script by the Kushans in the first century AD to their own Asian language, this strange outlier of the Hellenistic world left (so far as we can at present see) no material legacy to the new phase of Buddhist thought

208 Arretine-ware bowl made in Tuscany between 30 BC and AD 40. The original flared base on which it stood is missing

209 Painted glass goblet from Begram, probably originating from Syria in the first century AD

and patronage that swept across the region somewhere about AD 100. At the most it left a congenial soil prepared for new seeds from the West; and those seeds were now represented partly by Roman trade-goods at wayside cities such as Taxila and Begram, and partly no doubt by the introduction of occasional craftsmen from the Romano-Parthian world.[95] The evidence for Western craftsmen in India in the early centuries AD is not limited to the early tradition or legend of the purchase of St Thomas in Jerusalem to serve as master-builder of the palace at Taxila; this story is widely supplemented by substantive references to the employment of 'Yavanas' (Greek-speaking Westerners) by Indian princes in numerous capacities about and after the beginning of the Christian era.[96]

226

210 Plaster model for the *emblema* of a dish, found at Begram but undoubtedly originating from Alexandria

211 Bronze statuette of Hercules-Serapis found at Begram. The form of the figure is purely classical, but the *calathus* attribute of Serapis, points to an Alexandrian origin

212 Relief from Charsada, near Peshawar, depicting the legend of the Trojan Horse or some equivalent Buddhist story. The inspiration is classical but the workmanship Buddhist or 'Gandharan'

But that is, at best, only a part of the story. The so-called Graeco-Buddhist or Romano-Buddhist or Kushana art which emerged and flourished in and beyond ancient Gandhara – the environs of the Afghan-Pakistan frontier – between the second and fifth centuries AD contained also other elements in its composition: primarily Indian (after all, Buddhism was a wholly Indian manifestation), supplemented by loans from the varying affinities of Iranian art, not only Parthian from the west of the Persian massif but also Kushana from, or by way of, the eastern side of it.[97] All these elements, often very disparate, combined to fill the artistic vacuum of the frontier hills and plains with a new *Ersatz* art uninfluenced by any formative local tradition (there being none of any appreciable account) but in great measure integrated by the defining needs and wealthy patronage of the contemporary Buddhism which it almost exclusively served.

In this strangely miscellaneous and variable amalgam of alien skills and traditions – a sort of contrived Esperanto-art probably unique in art-history – we are here concerned only with the Roman or Graeco-Roman contribution, readily identifiable in its assured maturity. At a time when a resurgent Buddhism was hungrily

seeking new modes and materials for a spreading iconolatry, the Roman West, with its wide traditional range of figure-types and scenes, and later by its readily reproductive stucco, was able to supply an appreciable part of the answer. Recent, and very proper, emphasis of the part played by other contributors to the Buddhist art of Asia at this period need not, by reaction, induce any serious depreciation of the Western share. This remains appreciable and remarkable in kind and quantity. The free grouping of figures, often in Westernizing dress and sometimes remarkably reminiscent of second-century Roman sarcophagi, on not a little of the Gandhara carving, is a recurrent and even startling reminder of Graeco-Roman sources and even occasionally, perhaps, of Graeco-Roman workmanship. A scene from the Trojan legend might be used to illustrate a Buddhist tale or *jataka* (*Ill. 212*). Amongst the mass of Oriental plasterwork from Taxila in the Punjab or Hadda in Afghanistan are elements which forcibly refer back to the Roman world: un-Indian fawns, Asian barbarians who might be Gauls, roguish infants who recall a long line of Hellenistic and Roman brats but have little of the East about them (*Ill. 213*). In one way and another, this cross-bred Buddhist art is as extraordinary an instance of the long eastward reach of techniques and aesthetic concepts as, for an example in reverse, was the westward penetration of Chinoiserie sixteen centuries later. In both cases we have a basic trafficking of goods transmuted into a trafficking of ideas.

213 Head of a child from Taxila. The style is more Western than Buddhist and recalls many examples among Hellenistic and Roman sculpture

214 Stucco head of a Bodhisattva from Hadda. The rendering of the effeminate features is thoroughly Oriental

215 Stucco head from Sabratha. Its similarity to the Hadda head may point to an East-West movement of artistic ideas

A question remains upon which too little work has yet been attempted. Was there in Roman times a reverse current from East to West? From the Nearer East Rome drew much of its religious thinking, from the day in 205 BC when Scipio Africanus brought the mysterious Cybele, Mother of the Gods, from Phrygia to Rome and established her upon the Palatine, until the final triumph of the Christian Mystery in AD 313. It has been thought, too, though without close definition, that Western philosophy drew upon the East. But what of the reaction of Eastern art upon the West? Here too I suspect that there is more to say than has yet been said. I conclude with two illustrations, both of works in stucco. One (*Ill. 214*) comes from the Buddhist site of Hadda in Afghanistan. It is an effeminate, thoroughly Oriental Bodhisattva with heavy-lidded eyes, wavy hair, long nose and short rounded chin. The other (*Ill. 215*) is from the Roman city of Sabratha in Tripolitania; it has precisely the same Oriental, un-Western features. Is this a pointer to a return-movement along the Alexandria–India–China traffic-route?

Notes

Short Bibliography

List of Illustrations

Index

Notes

PREFACE

1 Toynbee, Jocelyn M.C., *The Hadrianic School* (Cambridge, 1934), p. xx.

2 Berenson, B., *The Arch of Constantine* (London, 1954).

CHAPTER ONE

3 Ward-Perkins, J.B., 'The Italian Element in Late Roman and Early Medieval Architecture', *Proceedings of the British Academy*, XXXIII (1947), 169.

4 Huxley, Julian, 'The Size of Living Things', in his *Man in the Modern World* (London, 1947).

5 Seyrig, H., in the *Bulletin du Musée de Beirut*, I (1937), 95 ff.

CHAPTER TWO

6 Gomme, A., quoted in *Proceedings of the British Academy*, XLV (1959), 337.

CHAPTER THREE

7 Cook, J.M., and Nicholls, R.V., 'Old Smyrna, 1948–1951', *Annual of the British School at Athens*, nos. 53–4, 1958–9, pp. 1–137.

8 Bradford, J., *Ancient Landscapes* (London, 1957), pp. 277–86.

9 Robinson, D.M., *Excavations at Olynthus*, especially Part XII (Baltimore, 1946).

10 Wiegand, T., and Schrader, H., *Priene, Ergebnisse der Ausgrabung in den Jahren 1895–98* (Berlin, 1904).

11 Boëthius, A., *The Golden House of Nero* (Michigan, 1960), p. 36.

12 For the latest work at Marzabotto, see Mansuelli, Guido A., in *The Illustrated London News*, October 13, 1962, pp. 556–60. For the earlier excavations see

Haverfield, F.J., *Ancient Town-planning* (Oxford, 1913), pp. 61–2, with references; for more recent views see Boëthius, A., *The Golden House of Nero* (Michigan, 1960), p. 47.

13 Meiggs, R., *Roman Ostia* (Oxford, 1960), p. 22.

14 Brown, F.E., *Memoirs of the American Academy at Rome*, XX (1951), and later.

15 Haverfield, F.J., *Ancient Town-planning* (Oxford, 1913), pp. 89–91.

16 Bendinelli, G., *Torino Romana*.

17 Richmond, I.A., 'Augustan Gates at Torino and Spello', *Papers of the British School at Rome*, XII (1932), 52–62.

18 Richmond, I.A., and Holford, W.G., 'Roman Verona: the Archaeology of its Town-plan', *Papers of the British School at Rome*, XIII (1935), 69–76.

19 For a general account of a number of Roman towns in Algeria, see Nash-Williams, V.E., 'Roman Africa', *Bulletin of the Board of Celtic Studies*, XVI (Cardiff, 1956), 135–64.

20 Haynes, D.E.L., *The Antiquities of Tripolitania*, excellent guide-book published by the Antiquities Dept., Tripolitania, Libya, 1959, obtainable from Glen Freebairn, 6 Clement's Inn, London, W.C.2.

21 Ward-Perkins, J.B., and Toynbee, Jocelyn M.C., 'The Hunting Baths at Lepcis Magna', *Archaeologia*, XCIII (Oxford, 1949), 165–95.

22 Starcky, J., *Palmyre* (Paris, 1952), a scholarly guide-book.

23 Von Gerkan, A., 'Die Stadtmauer von Palmyra', *Berytus*, II (Copenhagen, 1935), 25–33; Schlumberger, D., 'Le développement urbain de Palmyre', *ib.*, 149 ff.; Seyrig, H., 'Antiquités syriennes', *Syria*, XXVII (1950), II, 239–42; Van Berchem, D., 'Recherches sur la chronologie des

enceintes', *ib.*, XXXI (1954), 256–62. See also a recent review by Richmond, I.A., 'Palmyra under the aegis of the Romans', *Journal of Roman Studies*, LIII (London, 1963), 43–54.

24 For Roman Paris see Duval, P.M., *Paris antique* (Paris, 1961); de Pachtère, F.G., *Paris à l'époque gallo-romaine* (Paris, 1912).

25 There is no up-to-date and comprehensive account of Roman Trier. But see Brogan, O., *Roman Gaul* (London, 1953), pp. 111 and 242; Eiden, H., 'Untersuchungen an den spätromischen Horrea von St Irminen in Trier', *Trierer Zeitschrift*, 18 (1949), 73 ff.; Gose, E., *Der Tempelbezirk des Lenus Mars in Trier* (Trier, 1955); Reusch, W., *Die Basilika in Trier* (Trier, 1956); and generally, accounts of recent discoveries in *Trierer Zeitschrift*, 24–6 (1956–8), 399 ff.

26 The most recent plan is by Nash-Williams, V.E., in the *Bulletin of Celtic Studies*, XVI (1956), fig. 2, facing p. 138.

27 There is no up-to-date account of Roman London. For some of the most recent excavations, see Grimes, W.F., 'Excavations in the City of London' in *Recent Archaeological Excavations in Britain*, ed. by Bruce-Mitford, R.L.S. (London, 1956); notes in *Journal of Roman Studies*, XL (1950), 107; and Toynbee, J.M.C., 'A silver casket and strainer from the Walbrook Mithraeum in the City of London' (Leiden, E.J. Brill, 1963).

28 Steyert, A., *Nouvelle histoire de Lyon* (Lyon, 1895), I, 234, 245, 315–16; and Wuilleumier, P., *Lyon, métropole des Gaules* (Paris, 1953), pp. 26–7.

CHAPTER FOUR

29 Boëthius, A., *The Golden House of Nero* (Michigan, 1960), pp. 13, 21, 60–2.

30 For the most recent study of the temple, see Balty, J.C., *Études sur la Maison Carrée de Nîmes* (Latomus, Brussels, 1960).

31 For a recent summary account of the Baalbek temples, see Harding, G. Lankester, *Baalbek* (Beirut, 1963). Also Schulz, B., and Winnefeld, H., *Baalbek, Ergebnisse der Ausgrabungen 1898–1905*, 2 vols. (Berlin and Leipzig, 1921); Hoyningen-Huene and Robinson, D.M., *Baalbek, Palmyra* (photographs) (New York, 1946); Coupel, P., 'Travaux de restauration à Baalbek en 1933 and 1934', *Syria*, XVII (Paris, 1936), 321–34. Also, note 5, above.

32 For these temple-stairs, see the useful but inconclusive discussion by Amy, R., 'Temples à escaliers', *Syria*, XXVII (1950), 82–136.

33 Grant, M., *The World of Rome* (London, 1960), p. 290.

34 Reference to the round temple by the Tiber in Strong, D.E., and Ward-Perkins, J.B., 'The Temple of Castor in the Forum Romanum', *Papers of the British School at Rome*, XXX (1962), 4.

35 Beltrami, L., *Il Pantheon* (Milan, 1898); Robertson, D.S., *Greek and Roman Architecture* (Cambridge, 1943), pp. 246–51.

36 Discussed, for example, by Ward-Perkins, J.B. in 'The Italian Element in Late Roman and Early Medieval Architecture', *Proceedings of the British Academy*, XXXIII (London, 1948).

37 Conveniently assembled in Haynes, note 20 above.

38 For the basilica generally, see Ward-Perkins, J.B., 'Constantine and the Origins of the Christian Basilica', *Papers of the British School at Rome*, XXII (1954), 69 ff.

39 Minoprio, A., 'A Restoration of the Basilica of Constantine, Rome', *Papers of the British School at Rome*, XII (1932), 1–25.

40 Kenyon, Kathleen M., 'The Roman Theatre at Verulamium, St Albans', *Archaeologia*, LXXXIV (Oxford, 1935), 213–61.

41 A large literature includes Robertson, D.S., *Greek and Roman Architecture* (Cambridge, 1943), pp. 300ff.; Boëthius, A., *Roman and Greek Town Architecture* (Göteborg, 1948), and *The Golden House of Nero* (Michigan, 1960), *passim*.

42 Appian, *Historia Romana*, doubtless deriving from Polybius, who was an eye-witness.

43 For summary, see Brogan, O., *Roman Gaul* (London, 1953), pp. 123–5.

44 *Ib.*, p. 125.

45 Grenier, A., following Fustel de Coulanges and Jullian, C., in *Manuel d'archéologie gallo-romaine*, II (Paris, 1934), 914ff.; also Eydoux, H.-P., *La France antique* (Paris, 1962), p. 217.

46 Blanchet, A., *Les enceintes romaines de la Gaule* (Paris, 1907), p. 232.

47 Wheeler, R.E.M., 'Roman Buildings and Earthworks on the Cardiff Racecourse', *Transactions of the Cardiff Naturalists' Society*, LV (1925), 19–46; and Wheeler, 'A Roman Fortified House near Cardiff', *Journal of Roman Studies*, XI (1921), 67–85.

48 Summary in Brogan, O., as cited in note 43, pp. 121–2.

49 Lanciani, R., *La Villa Adriana* (Rome, 1906); and Aurigemma, S., *Villa Adriana* (Rome, 1962).

50 Boëthius, A., *The Golden House of Nero* (Michigan, 1960). But the subject demands a fresh study.

51 Adam, R., *Ruins of the Palace of the Emperor Diocletian at Spalato* (1764); Niemann, G., *Der Palast Diokletians in Spalato* (Vienna, 1910); Hébrard, E., and Zeiller, J., *Spalato, le palais de Dioclétien* (Paris, 1912).

52 Boëthius, A., *The Golden House of Nero* (Michigan, 1960), p. 74; Marcel Brion, *Pompeii and Herculaneum: the Glory and the Grief* (London, 1960), pl. 40.

53 Ward-Perkins, J.B., 'Etruscan Engineering', in Renard, M. (ed.), *Hommages à Albert Grenier* (Latomus, Brussels, 1962), pp. 1636–43.

54 Steyert, A., *Nouvelle Histoire de Lyon* (Lyon, 1895), I, 263 and 336b.

55 A viaduct which crossed nearly a mile of lagoon at Alexandria incorporated an aqueduct, but nothing is known of it. Lawrence, A.W., *Greek Architecture* (Penguin Books, 1957), p. 236.

56 Ward-Perkins, J.B., as cited above in note 53, p. 1641.

57 Ward-Perkins, J.B., 'The Art of the Severan Age', *Proceedings of the British Academy*, XXXVII (1951), 271ff.

58 Other examples will be found in the analytical list (down to 1939) of 'Triumphbogen' by Kähler, H., in Pauly-Wissowa, *Real-Encyclopädie*, VIIA, 374–494.

CHAPTER FIVE

59 Eugénie Strong's *Roman Sculpture* (London, 1907 and 1911) is still useful. For some aspects, see the excellent recent sketch by Strong, D.E., *Roman Imperial Sculpture* (London, 1961). Brendel, O.J., 'Prolegomena to a Book on Roman Art', *Memoirs of the American Academy in Rome*, XXI (1953), gives a survey and analysis of ancient and modern criticism. For a new and useful study of the portraiture, see Poulsen, V., *Les portraits romains*. I, République et dynastie julienne (Copenhagen, 1962).

60 Richmond, I.A., *Archaeology, and the After-Life in Pagan and Christian Imagery* (Oxford, 1950), p. 41. 'In the case of inhumation the desire is to leave the body intact with the inference that it will yet again somehow be of service; . . . that its form is of importance and will continue to be the vehicle of the spirit which has departed.' Compare also Toynbee, Jocelyn M.C., *The Hadrianic School* (Cambridge, 1934), p. 162.

61 Armstrong, A.H., in *The Greeks*, H. Lloyd-Jones ed. (London, 1962), p. 132.

62 Toynbee, Jocelyn M. C., in *Proceedings of the British Academy*, XXXIX (1953), 67–95, with earlier references. Also Weinstock, S., in *Journal of Roman Studies*, L (1960), 44–58; and Toynbee, *ib.*, LI (1961), 153–6.

63 See Rostovtzeff, M., *Dura-Europos and its Art* (Oxford, 1938), pl. I, p. 82; etc.

64 See Schlumberger, D., 'Descendants non-méditerranéens de l'art grec', *Syria*, XXXVII (1960), pl. XI, 2, and pl. XII, 1; and Seyrig, H., in *Syria*, XXIV (1944–5), 62, and XXVI (1949), 29–33.

65 Ward-Perkins, J. B., 'The Art of the Severan Age in the Light of Tripolitanian Discoveries', *Proceedings of the British Academy*, XXXVII (1951), 269–304.

66 Illustrated by Strong, D. E., *Roman Imperial Sculpture* (London, 1961), pl. 10.

67 Appian, *De rebus Punicis*, 66.

68 Pliny, *N.H.*, XXXV.23.

69 Reinach, A. J., 'La frise du monument de Paule-Emile à Delphes', *Bulletin de correspondance Hellénique*, XXXIV (Paris, 1910), 433–68; Strong, D. E., *Roman Imperial Sculpture*, pl. 13.

70 For the sarcophagi, see Toynbee, Jocelyn M. C., *The Hadrianic School* (Cambridge, 1934), pp. xiv and 166 ff.

71 Notable examples are Buddhist reliefs from the stupas at Bharhut, second half of second century BC, and at Sanchi, mid-first century BC. See particularly Marshall, Sir John, and Foucher, A., *The Monuments of Sanchi* (Govt. of India, undated, about 1940), I, 119 and 125–7.

72 Rostovtzeff, M., *Dura-Europos and its Art* (Oxford, 1938), pp. 90 and 123 ff.

73 Strong, Eugénie, *Roman Sculpture* (London, 1911), I, 157 ff.; and Strong, D. E., *Roman Imperial Sculpture* (London, 1961), pl. 40.

74 Freshfield, E. H., 'Notes on a Vellum Album containing some Original Sketches of Public Buildings . . . (at) Constantinople in 1574', *Archaeologia*, LXXII (1922), 87–104.

75 Mann, J. G., 'Instances of Antiquarian Feeling in Medieval and Renaissance Art', *Archaeological Journal*, LXXXIX (London, 1933), 259.

76 For a recent study of the date of the Zliten mosaics (?c. AD 200), see de Azevedo, M. Cagiano, 'La Data dei Mosaici di Zliten', *Hommages à Albert Grenier*, ed. Renard, M. (Latomus, Brussels, 1962), I, 374–80.

77 Berenson, B., *The Passionate Sightseer* (London, 1960), 32.

78 Strong, D. E., *Roman Imperial Sculpture* (London, 1961), pl. 50.

79 *Ib.*, pl. 49.

80 The upward projection of background-figures characterized Buddhist reliefs of the second and first centuries BC in India. References in notes 71 and 72 above.

81 Maiuri, A., *Roman Painting* (London, 1953), p. 49.

82 Carettoni, G., 'Due Nuovi Ambienti Dipinti sul Palatino', in *Bollettino d'Arte*, 1961, 189 ff.

CHAPTER SIX

83 Wheeler, M., *Rome beyond the Imperial Frontiers* (London, 1954), pp. 10 and 116.

84 Especially the famous Berlin papyrus 8935 of the first century AD, see Drexel, F., in *Mitteilungen des Deutschen Archaeologischen Instituts*, Roemische Abteilung, XXXVI–XXXVII (1921–2), 34–7; Adriani, A., *Le gobelet en argent*, Société Royale d'Archéologie d'Alexandrie, Cahier no. 1 (1931), p. 36, note 67.

85 Adriani as cited in previous note, p. 37, note 77.

86 See Walters, H. B., *Catalogue of the Silver Plate in the British Museum* (1921), p. xvii.

87 Schreiber, T., *Die Alexandrinische Toreutik* (Leipzig, 1894), 470 ff. And see this basic study generally. Möbius, Hans,

'Alexandria und Rom', *Bayerische Akademie der Wissenschaften, Philosophisch-Historische Klasse Abhandlungen*, Neue Folge, Heft 59 (Munich, 1964).

88 *Proceedings of the Prehistoric Society*, XXVIII (London, 1962), pl. v.

89 Wheeler, R.E.M. and T.V., *Prehistoric, Roman and post-Roman Site in Lydney Park, Gloucestershire* (Oxford, 1932), pp. 40 and 88.

90 *The Excavations at Dura-Europos*, Final Report IV, part IV, Fascicule 1, Frisch, Teresa G., and Toll, N.P., 'The Bronze Objects' (New Haven, 1949). For Legio III Gallica, see M. Rostovtzeff, *Dura-Europos and its Art* (Oxford, 1938), p. 26. For less certain links in the reverse direction – from the Euphrates to the Rhine – see Will, E., in *Syria*, XXXI (Paris, 1954), 278–85.

91 Will, Ernest, 'L'art sassanide et ses prédécesseurs', *Syria*, XXXIX (1962), 45–63; Schlumberger, D., 'Sur l'origine et sur la nature de l'art des Sassanides', *VIIIe Congrès International d'Archéologie Classique, Rapport et Communications* (Paris, 1963).

92 See Comfort, H., in Bowen, R. Le B., and Albright, Frank P., *Archaeological Discoveries in South Arabia* (Baltimore, 1958), pp. 199ff.

93 Hackin, J., *Recherches archéologiques à Begram* (Mémoires de la Délégation Archéologique Française en Afghanistan, IX, Paris, 1939); Hackin, J., *et al.*, *Nouvelles recherches archéologiques à Begram* (Mémoires, etc., Paris, 1954); Wheeler, M., *Rome beyond the Imperial Frontiers* (London, 1954), p. 164.

94 As from Boscoreale, Pompeii: *British Museum Catalogue of the Silver Plate* (1921), no. 26; *Monuments Piot*, V (Paris, 1899), pl. 2 and pp. 44–47.

95 Soper, A.C., 'The Roman Style in Gandhara', *American Journal of Archaeology*, 55 (1951), 305; and Rowland, Benjamin, *The Art and Architecture of India* (Penguin Books, 1953), p. 79.

96 Wheeler, M., *Rome beyond the Imperial Frontiers* (1954), 132ff.

97 For this, see the important contribution by Schlumberger, D., 'Descendants non-méditerranéens de l'art grec', *Syria*, XXXVII (1960), 131–66 and 253–318.

Short Bibliography

AURIGEMMA, S., *Villa Adriana* (Rome, 1962).

BOËTHIUS, AXEL, *The Golden House of Nero: Some Aspects of Roman Architecture* (Michigan, 1960).

GRANT, MICHAEL, *The World of Rome* (London, 1960).

GRIMAL, PIERRE, *La civilisation romaine* (Paris, 1960). English edition, *The Civilization of Rome* (London, 1963).

HINKS, R. P., *Greek and Roman Portrait Sculpture* (London, 1935).

KÄHLER, H., *Rom und Seine Welt* (Baden-Baden, 1963). English edition, *Rome and Her Empire* ('Art of the World' series, London, 1963).

MAIURI, A., *La peinture romaine* (Geneva, Editions Skira, 1953). English edition, *Roman Painting* (Editions Skira, 1953).

ROBERTSON, D. S., *Greek and Roman Architecture* (Cambridge, 1943).

ROSTOVTZEFF, M., *Dura-Europos and its Art* (Oxford, 1938).

STRONG, D. E., *Roman Imperial Sculpture* (London, 1961).

STRONG, EUGÉNIE, *Roman Sculpture* (London, 1907 and 1911). (Partly out of date, but still the most useful general survey.)

TOYNBEE, JOCELYN M. C., *The Hadrianic School* (Cambridge, 1934).

——*Art in Roman Britain* (London, 1962).

List of Illustrations

30 Theatre, Timgad. AD 161–9. Photo: V. E. Nash-Williams.

31 Plan; Lepcis Magna. After D. E. L. Haynes.

32 Market-place, Lepcis Magna. 9–8 BC. Photo: Miss G. Farnell.

33 Market-place, Lepcis Magna; standard measures of length. 9–8 BC. Photo: Miss G. Farnell.

34 Market-place, Lepcis Magna; standard measures of volume. 9–8 BC. Photo: Miss G. Farnell.

35 Theatre, Lepcis Magna. AD 1–2. Photo: Miss G. Farnell.

36 Basilica, Lepcis Magna. Completed AD 216. Photo: J. B. Ward-Perkins.

37 Model; the harbour, Lepcis Magna. Rebuilt early third century AD. Photo: Editions Arthaud.

38 'Hunting Baths', Lepcis Magna. Early third century AD. Photo: Miss G. Farnell.

39 Wall-painting; hunters and wild animals. Main hall of the 'Hunting Baths', Lepcis Magna, early third century AD. Photo: Miss G. Farnell.

40 Forum, Lepcis Magna. c. AD 200. Photo: Miss G. Farnell.

41 Plan; Palmyra. Drawn by Gerard Bakker.

42 Oval colonnaded market-place, Jerash. Second or third century AD. Photo: Mikaël Audrain.

43 Triumphal arch, Palmyra. Probably second century AD. Photo: Miss N. J. H. Lord.

44 Corinthian colonnade, Palmyra. Late second century AD. Photo: Miss G. Farnell.

45 Temple of Bel, Palmyra. AD 32. Photo: Prof. Sir Ian Richmond.

46 Aerial view of Paris; Roman streets and buildings superimposed. Photo: Compagnie aérienne française.

47 Cluny Baths, Paris; the *frigidarium*. Probably late second century AD. Photo: Eileen Tweedy.

48 Plan; the amphitheatre, Paris. Early first century AD. After P.-M. Duval and F.-G. de Pachtère.

49 Aerial view of Trier. Photo: Rheinisches Landesmuseum, Trier.

50 Plan; Roman Trier. Drawn by Jon Wilsher.

51 Constantinian Baths, Trier. c. AD 300. Photo: Rheinisches Landesmuseum, Trier.

52 Porta Nigra, Trier. Early fourth century AD. Photo: Rheinisches Landesmuseum, Trier.

53 *Aula Palatina*, Trier. c. AD 300. Photo: Rheinisches Landesmuseum, Trier.

54 Plan; Roman Caerwent. Planned probably first century AD. After V. E. Nash-Williams, *Bulletin of the Board of Celtic Studies*, XVI (1956).

55 Temple-quarter, Caerwent. Reconstruction painting: Alan Sorrell, by permission of the National Museum of Wales.

56 'Romano–Celtic' temple, Caerwent; excavated foundations. Photo: by permission of the National Museum of Wales.

57 Forum, Caerwent. Reconstruction painting: Alan Sorrell, by permission of the National Museum of Wales.

58 Defensive wall, Caerwent; hollow polygonal tower. After AD 330. Photo: by permission of the National Museum of Wales.

59 Southern defensive wall, Caerwent. Late second century AD. Photo: by permission of the National Museum of Wales.

60 Plan; Roman London. Drawn by Ian Mackenzie Kerr.

61 Plan; the basilica, London. Probably soon after AD 60. Drawn by Martin Weaver.

62 Mithraeum, London; exterior. *c.* AD 180. Reconstruction drawing: Alan Sorrell. Copyright — *The Illustrated London News* ©.

63 Mithraeum, London; interior. *c.* AD 180. Reconstruction drawing: Alan Sorrell. Copyright — *The Illustrated London News* ©.

64 Silver plate; pyxis and strainer with hunting scenes. London Mithraeum, late third or fourth century AD. (Ht. 2½ in.; 6·3 cm.) Guildhall Museum, London. Photo: by courtesy of Guildhall Museum.

65 Temple of Rome and Augustus, Lepcis Magna: lateral stairs. AD 14–19. Photo: The British School at Rome.

66 Capitolium, Thuburbo Majus; dedicated to Jupiter, Juno and Minerva. AD 168. Photo: Sir Mortimer Wheeler.

67 Temple of Jupiter Capitolinus, Rome; part of the temple wall. 509 BC. Sala del Muro Romano, Museo Nuovo Capitolino, Rome. Photo: Fototeca Unione.

68 Maison Carrée, Nîmes. *c.* 16 BC. Photo: Giraudon.

69 Plan; Temple of 'Bacchus', Baalbek. *c.* AD 150–200. Drawn by Martin Weaver.

70 Temple of 'Bacchus', Baalbek; portico ceiling. *c.* AD 150–200. Photo: Miss G. Farnell.

71 Temple of 'Bacchus', Baalbek; exterior. *c.* AD 150–200. Photo: Miss G. Farnell.

72 Temple of 'Bacchus', Baalbek; interior of the *cella.* *c.* AD 150–200. Photo: Miss G. Farnell.

73 Temple of 'Bacchus', Baalbek; carved doorway. *c.* AD 150–200. Photo: Thames and Hudson Archive.

74 Drawing; Temple of 'Venus', Baalbek. Second or early third century AD. Reconstruction drawing: Peter Pratt.

75 Temple of 'Venus', Baalbek; exterior. Second or early third century AD. Photo: Hoyningen-Huene.

76 Temple of 'Bacchus', Baalbek; interior. *c.* AD 150–200. Reconstruction painting: William Suddaby.

77 Temple of 'Vesta', Tivoli; column-capitals and frieze. Early first century BC. Photo: Josephine Powell.

78 S. Maria del Sole, Rome. First century BC. Photo: Atterocca, Terni.

79 Temple of 'Vesta', Tivoli. Early first century BC. Photo: Josephine Powell.

80 Bank of England, London; 'Tivoli Corner'. 1788–1833. Photo: National Buildings Record.

81 Painting; interior of the Pantheon by G. P. Pannini (*c.* 1750). Built *c.* AD 126. National Gallery of Art, Washington, D.C. Samuel H. Kress Collection.

82 Aerial view of the Pantheon, Rome. *c.* AD 126. Photo: No. 8289 authorized to be reproduced by Stato Maggiore Aeronautica Militare Italiana, 3rd July 1963.

83 Pantheon, Rome; exterior of rotunda and portico. *c.* AD 126. Photo: M. B. Cookson.

84 Stabian Baths, Pompeii; arches with stucco decoration. Second century BC. Photo: Edwin Smith.

85 Plan; Stabian Baths, Pompeii. Second century BC. Drawn by Martin Weaver.

86 Plan; Hadrian's Baths, Lepcis Magna. AD 126–7. After D. E. L. Haynes.

87 Hadrian's Baths, Lepcis Magna; latrine. AD 126–7. Photo: Miss G. Farnell.

88 Hadrian's Baths, Lepcis Magna; *frigidarium.* AD 126–7. Reconstruction by Cecil C. Briggs. Photo: American Academy in Rome.

89 Diorama of the Athenian Agora. Second century BC. Royal Ontario Museum, Canada. Museum photograph.·

90 Plan; basilica, Cosa. Mid second century BC. Drawn by Martin Weaver.

91 Plan; basilica, Pompeii. Before 78 BC. Drawn by Martin Weaver.

92 Basilica Nova, Rome. c. AD 313. Photo: Edwin Smith.

93 Basilica Nova, Rome; interior. c. AD 313. Reconstruction painting: William Suddaby.

94 Theatre, Aspendos; *scaenae frons*. Second century AD. Photo: Miss G. Farnell.

95 Theatre, Sabratha. Late second century AD. Photo: Miss G. Farnell.

96 Wall-painting; riots in the amphitheatre at Pompeii. Pompeii, AD 59. Museo Nazionale, Naples. Photo: Alfredo Foglia.

97 Amphitheatre, Pompeii; exterior. c. 80 BC. Photo: Peter Clayton.

98 Amphitheatre, Pompeii; interior. c. 80 BC. Photo: Peter Clayton.

99 Theatre, Orange; *scaenae frons*. Time of Augustus (27 BC–AD 14). Photo: Miss N. J. H. Lord.

100 Amphitheatre, Nîmes; exterior. Probably soon after 30 BC. Photo: Giraudon.

101 Amphitheatre, Lepcis Magna. Photo: Miss G. Farnell.

102 Colosseum, Rome; exterior. Late first century AD. Photo: Edwin Smith.

103 Colosseum, Rome; interior. Late first century AD. Photo: Colin Sorensen.

104 Circus, Perge; supporting arches. Probably second century AD. Photo: Miss G. Farnell.

105 Model of Rome; area around the Circus Maximus. Fourth century AD. Museo della Civiltà Romana. Photo: Oscar Savio.

106 House of the Vettii, Pompeii; restored garden and peristyle. Before AD 79. Photo: Peter Clayton.

107 'House of the Trident', Delos. c. 100 BC. Photo: Sir Mortimer Wheeler.

108 'House of the Wooden Partition', Herculaneum; *atrium*. Before AD 79. Photo: Colin Sorensen.

109 House of the Vettii, Pompeii; opening in roof of the *atrium*. Before AD 79. Photo: Edwin Smith.

110 Model; tenement-block, Ostia. Second century AD. Photo: Mansell–Alinari.

111 House of Diana, Ostia; exterior. Second century AD. Photo: Fototeca Unione.

112 House of Diana, Ostia; stairs from the street. Second century AD. Photo: Fototeca Unione.

113 Roman house on Delos, originally five storeys high. c. 100 BC. Photo: Sir Mortimer Wheeler.

114 'House of the Painted Vault', Ostia; detail of the ceiling. Second century AD. Photo: Fototeca Unione.

115 Plan; House of Amor and Psyche, Ostia. Probably fourth century AD. Drawn by Martin Weaver.

116 House of Fortuna Annonaria, Ostia. Private lavatory. Second century AD. Photo: Fototeca Unione.

117 House of Amor and Psyche, Ostia; view into the nymphaeum. Probably fourth century AD. Photo: M. B. Cookson.

118 Wall-painting; country house with porticos. Pompeii, before AD 79. Museo Nazionale, Naples. Photo: Georgina Masson.

119 Mosaic; detail of 'bikini girl' in 'Room of the Ten Girls'. Imperial villa, Piazza Armerina, late third century AD. Photo: André Held.

120 Plan; part of Hadrian's villa, Tivoli. *c.* AD 125–38. Drawn by Martin Weaver.

121 Hadrian's villa, Tivoli; swimming-pool in the 'Poikile'. *c.* AD 125–38. Photo: Georgina Masson.

122 Hadrian's villa, Tivoli; Round temple, *c.* AD 125–38. Photo: Georgina Masson.

123 Hadrian's villa, Tivoli; 'Canopus' Canal. *c.* AD 125–38. Photo: Edwin Smith.

124 Model; Hadrian's villa, Tivoli. *c.* AD 125–38. Photo: by kind permission of Dr E. Richter.

125 Drawing; Golden House of Nero. AD 64–8. Photo: by kind permission of Signor V. Messina and the Photographic Archives of the American Academy in Rome.

126 Wall-painting; villa and porticos. House of Lucretius Fronto. Pompeii, before AD 79. Photo: Alfredo Foglia.

127 Palace of Diocletian, Split. *c.* AD 300. Reconstruction painting: Ernest Hébrard.

128 Wall-painting; arch springing from column-capitals. Villa of the Mysteries, Pompeii, first century BC. Photo: Alfredo Foglia.

129 Palace of Diocletian, Split; arches springing from column-capitals. *c.* AD 300. Photo: Tanjug.

130 Suburban Baths, Herculaneum; arches springing from capitals. Before AD 79. Photo: Edwin Smith.

131 Mouth of the Cloaca Maxima, Rome, as it was in 1877, before the present embankment was built. Probably Etruscan, partially rebuilt between 27 BC and AD 14. Photo: Fototeca Unione.

132 Pont du Gard, Nîmes. *c.* AD 14. Photo: from Cali, F., *The Wonders of France*, London, 1961.

133 Aqueduct between Zaghouan and Carthage. Photo: Sir Mortimer Wheeler.

134 Aqueduct in Segovia. *c.* AD 10. Photo: from *The Wonders of Spain* (*op. cit.*).

135 Milvian bridge, Rome. 109 BC. Photo: Fototeca Unione.

136 Roman bridge, Alcantara. AD 106. Photo: Mas.

137 Triumphal arch, Timgad. Second century AD. Photo: Thames and Hudson Archive.

138 Arch of Septimius Severus, Lepcis Magna. *c.* AD 200. Reconstruction by courtesy of S. D. T. Spittle.

139 Arch of Titus, Rome, *c.* AD 81–2. Photo: Georgina Masson.

140 Arch of Constantine, Rome. AD 312–15. Photo: Mansell–Alinari.

141 Marble herm of Pericles; Roman copy of original of mid-fifth century BC by Cresilas. Found at Tivoli. (Ht. 23 in.; 58·5 cm.) British Museum, London. Photo: Trustees of the British Museum.

142 Marble statue; Roman patrician carrying death-masks of his ancestors. Rome, first century BC/AD. Museo Barberini, Rome. Photo: German Archaeological Institute, Rome.

143 Marble altar; Ara Pacis Augustae. Campus Martius, Rome, 13–9 BC. Photo: Mansell–Alinari.

144 Ara Pacis Augustae; detail from frieze of senators and officials. Rome, 13–9 BC. Photo: Mansell–Alinari.

145 Ara Pacis Augustae; detail, small child. Rome, 13–9 BC. Photo: Mansell–Anderson.

146 Ara Pacis Augustae; detail, woman with finger to lips. Rome, 13–9 BC. Photo: Mansell–Anderson.

147 Stone relief; offering of incense. Palmyra, AD 191. Photo: Institut français d'archéologie, Beirut. From *Syria*, 1960, pl. XII.

148 Stone relief; the gods Aglibol, Baal-shamin and Malakbel. Palmyra, first half of first century AD. (22×27 in.; 56×69 cm.) Musée du Louvre, Paris. Photo: Archives Photographiques.

149 Marble relief; Ampudius with his wife and daughter. First century AD. (24×64 in.; 61×163 cm.) British Museum, London. Photo: Trustees of the British Museum.

150 Marble bust; ageing woman. Late first century BC. Museo delle Terme, Rome. Photo: M. B. Cookson.

151 Marble bust; Commodus as Hercules. Rome, AD 180–93. Palazzo dei Conservatori, Rome. Photo: German Archaeological Institute, Rome.

152 Marble head; old woman. Tripolitania, third century AD. Castello Museum, Tripoli. Photo: Antiquities Department, Tripolitania.

153 Marble bust; Philip the Arabian. Porcigliano, AD 244–9. Musei e Gallerie Pontificie, Vatican. Museum photograph.

154 Mosaic; Battle of the Issus. House of the Faun, Pompeii, before AD 79. From original Greek painting of c. 330 BC. (106¾×201½ in.; 271×512 cm.) Museo Nazionale, Naples. Photo: Alfredo Foglia.

155 Marble relief; sarcophagus with successive episodes in a child's life. Trier, second or third century AD. Musée du Louvre, Paris. Photo: Giraudon.

156 Trajan's Column; general view. Rome, AD 113. Photo: Georgina Masson.

157 Trajan's Column; first four bands. Rome, AD 113. Photo: Fototeca Unione.

158 Trajan's Column; detail of battle scenes. Rome, AD 113. Photo: Mansell–Alinari.

159 'Great Trajanic Frieze'; detail incorporated in the Arch of Constantine. Rome, early second century AD. Photo: German Archaeological Institute, Rome.

160 Bronze pillar; scenes from the life of Christ. Hildesheim, 1022. Photo: Cathedral, Hildesheim.

161 Vendôme Column, Paris; reliefs depicting the campaigns of the Grand Army. Erected 1806–10, destroyed 1871, replaced 1875. Photo: Giraudon.

162 Marble relief; Dionysus visiting the house of a mortal. Alexandria, probably Graeco–Roman copy of original of third century BC. (31×59½ in.; 91·5×151 cm.) British Museum, London. Photo: Trustees of the British Museum.

163 Wall-painting; domestic landscape from Tripolitania with huts and figures. Castello Museum, Tripoli. Photo: Roger Wood.

164 Wall-painting; villa with porticos beside a lake. Pompeii, before AD 79. Museo Nazionale, Naples. Photo: André Held.

165 Wall-painting; country villa with porticos. Pompeii, before AD 79. Museo Nazionale, Naples. Photo: André Held.

166 Wall-painting; 'Garden of Livia'. Prima Porta, near Rome, late first century BC. (Ht. of wall, 118 in.; 300 cm.) Museo delle Terme, Rome. Photo: Georgina Masson.

167 Wall-painting; false window in the Golden House of Nero. Rome, AD 65. Photo: Thames and Hudson Archive.

168 Corridor in the Golden House of Nero. Rome, AD 65. Photo: Thames and Hudson Archive.

169 Marble relief; walled Italian hill-town. Found in Lake Fucino. First century AD. Villa Torlonia, Avezzano. Photo: Mansell–Alinari.

170 Mosaic; 'Nilotic' scene with hippopotamus, crocodile and ducks. Pompeii, before AD 79. Museo Nazionale, Naples. Photo: Scala.

171 Mosaic; threshing scene. Zliten, Tripolitania, probably c. AD 200. Castello Museum, Tripoli. Photo: Roger Wood.

172 Mosaic; detail of birds in a nest. Zliten, Tripolitania, probably *c.* AD 200. Castello Museum, Tripoli. Photo: Roger Wood.

173 Mosaic; lion attacking a bull. Hadrian's villa, Tivoli, *c.* AD 130. Musei e Gallerie Pontificie, Vatican. Museum photograph.

174 Mosaic; goats and goatherd. Hadrian's villa, Tivoli, *c.* AD 130. Musei e Gallerie Pontificie, Vatican. Museum photograph.

175 Relief; scene of sacrifice beside the temple of Magna Mater, reconstructed from casts of fragments of the Ara Pietatis of Tiberius. Rome, early first century AD. Museo della Civiltà Romana. Photo: Fototeca Unione.

176 Stone relief; soldiers bearing spoils from the Jewish wars. Passage of Arch of Titus, Rome, *c.* AD 81–2. (Ht. 79½ in.; 202 cm.) Photo: Mansell–Alinari.

177 Stone relief; Titus in triumphal chariot. Passage of Arch of Titus, Rome, *c.* AD 81–2. (Ht. 79½ in.; 202 cm.) Photo: Mansell–Alinari.

178 Stone relief; Septimius Severus in triumphal chariot. Attic of Arch of Septimius Severus, Lepcis Magna, *c.* AD 200. (Ht. 67 in.; 170 cm.) Photo: Antiquities Department, Tripolitania.

179 Wall-painting; Achilles revealed by Diomedes and Odysseus on Scyros. House of the Dioscuri, Pompeii, before AD 79. Museo Nazionale, Naples. Photo: Alfredo Foglia.

180 Wall-painting; the Trojan Horse. Pompeii, before AD 79. Museo Nazionale, Naples. Photo: Scala.

181 Wall-painting; Sacrifice to Dionysus. Herculaneum, before AD 79. Museo Nazionale, Naples. Photo: André Held.

182 Wall-painting; Romantic Landscape. Villa of Agrippa Postumus, near Pompeii, before AD 79. (61¼ × 39¼ in.; 156 × 100 cm.) Museo Nazionale, Naples. Photo: André Held.

183 Wall-painting; Houses at Noon. Pompeii, before AD 79. Museo Nazionale, Naples. Photo: Alfredo Foglia.

184 Wall-painting; romantic landscape with pastoral scene. Pompeii, before AD 79. (20¼ × 19½ in., 51·5 × 49·5 cm.) Museo Nazionale, Naples. Photo: André Held.

185 Wall-painting; harbour scene. Stabiae, before AD 79. (9½ × 10½ in.; 24 × 27 cm.) Museo Nazionale, Naples. Photo: André Held.

186 Mosaic; drinking doves. Hadrian's villa, Tivoli, AD 124. (33½ × 38½ in.; 85 × 98 cm.). Museo Capitolino, Rome. Photo: Eileen Tweedy.

187 Wall-painting; still-life with kingfisher, vase, trident and sea-fish. Herculaneum, before AD 79. (16½ × 18¾ in.; 42 × 48 cm.) Museo Nazionale, Naples. Photo: Alfredo Foglia.

188 Wall-painting; still-life with thrushes, eggs and domestic utensils. House of Julia Felix, Pompeii, before AD 79. Museo Nazionale, Naples. Photo: Eileen Tweedy.

189 Wall-painting; still-life with fruit-bowl and amphora. House of Julia Felix, Pompeii, before AD 79. (35½ × 48 in.; 89·5 × 122 cm.) Museo Nazionale, Naples. Photo: Alfredo Foglia.

190 Wall-painting; Fourth-Style scenographic decoration. Herculaneum, shortly before AD 79. Museo Nazionale, Naples. Photo: Scala.

191 Floor-mosaic; an 'unswept room' (*asaroton oecon*). Aventine, Rome, derived from Hellenistic original. Museo Profano Lateranense, Vatican. Photo: Mansell–Anderson.

192 Silver plate; the Great Dish, flanged bowl, platter, goblet and spoon. Mildenhall, fourth century AD. (Diam. of Great Dish 24 in.; 61 cm.) British Museum, London. Photo: Trustees of the British Museum.

193 Silver plate; two drinking vessels. Hildesheim, time of Augustus (27 BC–AD 14). Photo: Staatliche Museen, Berlin.

194 Burial hoard; Roman and native objects of silver and bronze. Hoby, first century BC/AD. (Ht. of silver cups, *c*. 3¾ in.; 9·5 cm.) Danish National Museum, Copenhagen. Museum photograph.

195 Silver plate; *scyphus* from the Boscoreale treasure. Before AD 79. Musée du Louvre, Paris. Photo: Mansell–Alinari.

196 Prototype of beaker; Isis with Harpocrates or Horus. Nile Delta. Staatliche Museen, Berlin: Museum photograph.

197 Mould for *emblema* of a dish; Aphrodite and *erotes*. Sabratha, Site Museum. Photo: Sir Mortimer Wheeler.

198 Examples of Roman glass. Cologne, Cyzicus and Syria, first to fourth centuries AD. (Ht. of tallest, 8½ in.; 21·6 cm.) British Museum, London. Photo: John Webb.

199 Bronze ornaments; human faces transformed into curvilinear patterns. Stanwick, mid-first century AD. (*c*. 3 × 3 in.; 7·3 × 7·5 cm.) British Museum, London. Photo: Trustees of the British Museum.

200 Bronze ornament; stylized horse's head. Stanwick, mid-first century AD. (Ht. 4¼ in.; 10·9 cm.) British Museum, London. Photo: Trustees of the British Museum.

201 Bronze model; dog, found near the temple of Nodens at Lydney. (Length 3¼ in.; 8·2 cm.) Private Collection. Photo: John Webb.

202 Limestone head of a man. Gloucester, first century AD. (Ht. 8 in.; 20 cm.) Gloucester City and Folk Museums. Museum photograph.

203 Bronze ornaments; decorative curvilinear patterns. Dura-Europos, *c*. AD 165–256. Drawn by Jon Wilsher.

204 Stone relief; detail of Triclinium of Maqqai, figures in Iranian costume. Hypogeum of Atenatan, Palmyra, third century AD. From *Syria*, 1960, pl. X, 5.

205 Stone relief; figures in Iranian costume. Gandhara, second or third century AD. Museum of Archaeology, Toronto. From *Syria*, 1960, pl. X, 6.

206 Silver plate; dish with bust of 'Cleopatra' or 'Africa'. Boscoreale, before AD 79. Musée du Louvre, Paris. Photo: Mansell–Alinari.

207 Bronze statuette; Horus–Harpocrates. Taxila, first century AD. (Ht. 5 in.; 13 cm.) Photo: Archaeological Survey of India.

208 Arretine-ware bowl. Capua, 30 BC–AD 40. (Max. diam. *c*. 8¼ in.; 21 cm.) British Museum, London. Photo: John Webb.

209 Glass; painted goblet. Begram, first century AD. (Diam. at top, 3⅛ in.; 8 cm.) Kabul Museum. Photo: Josephine Powell.

210 Stucco model for *emblema* of a dish; helmeted youth, alternatively known as Athena. From Begram. (Diam. 5 in.; 12·5 cm.) Kabul Museum. Photo: Josephine Powell.

211 Bronze statuette; Hercules–Serapis. Begram. (Ht. 9½ in.; 24 cm.) Kabul Museum. Photo: Josephine Powell.

212 Stone relief; legend of the Trojan Horse or some similar Buddhist legend. Charsada, N.W. Frontier of Pakistan. (Length 30 in.; 77 cm.) Photo: from Sir Mortimer Wheeler.

213 Stucco head of a child. Jaulian monastery, Taxila. (Ht. 4½ in.; 11·5 cm.) Photo: Archaeological Survey of India.

214 Stucco head; Bodhisattva. From Hadda, Afghanistan. After J. J. Barthoux, *Les Fouilles de Hadda* (Paris, 1930).

215 Stucco head. (Ht. 5 in.; 12·7 cm.) Sabratha, Site Museum. Photo: Sir Mortimer Wheeler.

Index